W9-BTH-817

Digital Nature Photography

Digital Nature Photography:
The Art and the Science

John and Barbara Gerlach

AMSTERDAM • BOSTON • HEIDELBERG • LONDON • NEW YORK • OXFORD
PARIS • SAN DIEGO • SAN FRANCISCO • SINGAPORE • SYDNEY • TOKYO

Focal Press is an imprint of Elsevier

Acquisitions Editor: Diane Heppner
Developmental Editor: Valerie Geary
Publishing Services Manager: George Morrison
Project Manager: Kathryn Liston
Assistant Editor: Doug Shults
Marketing Manager: Marcel Koppes
Interior Design: Alisa Andreola
Cover Design: Maria Mann

Focal Press is an imprint of Elsevier
30 Corporate Drive, Suite 400, Burlington, MA 01803, USA
Linacre House, Jordan Hill, Oxford OX2 8DP, UK

Copyright © 2007, Elsevier Inc. All rights reserved.

No part of this publication may be reproduced, stored in a retrieval system, or transmitted
in any form or by any means, electronic, mechanical, photocopying, recording, or otherwise,
without the prior written permission of the publisher.

Permissions may be sought directly from Elsevier's Science & Technology Rights
Department in Oxford, UK: phone: (+44) 1865 843830, fax: (+44) 1865 853333,
E-mail: permissions@elsevier.com. You may also complete your request on-line via the
Elsevier homepage (http://elsevier.com), by selecting "Support & Contact" then
"Copyright and Permission" and then "Obtaining Permissions."

 Recognizing the importance of preserving what has been written, Elsevier prints its books
on acid-free paper whenever possible.

Library of Congress Cataloging-in-Publication Data

(Application submitted)

British Library Cataloguing-in-Publication Data
A catalogue record for this book is available from the British Library.

ISBN: 978-0-240-80856-7

For information on all Focal Press publications
visit our website at www.books.elsevier.com

Typeset by Charon Tec Ltd (A Macmillan Company), Chennai, India
www.charontec.com
Printed in China

08 09 10 11 10 09 08 07 06 05 04 03 02

Working together to grow
libraries in developing countries

www.elsevier.com | www.bookaid.org | www.sabre.org

ELSEVIER BOOK AID International Sabre Foundation

Contents

John and Barbara Gerlach have been professional nature photographers for more than 25 years. Their beautiful nature photographs are published in magazines, calendars, and books worldwide. They travel the globe leading photographic safaris to terrific wildlife destinations and teach field workshops on landscape, close-up, and hummingbird photography. More than 50,000 people have attended their intensive 1-day nature photography instructional seminars. Both love to teach others how to make their own fine photographs. They enjoy living in the mountains near Yellowstone National Park and frequently ride their horses in the backcountry to photograph. For details about their instructional nature photography field programs, please go to www.gerlachnaturephoto.com

Acknowledgments

I want to thank my best friend and wife, Barbara who has been my partner in life and business since the late eighties. Without her help, I doubt I would have ever enjoyed the success that has come my way. Together we have traveled to remote corners of the world photographing as a team. It's been a wonderful life, better than I could have imagined. While I wrote this book, she helped me every step of the way. Her ability to locate my silly mistakes and her suggestions for content were invaluable. Half of the photos in this book are hers too. I thought about writing this book to include her more using we and our, but the editors decided that would make the text a bit "clunky" to read.

We wish to thank our parents and especially our mothers for putting up with all the mischief young naturalists heaped upon them. My mother, Donna suffered through countless wild pets which included red-tailed hawks, crows, raccoons, and "herds" of chipmunks in the basement.

Barbara's mother Mary Ann endured similar animal misadventures. Since she had a small farm, it seemed only natural that all lost animals should live there so Barbara brought them home. She had an assortment of raccoons and skunks for pets, in addition to all of the barnyard animals.

I thank Larry West and John Shaw who changed my life when I attended their weekend nature photography workshop in the mid-seventies while in college. I thought I was a decent nature photographer, but when I saw their images, I knew that not only were their photos better than mine, but I didn't even know you could shoot photos that good. I have strived to be the best nature photographer I could be ever since.

I want to thank a few kind folks who encouraged me to pursue writing a nature photography book. My heart goes out to Peter Burian who hired me to write a number of magazine articles. He's a wonderful writer and excellent photographer in his own right who always encouraged me to pursue book projects. He was also the content editor for this book who helped me organize things better and tighten up the text. Ian Adams is a superb landscape photographer from Ohio who has always been willing to answer any question I might have, especially in regards to large format photography. I was fortunate to meet Tony Sweet while conducting seminars on the East Coast in 2005. He was surprised I had not written a book and encouraged me to pursue it. I think his comments along with encouragement from my wife at that time finally moved me into action. I spent the next 2 weeks working hard on a detailed book proposal and mailed it off which led to this book.

I confess that I am a book lover. Give me a cup of gourmet coffee and a new book and I am as happy as can be. I literally own hundreds of fine books so it was exciting to create this book.

I want to thank the many thousands of students who have attended my nature photography programs over the years. Their probing questions helped me enormously in understanding many facets of nature photography. Teaching has been a wonderful win-win situation for all of us. For them I write this book.

Many people have helped me over the years. At the risk of leaving out some who are most deserving of my gratitude, I do wish to highlight a few. Helen Longest-Saccone hired me to write a column for Nature Photographer Magazine when it first began more than a decade ago. Writing these columns has allowed me to share the things I discover about nature photography with others. Helen has always been most supportive and allows me to write about anything I want to. Teaching field workshops has been most enjoyable. In 1988, I began teaching field workshops in Michigan's beautiful Upper Peninsula. The workshop is based at the Timber Ridge Motel and Lodge. I wish to thank the owners for putting up with all the changes I made to their lodge every time we conduct programs there. It has been and continues to be a wonderful experience working with Mike, Mary Sue, Janice, and Terry Nolan. I appreciate Bill Howell for hiring me to lead photo tours in Yellowstone

National Park for the Holiday Inn Sunspree Resort Hotel. Yellowstone park ranger Dennis Young and Denise Herman have been helpful pointing out new photo opportunities such as the bobcat during our winter tours for many seasons. Pam Hawkins helped Barbara enormously with PhotoShop early on when she was first getting into it. With Pam's patient help, Barbara was able to conquer the basics of making prints so she could move ahead. Early in my career, Alan Charnley and Rod Planck helped enormously in developing new photographic techniques while joining me on photo trips.

Hummingbirds are an important part of our lives. We wish to express our appreciation to Hans and Cindy Koch for allowing us to conduct hummingbird photo workshops at their gorgeous guest ranch in the mountains of Southeastern British Columbia.

David Blanton hired me in the early eighties to lead foreign photo tours for Voyagers International. Although it has been bought out by International Expeditions, we led numerous photo tours to Kenya, Tanzania, Galapagos, Antarctica, and the Falkland Islands for David. While we don't travel as much anymore, we continue to lead a terrific photo tour to Kenya

We found this bobcat feeding on the remains of an elk thanks to a tip by Denise Herman, our friend and naturalist in Yellowstone.

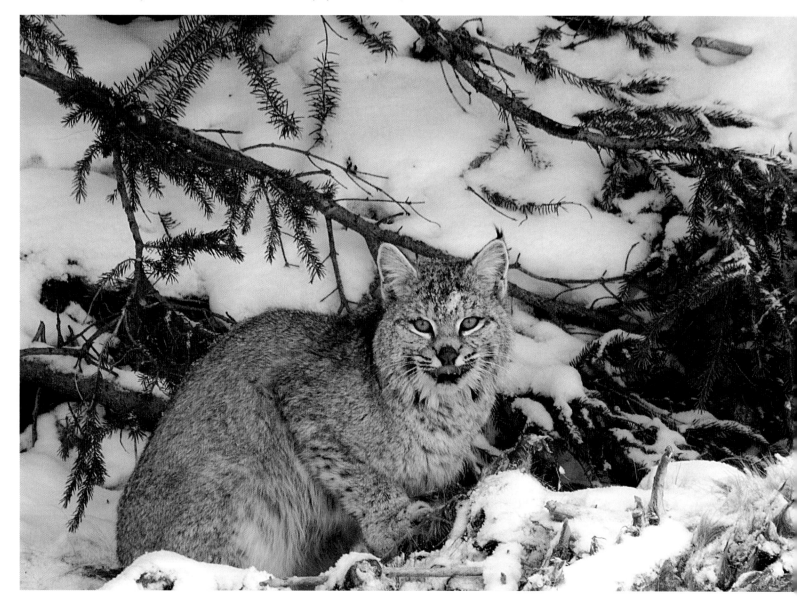

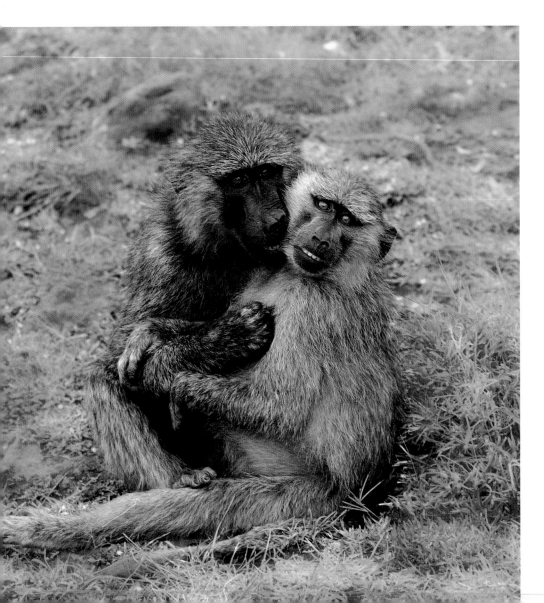

every year for International Expeditions. The staff at International Expeditions (especially Kim Guth) has been superb.

Michele Smith, our office manager, deserves special thanks for putting up with our hectic trip schedule. She and her husband Shay have helped us in numerous ways aside from the office work such as putting shoes on our horses and baby sitting them when we go on long business trips.

Finally, we wish to express our profound gratitude for the faith that the staff at Focal Press had in us and this book. They have been patient and helpful with this first-time book writer who had to learn the process of writing a book. Always cheerful Valerie Geary nudged me along in a most gentle way to keep things on schedule.

Olive baboons are social primates that are easily photographed on Kenya wildlife photo safaris.

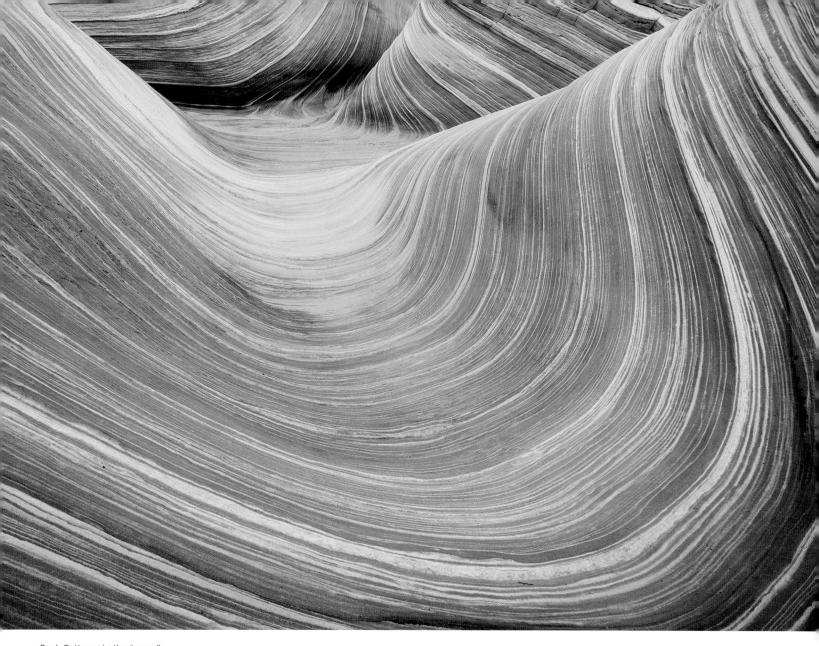

Rock Patterns in the "wave".
Cool days in March are the perfect time to visit the "Wave". This famous spot that lies in the Paria Canyon Wilderness near Page, AZ is a 6-mile round-trip hike. A daily permit is required, but it was easy to obtain during March.

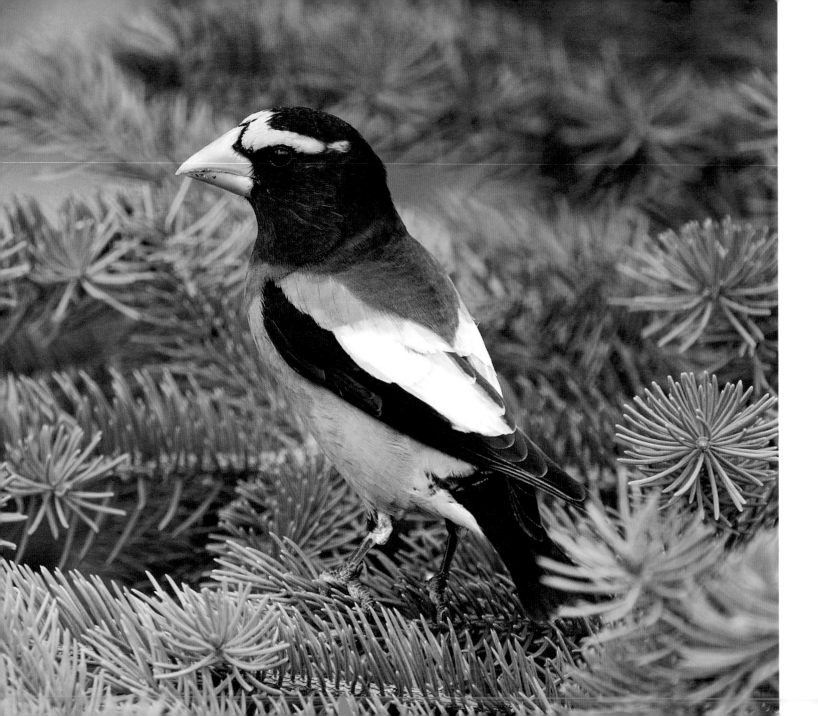

I was born with a keen interest and fascination for the natural world. Even as a small child growing up in the farm country of southern Michigan, I spent every possible moment outside learning about animals. I remember countless hours catching frogs or insects. I especially liked fishing and spent every summer day catching bass, northern pike, and bluegills.

While all wildlife fascinated me, I was particularly fond of birds, a passion that remains with me today. I remember seeing and learning the calls of all the common birds such as mourning doves, black-capped chickadees, white-breasted nuthatches, cardinals, blue jays, and robins before I was 10-years old. Nobody around me knew the birds so I taught myself using Petersen's Field Guides as best I could. Every new bird seen and identified brought great pleasure to me. I especially enjoyed learning winter birds and found each new species sighted most satisfying. Since some species didn't visit every year, it took several seasons to see most of them that could be expected in southern Michigan such as snow buntings, common redpolls, tree sparrows, red crossbills, evening grosbeaks, purple finches, and pine siskens.

My keen interest in birds and photographing them continues today, four decades later. Recently, I had another one of those special new bird moments. My wife Barbara was riding her horse in the forest near our Idaho mountain home when she discovered a woodpecker's nest. She finds a lot of woodpecker nests around the Fourth of July because baby woodpeckers make a constant loud buzzing sound. Since she has excellent hearing, she commonly hears the young from distances of 100 yards or more on a still day and tracks the sound down. We enjoy photographing nesting woodpeckers so she finds each nest to see if it is a suitable nest for photography. We are looking for nests that are close to the ground which means less than 10-feet high. By locating a number of nests, we find a couple nests every year that are easy

LEFT: This male evening grosbeak is readily attracted to backyard feeders with sunflower seeds.

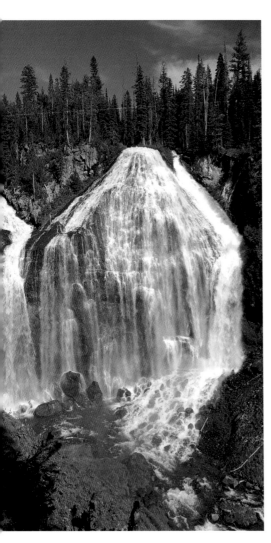

Two rivers join together at the top of Union Falls which accounts for it's name. One of the most beautiful waterfalls in Yellowstone National Park, it is enjoyed by few visitors due to being far in the backcountry.

to photograph. She is quite good at identifying all the local species of woodpeckers around our home which include downy, hairy, northern flicker, and red-naped sapsucker. She watched the friendly pair of woodpeckers feeding its babies from 10 yards away with binoculars, but could not identify them. She excitedly rode home to tell me about the mystery birds. I quizzed her closely to find out one looked sort of like a small flicker and the other was mostly black with a bright yellow belly and the nest was only 3 feet above the ground. She said the two birds feeding the young were so different in appearance that they didn't look like they belonged to each other. I soon came to the conclusion she may have found the nest of Williamson's sapsucker, a bird I had never seen before. We immediately mounted up and rode our horses 3 miles to the nest. With great anticipation, we awaited the bird's arrival at the nest tree. Within a few minutes, the unmistakable male Williamson's sapsucker landed at the nest cavity to feed the young. He was soon followed by the female. It was difficult to contain my excitement. I am certain my hair (at least what I have left) stood up on end when I first saw them. We enjoyed photographing these very trusting birds in the followings days. I am glad my passion for birds has continued for all of these years. If I tend to mention birds a bit too much in this book, please forgive me.

You'll notice we used our horses to visit the Williamson's sapsucker nest. We commonly use horses to reach remote backcountry locations to take nature photographs. Horses are an efficient and quiet way to explore the backcountry. Wildlife tends to be much less afraid of humans mounted on horses. A remote waterfall such as Union Falls, considered by many to be the most beautiful waterfalls in Yellowstone National Park, is an easy 16-mile round-trip day ride on horses. These wonderful animals make it possible to explore and photograph in places that would be difficult and time consuming to reach on foot. I believe horses are greatly underutilized by nature photographers today. If you love remote places, do consider using horses to reach them.

My interest in nature is broad. In addition to birds, I really enjoy photographing wildflowers (especially orchids), butterflies, amphibians, reptiles, mammals, frost, dew, fruits, ferns, autumn color, and natural landscapes. Since I live near Yellowstone National Park, I commonly photograph geysers and confess to being a geyser gazer.

I began my photo career with the old Canon FD system which performed well for many years. When Canon introduced their new EOS system, I had to buy all new lenses to go with the new lens mount on the EOS camera body. Since I had to buy everything, I decided to switch to Nikon and shot that system quite successfully for a decade. Eventually, Canon made a series of tilt–shift

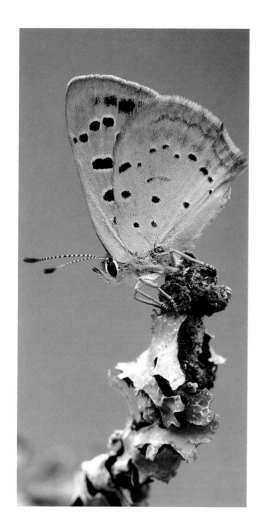

This American copper butterfly is slightly larger than a dime and frequents open meadows.

Frosty mornings are frequent in the high mountains of Idaho. These frosted willows in front of Black Mountain were near our front yard.

lenses that included 24 mm, 45 mm, and 90 mm focal lengths. These lenses offered tilt–shift capability in 35 mm format. I shot 4 × 5 view cameras at the time and knew what tilt and shift controls could do for me. I soon bought all three of these lenses and an inexpensive EOS body to shoot them on. Eventually, I bought more and more Canon EOS gear until I finally sold all of my Nikon equipment and went with the Canon EOS system which I continue to happily use today.

You might be surprised to hear that Barbara shoots the Nikon system. She started out with Nikon and continues to love it. It works very well for her and is a fine system. We shoot two different camera systems for some important reasons. First, if you were to ask each of us which system is best, you would get two different answers. Second, shooting two systems gives us access to the best each system has to offer. Third, we teach numerous photography workshops and lead photo tours throughout the year.

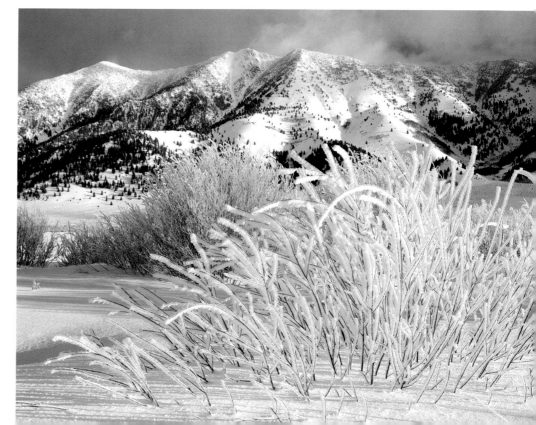

The vast majority of our clients shoot either Nikon or Canon, especially now that nature photography has embraced digital so it is easy to help them with equipment problems.

Since we shoot the Nikon and Canon systems, it is not surprising that we mention equipment from both manufacturers throughout the book. Nikon and Canon are companies that invest a lot of research dollars into developing their digital camera systems. We love seeing new lenses and camera bodies coming out at regular intervals and having lots of choices. While we have a preference for Nikon and Canon, it doesn't mean the other systems aren't good too. Certainly Sony, Pentax, Samsung, Olympus, and Sigma make fine products too. But, they don't make as many lenses and camera bodies so your choices are fewer.

I remember what Marvin Dembinsky, one of my stock agents, had to say about me decades ago. After reviewing some of my latest images for inclusion in his files, he said, "you sure are driven." I suspect that he was correct. I started taking nature photographs when I was a teenager. My passion for exploring natural areas and photographing the unique objects I found there burned like a white-hot torch. It still does many decades later! With the powerful tools and capabilities digital capture offers today, my enthusiasm for nature photography is as hot as ever. Digital has energized the nature photography field. So many new ways are now possible for taking wonderful nature images that were not available in the film era. Only now are nature photographers beginning to utilize all the new tools that are available to the digital photographer.

I hope you'll enjoy this book. I am writing it with the same passion I have for going outdoors and making nature images. I love teaching photography just as much as taking my own photos. Perhaps that's why our photographic workshops and tours have been so successful over the years. My goal in every workshop is to help my clients take some of the finest nature images they have ever done. That is my goal for this book. I want to help you master those key factors that make it easy to consistently shoot outstanding images. Everyone can learn to take excellent nature images shot after shot. But, you do need to buy some equipment and develop superb shooting habits.

You'll notice this book stresses field techniques and strategies that produce excellent images. The content is intended to help you shoot the best possible images in the camera, not to show you how to "fix-it" later with software. I am no computer wizard, though Barbara is a borderline computer nerd. If you want a book on the digital darkroom, this isn't the book for you. There are plenty of other books that cover that very topic. Fortunately, my editors at Focal Press have encouraged me to write a book that emphasizes my strength which is shooting original images in the field.

For years, I avoided trying to get a book contract because I was afraid that it would require me to spend too much time on the computer which is time I wouldn't be spending outdoors. My fears turned out to be well founded. Writing a book does take more hours then you could believe. However, I enjoyed the process immensely and hope this book inspires others to perfect their own nature photography skills.

I wish you the best of luck as you explore digital nature photography. With enough effort, you'll be successful and the discoveries you make in the natural world will fill your heart with fond memories!

We have photographed the incredible fall color near Munising, Michigan for more than 20 years. Now that we shoot only digital, we have to reshoot everything over again and couldn't be happier about it.

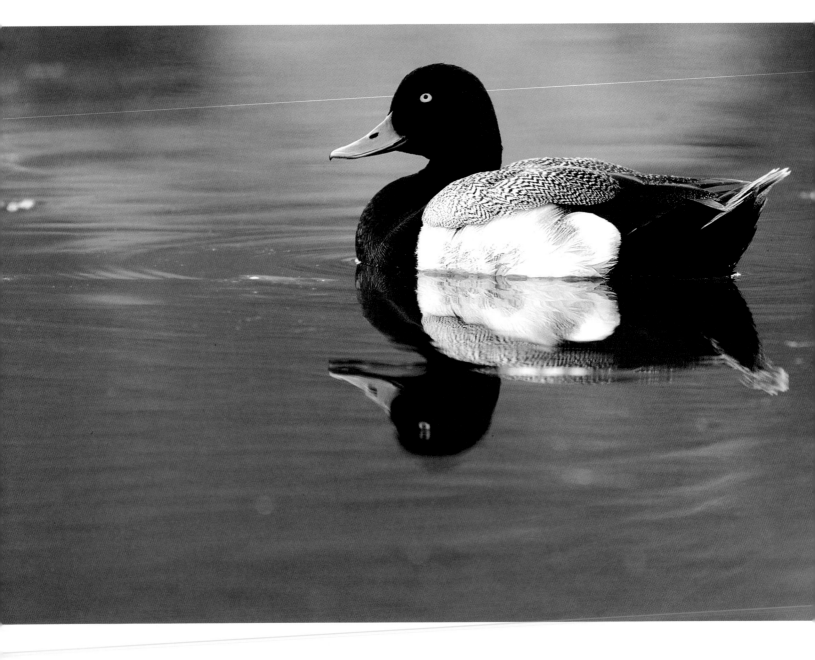

The Excitement Over Digital Photography

Digital photography is generating excitement in the world of nature photography unlike anything else in my long career. I have always cared dearly about obtaining quality images. As a result, I missed the early stages of the digital revolution because it didn't make any sense to buy cameras that were far more expensive than top of the line film cameras, only to get inferior results. But, by 2003, the best digital cameras were coming close to the quality offered by the best slide films. Perhaps they weren't quite as good as Fuji Velvia 50 slide film, but digital capture was excellent and becoming widely accepted by photo buyers. When the 16.7-megapixel Canon 1Ds Mark II became available a year later, digital capture was at least as good as slide film and more fun too.

The new tools offered by digital such as being able to change the ISO from one shot to the next, changing white balance to match the light conditions, and shooting panoramics and stitching the images together with software, have tremendously affected the way nature photographers shoot in the field. Students shooting digital learn much faster. The instant feedback offered by digital capture makes it so easy to fix exposure, white balance, composition, or focusing mistakes in the field while the subject is still present. That's a huge advantage!

WHY TAKE NATURE PHOTOGRAPHS?

We all have reasons for photographing nature. Perhaps you are more interested in winning a photo contest at the State fair or camera club. Perhaps you want to get published in a calendar, magazine, or book. Perhaps you want a beautiful web site or gorgeous prints on the wall. Perhaps you love digital cameras and computers so you make images to use those tools. Perhaps you love being in natural places and making photos gives you an excuse to spend time enjoying natural events. You may photograph for fun or hope to make some money from your images. All of these are valid reasons to photograph nature. Most likely

LEFT: Lesser scaup are diving ducks that spend time "dating" on our small farm pond every May and June. Since the pond is often ripple free at dawn, we can capture images with a pleasing mirror reflection.

FOLLOWING PAGES: A clear and calm January afternoon was the perfect time to photograph Midway Geyser Basin with three separate images that were stitched together manually.

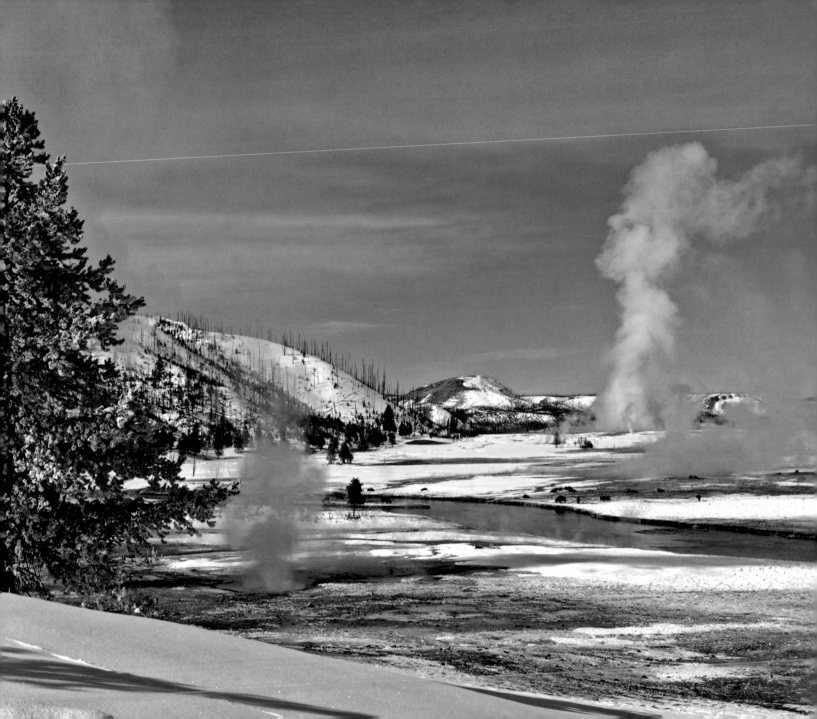

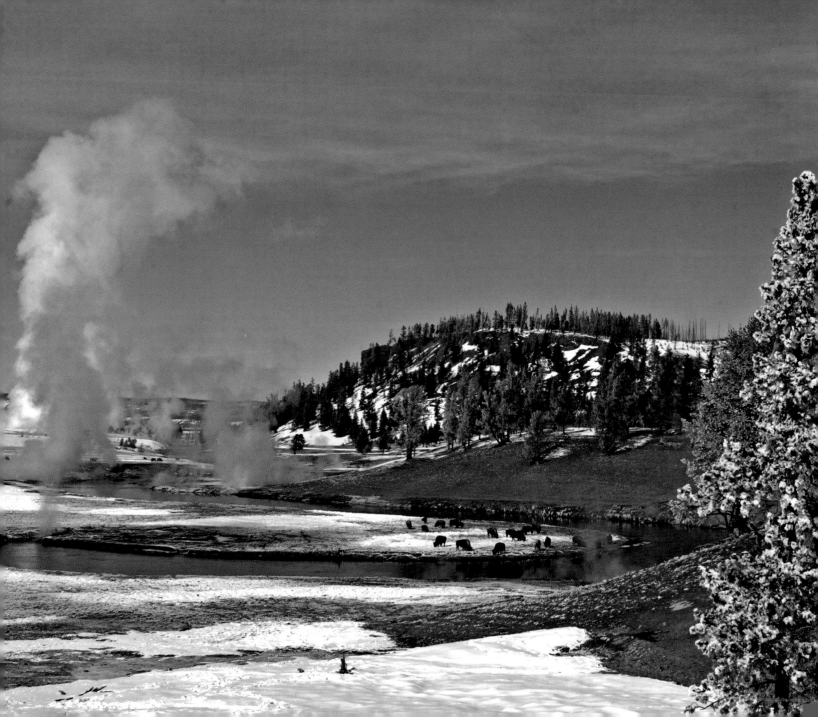

your reasons for taking photographs of nature include a combination of these.

GREAT PLACES TO TAKE NATURE PHOTOGRAPHS

One of the wonderful things about nature photography is that it can be done any-where. You don't need to travel the world to take nature photographs. Even if you live in a large city, natural areas are nearby. New York City has Central Park, plus zoos and botanical gardens. Let's start with your own property. If your entire property is a mowed lawn, perhaps you could plant a flower garden. Then you would have many opportunities to photograph flowers and the insects that are attracted to them. Bird feeders and water baths should attract a large variety of colorful songbirds. Any nearby meadow full of wildflowers is cer-tain to be packed with photogenic subjects, especially on a cool dewy morning. Nearby forests, lakes, marshes, and seashores offer many opportunities for the nature photog-rapher. In many locations, public land is available to use.

I grew up in Lapeer County, a rural county 60 miles North of Detroit. While most of the county was private land, gain-ing permission to photograph on private property was easy to get. State parks were available too and I spent many hours at Seven Ponds Nature Center photographing

Dewy meadows are certain to harbor numerous adorable subjects like this Common St. Johnswort that supports a delicate spider web loaded with dewdrops.

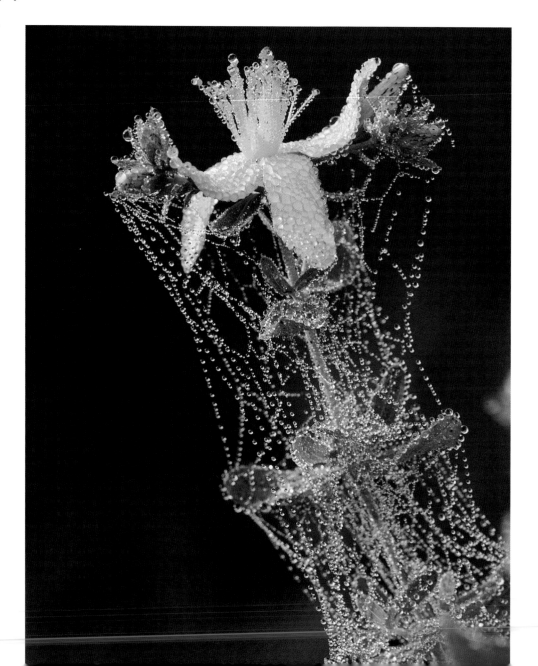

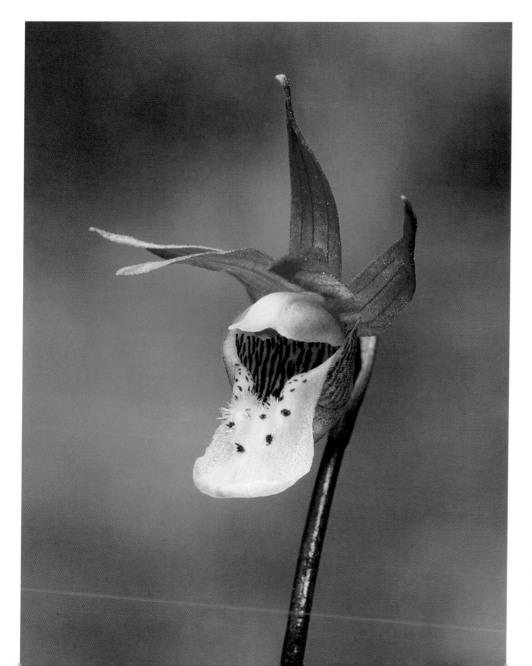

the wildflowers in their restored prairie. I did most of my nature photography in the Lapeer State Game Area, a huge block of wild land that was purchased by hunters and fishermen to keep it wild. I found so many different subjects to photograph that I could have spent my entire life photographing in Lapeer County without ever running out of new subjects to photograph.

TREAD LIGHTLY ON THE LAND

It's important to respect your subject and it's environment. Try to impact the natural world as little as you can. It is not possible to have no impact, but your impact can be minimized. Avoid damaging your subjects. Don't pick wildflowers. Try to stay on trails or bare areas to avoid stepping on delicate flowers. Don't harass wildlife. I like to photograph wild orchids for example. While all of us would avoid damaging the orchids we can see in bloom, it's important to recognize the orchids that haven't yet bloomed so they won't be crushed. I usually photograph a couple of nesting birds near my home each year. I always pick the easiest nests with birds that are fairly habituated to me already. The number of mountain bluebirds that nest on our property varies from 5 pair to 7 pairs-depending on the year. Some mountain bluebirds wouldn't allow me to approach closely, but one pair readily ate meal

Calypso orchids are common wildflowers that bloom around the Fourth of July near our Idaho home. This blossom was isolated from the background with a 200 mm macro lens.

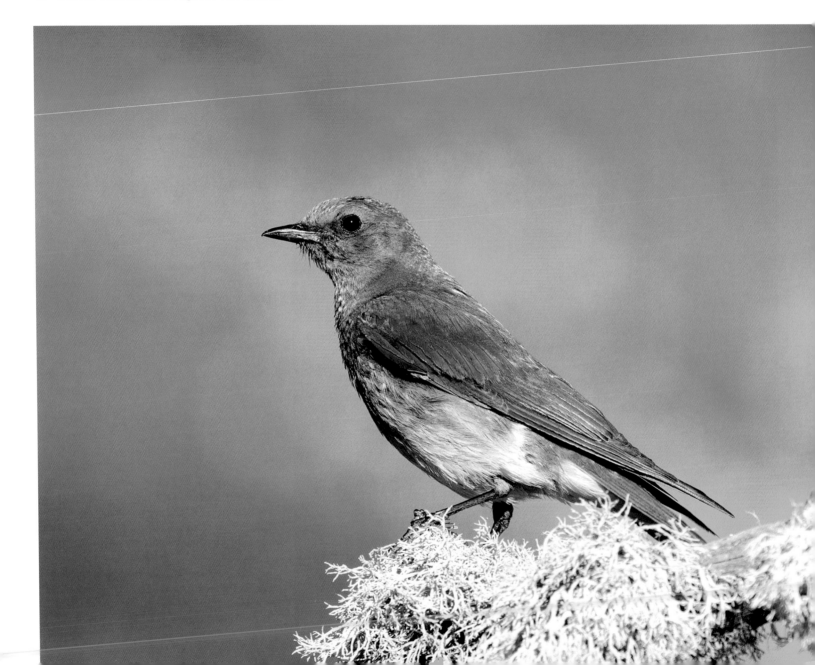

worms out of my hand so that was the pair to photograph. A wide assortment of woodpeckers nest near my property and they are always easy to photograph. On the other hand, a pair of northern goshawks nest a few hundred yards behind my home in the dense lodgepole forest. They are skittish birds that are prone to abandoning their nest if bothered by humans so it is too risky to try to photograph them.

QUALITY MATTERS

It's wise to use the best techniques possible to get the finest image quality. If your goal is super images, then never cut corners when it comes to technique. One serious drawback to digital technology is some folks are becoming sloppy in their technique because they think problems can be fixed with software. While software capabilities are truly amazing, they can't fix everything. Out-of-focus images are still out-of-focus no matter what you do. Grossly overexposed images don't improve much with software either.

Images that require a lot of help from software are probably not very good to begin with. My goal and I hope your goal is to shoot the finest possible image in the field. Any image that requires few adjustments with image-editing software is the image you should be striving for while shooting in the field. It's been said many times before and bears repeating, "Garbage in, garbage out".

LEFT: It helps to have a wildlife friendly yard. Several pairs of mountain bluebirds nest in our wooden nest boxes every June.

I stress producing high-quality images throughout this book. I don't cut any corners while emphasizing those critical techniques that produce wonderful and technically sound images time after time. Anyone can learn to take excellent images, but it does require that you master technique. It just requires practice and time to succeed.

USE EXCELLENT EQUIPMENT

Buying good camera equipment is important to your success. You certainly don't need the latest and greatest top of the line camera to succeed. I tend to have a lot of equipment because I am always trying to find better ways to make quality images. However, I am not an equipment junkie and I struggle to learn new camera gear just like you do. Equipment that is suitable for nature photography is a real joy to use so it's important to get the features you need. In many cases, I will tell you exactly what equipment I use and why, but also suggest other possibilities that might be less expensive or easier for you to carry in the field.

DEVELOP EXCELLENT SHOOTING HABITS

You'll find that whatever camera system you use, it changes rapidly over time. This is even more true today because of the rapid advances in digital technology. You'll be continuously tempted by the latest and greatest cameras and lenses. But, no camera has ever taken a great picture all by itself so don't depend too much on the equipment. Developing excellent shooting habits that consistently produce quality is the key to becoming a really good nature

photographer. Using a tripod whenever possible, finding photogenic subjects, using light well, focusing carefully, composing thoughtfully, and selecting creative angles are all critical to creating outstanding images. While equipment changes rapidly during your photographic journey, the creative side of photography does not evolve nearly as fast, so don't focus so much on equipment that you neglect the artistic side of nature photography which is more important than cameras and lenses.

BECOME A BETTER NATURALIST

The more you know about nature, the better your images. You don't need a degree in biology to become an excellent naturalist. Many of the best birders or wildflower lovers are self-taught. Many field guides are available today on very specific subjects. When I started out, you could buy a field guide to the birds of the Eastern US and another to the Western US. Now most states have their own field guides which are far more precise and detailed than general guides. There are even field guides on specific groups of birds such as hummingbirds, hawks and owls, and waterfowl. Many nature centers, local colleges, and parks offer field classes on natural history subjects. These are all worth taking to broaden your knowledge of nature. The more you know about nature, the more you'll enjoy your time in the outdoors and the more you'll find to photograph. The best nature photographers tend to be knowledgeable naturalists so learn more about nature right along with learning about digital photography.

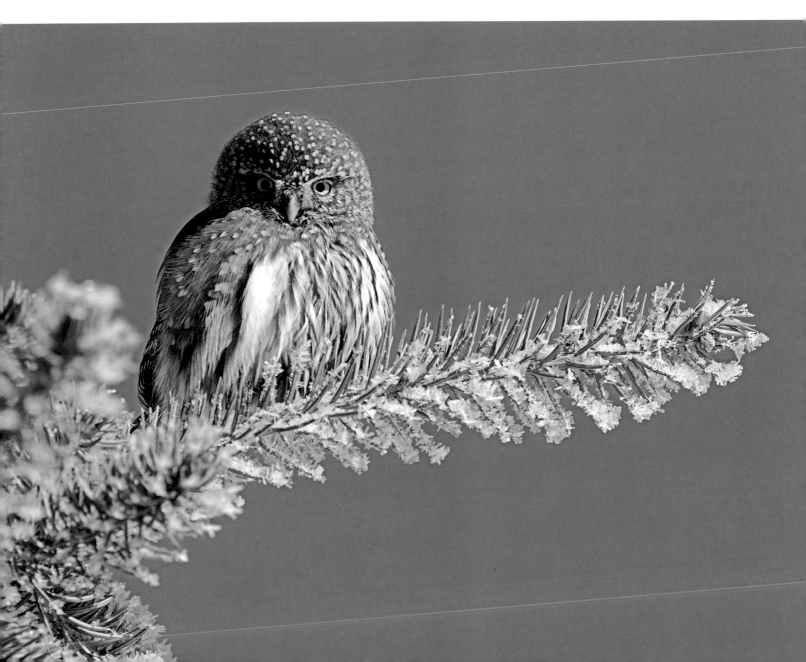

PROFESSIONAL VS. AMATEUR NATURE PHOTOGRAPHERS

Are professional nature photographers better than amateurs? I know quite a few professional nature photographers and some are better than most amateurs and some aren't. Saying you are a professional photographer means you make the majority of your money from photography. Amateurs make his/her money in some other way. Identifying yourself as an amateur or pro nature photographer really says nothing about your knowledge or skill level. It merely indicates your source of income. One of the finest nature photographers I know who easily would occupy a slot in my top 10 list of nature photographers is Alan Charnley. You haven't heard of Alan because he doesn't try to sell photos or make any money from his nature photography. He has been my dentist for the past 30 years. Incredibly successful in his practice, he doesn't need or want to bother with making money from nature photography. He does it strictly for the fun of it. Plenty of amateur nature photographers like Alan are every bit as good as the professionals. Everyone can be an excellent nature photographer if they apply themselves and spend enough time in the field finding wonderful subjects to photograph.

LEFT: This Northern Pygmy Owl is a fierce diurnal hunter of small birds. It frequently patrols our bird feeder hoping to find an inattentive visitor.

THE THREE FACTORS THAT MAKE A WONDERFUL NATURE IMAGE

Over the past three decades, I have examined thousands of nature images produced by my students, other photographers, and myself. All of the really outstanding images I see exhibit three characteristics. While I don't want producing excellent nature images to boil down to a formula, there are three keys to consistently making rewarding images. These factors include using excellent technique to capture a photogenic subject in a wonderful situation. You need all three, subject, technique, and situation to make stunning images time after time. If any one of these is missing, the resulting picture usually becomes just another image. Let's look at each of the three factors in detail.

Technique is the first priority for beginning nature photographers. You want to shoot properly exposed, well composed, and sharp images. It is important to learn to use your equipment to extract the greatest

BELOW: Black-capped chickadees are abundant at our winter feeding stations. They are so fast that we hand-hold 300mm lenses that have image-stabilization, push up the ISO to at least 200, and shoot around f/5.6 to maintain high shutter speed for sharp images.

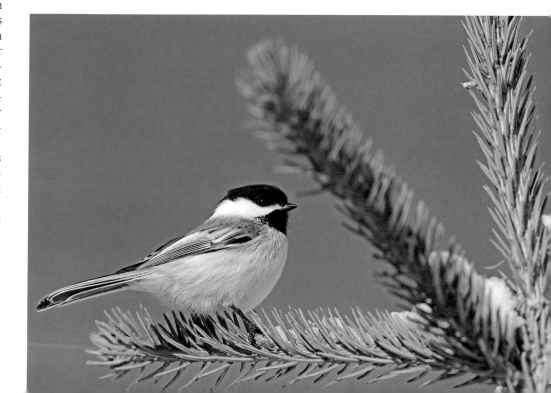

sharpness your camera gear can deliver by using the best optics, filters, and tripods to make sharpness a certainty. Take the time to master exposure. You must fully understand f-stops and shutter speeds, ISO values, metering patterns, histograms, highlight alerts, and compensation dials for flash and natural light. While technique is critical to success, don't become so obsessed about it that you are oblivious to the other factors that make a successful image.

Subject selection is just as important as technique though. Photographing a

chickadee in late summer is certain to be an unattractive photo no matter how sharp and well exposed the image. These birds molt during late summer so they are missing many feathers making them unattractive. It is much better to photograph chickadees in late fall to mid-spring when they are fully feathered. Most nature subjects have periods of time when they are more photogenic than others. Wildflowers are excellent examples. Some blossoms are more pleasing to view than others. In a wildflower meadow, search for the best blossoms to photograph. There is no point in photographing

a blossom that is beginning to wilt when other blossoms are in peak condition. In Northern Michigan, meadows are typically soaked with dew following cool, clear nights. Some meadows bordering lakes are full of roosting dragonflies and grasshoppers that are bejeweled with dew. By searching the meadow in predawn light, find as many sleeping dragonflies as possible. In a half hour, you might find 15–30 dew-laden dragonflies and a couple of butterflies. Don't photograph everything you find, but work only the most outstanding specimens. Rather than taking a few images of 30 different subjects, carefully select the most photogenic and take dozens of images of the very best. Selecting the subjects that offer the most promise is crucial to success. Avoid wasting time in photographing unexciting subjects. Find the best opportunities and work them thoroughly!

The situation is critical too. A male lesser scaup in spring breeding plumage is a gorgeous diving duck. But, trying to photograph one that is too far away bouncing in the waves at noon on a sunny day is certainly going to be an uninspiring photo. The light is ugly and the image probably won't be sharp either. I mention lesser scaup because I have a pond on my property that attracts them in the spring. Scaup like to use my small pond for courtship displays. These scaup are used to seeing humans and horses so they have become quite fearless. It's easy to go to the pond early in the morning during June when it is calm and sunny, and photograph the male and female scaup with spectacular mirror reflections.

In a meadow full of wildflowers, always look for the very best blossoms such as these Lewis's monkey flowers.

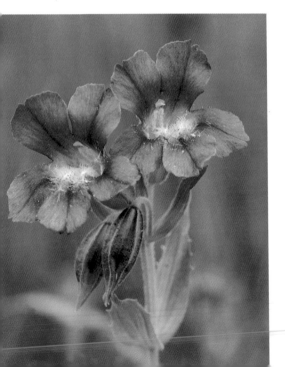

This tiny grasshopper has spent the night perched on this gray-headed coneflower.

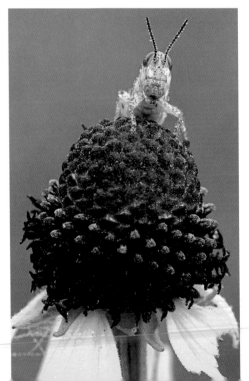

Weather conditions can create terrific situations for making wonderful images while totally eliminating other possibilities. It's important to recognize favorable or unfavorable weather so you can effectively adjust your plans to put yourself in a place where subjects abound in good situations. I have led winter photography tours in Yellowstone National Park for years. Often the participants want a daily schedule so they know ahead of time what they will

photograph each day. Some seem surprised when I tell them I have no idea what we will do tomorrow. Since there is no way to accurately predict the weather ahead of time, I can't decide where we are going until we drive our snowmobiles through the park gate. Even then, plans may change if the weather changes or unexpected opportunities arise such as the time we found a bobcat feeding on an elk carcass. The thermal regions of Yellowstone require sun and blue sky to photograph well. The famous geyser called Old Faithful doesn't photograph well against a backdrop of white clouds because the steam blends in with the clouds. You must have blue sky to really show the steam off. If it is cloudy, it is pointless to spend time photographing geysers. The light (situation) is all wrong. But, it doesn't mean you can't take nice photos. Subjects that photograph beautifully on cloudy days include waterfalls, the Grand Canyon of the Yellowstone, and wildlife. If it is cloudy and snowing hard, then don't bother with the Grand Canyon of the Yellowstone because falling snow obscures the huge canyon. Heavy snowfall makes it difficult to photograph landscapes well, but is ideal for wildlife photography. Wind-blown snow shows up nicely against

the dark fur of bison or moose imparting a winter mood to the image.

As you develop your photographic skills, keep in mind the critical role of technique, subject selection, and situation to make excellent nature images. This combination is crucial to consistently creating fine images. All three components are equally important!

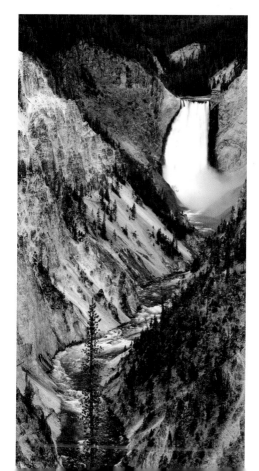

LEFT: The blue sky outlines the steam and water of an Old Faithful eruption which happens about every 90 minutes.

RIGHT: Lower Falls and the Grand Canyon of the Yellowstone photograph nicely on a cloudy day. On sunny days, dark shadows often hide the bottom of the canyon from the camera.

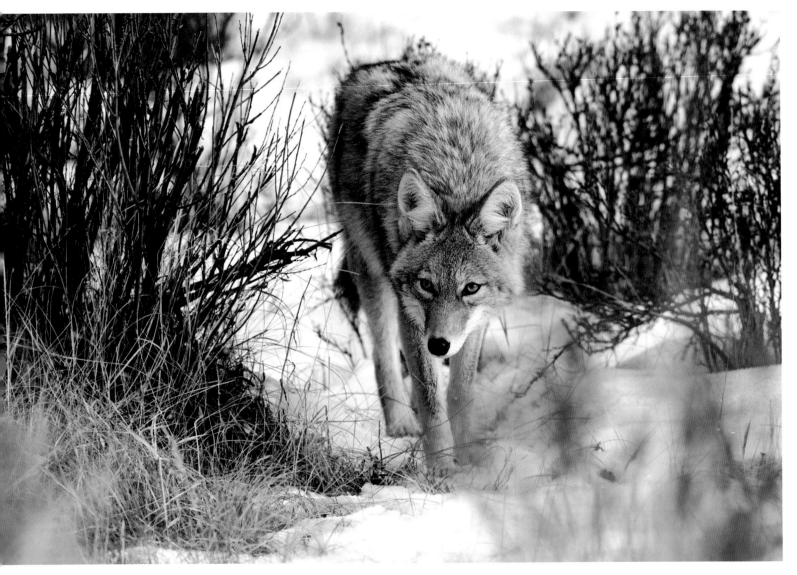

A bright cloudy day is perfect for photographing mammals like this hunting coyote if the sky isn't in the image.

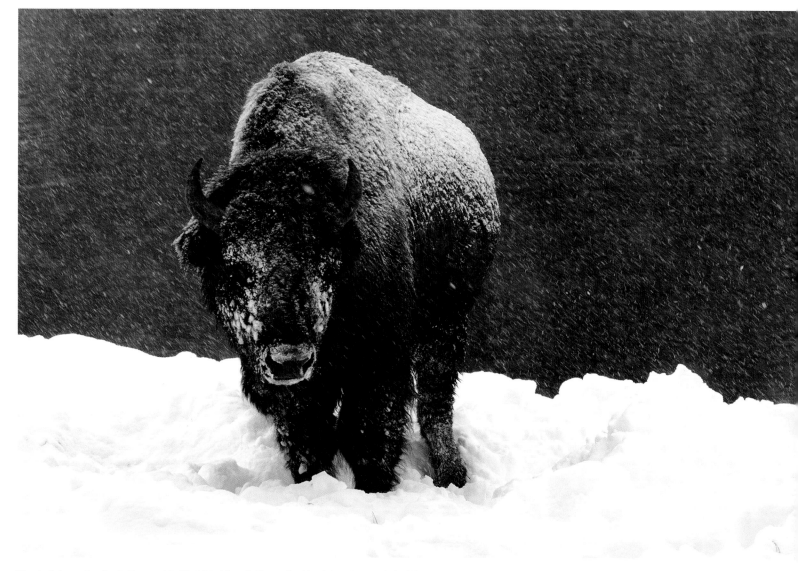

The dark fur and water in the pond behind this bison is the perfect backdrop to reveal the falling snowflakes.

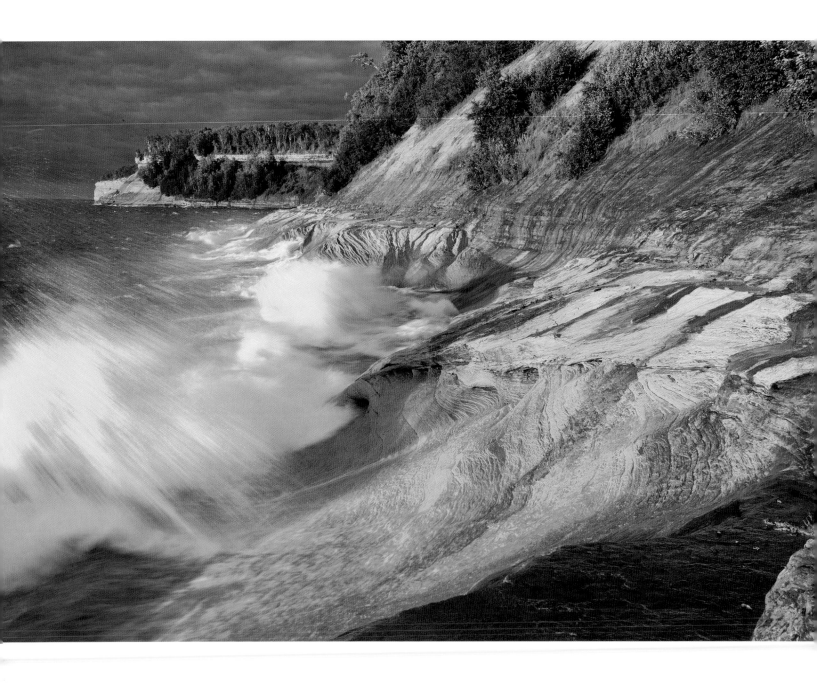

Developing Your Photographic Skills

2

It is impossible to begin as a super photographer, no matter how smart you are. Skills must be developed and mistakes made so you can see for yourself what works and what doesn't work. Fortunately, the process is fairly straightforward and you can become an outstanding photographer rather rapidly if you invest the time.

Many of my students rapidly become outstanding nature photographers and some have gone on to become highly successful professionals in the tough field of nature photography. While no two individuals pursued exactly the same path to becoming accomplished photographers, all of them shared a similar path. The following paragraphs suggest a route that will help you on your journey to becoming an accomplished nature photographer.

STUDY THE MANUAL

Far too many people fail to study the instruction manual that comes with the camera, lens, or flash. The manual provides important information that you must know to help you master the equipment. Equipment manuals are packed with information so don't plan to read it quickly and fully comprehend the material. It takes a lot of effort. Even though I have been a nature photographer for decades, I thoroughly study the manual of any new equipment I buy. And I do mean study. Every time I buy a new camera body, I read a couple of chapters in the manual each day, take notes, and use a yellow highlighter pen to mark important information that I don't know. Over a period of a week, I'll work my way through the entire book. I even study the features on the camera that I think I won't use because it is important to know everything the camera can do in case you need it later. Once the manual has

LEFT: This wave crashing on the eroded rocks at Pictured Rocks National Lakeshore along with the stormy sky hints at the power of Lake Superior.

been studied hard, always keep it with you for review and to look up items you may have forgotten.

HANDLE YOUR EQUIPMENT

You must frequently handle your photographic gear which includes cameras, lenses, tripods and heads, filters, flashes, and anything else to feel at ease with them. The more you handle them, the more familiar you become with all of their features. Turning on the camera and working your way though all the menus help you become at ease with the equipment. As you handle the camera, make sure you know what every button on the camera does. If you don't know its function, look it up in the manual.

Becoming at ease with handling camera equipment is easier for some than others. Here's one observation I have made teaching field workshops. Of the three professions, medical doctors, lawyers, and dentists, what profession tends to be more adept at taking excellent nature photographs and which one tends to lag behind? Dentists tend to excel at nature photography. Medical doctors tend to be somewhat less skillful and lawyers come in a distant third. I don't mean all dentists are excellent nature photographers and all lawyers are average because I know some dentists who are average while I know a couple lawyers who are superb. But, as a group, 100 dentists will easily produce better images than 100 lawyers if they are picked at random and provided the same equipment and opportunities.

Why do dentists tend to be such good photographers while lawyers tend to be average? The folks making up both professions are smart and highly educated so clearly being smart is not the only factor. Perhaps the answer lies in what they do for a living. Dentists are creative people who use tiny tools day in and day out. Lawyers tend to be word people who excel at public speaking and writing, but they don't use a lot of small tools at work. Becoming a successful nature photographer requires skills for handling lenses, filters, the buttons and dials on cameras, and flashes efficiently. These small tools demand precise adjustments to get the most out of them. Anyone who has a career or another hobby where they use small tools frequently has a head start in photography.

Books and magazines about birds can help you find places to photograph unusual birds such as this purple gallinule in the Florida Everglades.

SUBSCRIBE TO MAGAZINES

Magazines on photography and natural history can be enormously useful so it is worthwhile to subscribe to at least a few of them. Since magazines are published monthly or quarterly, they are able to report timely information regarding recent advances in photography. While field techniques change slowly for nature photography, equipment choices change rapidly. The latest information about new cameras, lenses, tripods, printers, and software quickly appears in magazines. In addition to up-to-date equipment reviews, magazines typically describe outstanding photo destinations and may feature interviews with the leading photographers of our time.

All of us lead busy lives so there isn't time to read every magazine that is appealing. It is important to narrow down the list of choices to those that are the most useful. In my case, I subscribe to eight different magazines and do have trouble finding time to read all of them. Here's a list of the eight magazines I read and why.

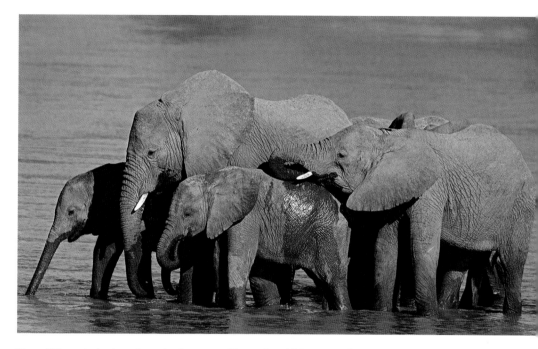

These African elephants make a pleasing composition as they drink water at Samburu National Park in Kenya.

Outdoor Photographer

I have been a subscriber to this US magazine since it was first published in the eighties. Each issue is full of product reports, where to go articles, and many other topics that are of special interest to nature photographers (www.outdoorphotographer.com).

Popular Photography

This US magazine is published every month and covers new equipment and shooting techniques. It is more general than the other photo magazines I get and that is why I like it. Lighting techniques for wedding or portrait photography could easily be adapted to nature photography (www.popphoto.com).

Nature Photographer

I write a column for this magazine which is very strong on describing places to go to make outstanding nature images. The magazine is full of inspiring images. Few articles cover new products, but that is fine since the other magazines cover that so well (www.naturephotographermag.com).

PCPhoto

This magazine describes the latest digital photo equipment and offers tips for using it effectively. It helps me keep up with all the rapidly changing digital equipment (pcphotomag@neodata.com).

Digital PhotoPro

This fine magazine is intended for advanced digital users, so I like the in-depth articles on equipment, digital photo processing, and software (digitalphotopro@neodata.com).

EOS Magazine

Published in Europe, this magazine specifically covers the Canon EOS system with in-depth articles and reviews on the latest EOS equipment and techniques for using the equipment. Since I use the Canon EOS system, the narrow focus on the EOS system appeals to me (www.eos-magazine.com).

WildBird

I'm an avid birder so detailed articles about birds and places to see and perhaps photograph birds are appealing to me. The May/June edition is the annual hummingbird issue which is especially useful (Wildbird/PO Box 37193/Boone, IA 50037-0193 (800) 542-1600).

The Trail Rider

Since horses cover rough ground so easily, I frequently use my horse to locate wonderful nature subjects to photograph around my mountain home. Riding a horse makes it easy to cover a lot of ground to find the best wildflower blooms, scenic vista, or perhaps a nesting woodpecker. This magazine covers critical information that is important to know when riding steep mountain trails (www.trailridermagazine.com).

Many other fine photo magazines are published around the world. Quite a few well-done magazines like EOS Magazine are published in Europe. I like some Canadian magazines too, but don't subscribe to them now because I don't have time to read everything I get now. I am sure other fine photo magazines exist worldwide so be sure to check out everything in your home country first. A good

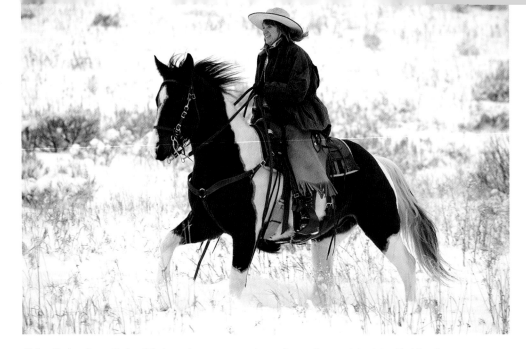

Riding Barbara's spotted saddle horse is a super way to reach remote mountain vistas that few have seen or photographed.

place to start is any large bookstore that offers a wide assortment of magazines.

JOIN A CAMERA CLUB

Camera clubs are quite popular with many photographers. A great deal of knowledge is found among the club members regarding equipment, shooting techniques, and places to go to photograph whatever appeals to you. Club members share their information freely and some highly skilled members present instructional programs on photography. Clubs offer photo contests and may critique images too. Some clubs band together to form Camera Club Councils for competition between clubs or to conduct educational multi-day photography seminars. Early in my career, I attending some of these events and found them to be beneficial and fun. I still attend these events, but always as a program presenter. I met Barbara when I was the keynote speaker at the Southwestern Michigan Council of Camera Clubs annual seminar.

Finding a camera club is easy. Local camera clubs usually list their events in the local paper. The Internet is a valuable tool for locating clubs too because nearly every club has a web site. If you live in California for example, try searching the web for California and camera club. Many camera club leads will appear on your computer monitor. The local camera store should know about any area camera clubs too.

Do make sure the focus of the camera club coincides with your interests. If your primary interest is color nature photography, a club that is devoted to black and white or stereo photography won't be a good match. Attend the meetings of several clubs to see what they are like before deciding which one to join. Clubs are always looking for new members so they are happy when visitors and potential new members attend the meetings.

ATTEND INSTRUCTIONAL PHOTOGRAPHY PROGRAMS

Participating in photo seminars, workshops, and tours is a terrific way to advance your photographic skills. Since many people are confused about how seminars, workshops, and tours are different from each other, lets explain the difference.

Seminars are usually 1-day affairs, but they could last 2 or even 3 days. A seminar is taught by a skilled photographer who has excellent public speaking skills to a large audience that could number in the hundreds. Instructional slide or digital programs are presented on various topics. A good seminar provides detailed notes too. Since the number of participants is high, the cost per participant is typically quite low in the $75 to $150 per day range.

Participating in a nature photography tour of South Florida that emphasizes birds will give you the opportunity to photograph many unusual species at close range such as this Double-crested Cormorant.

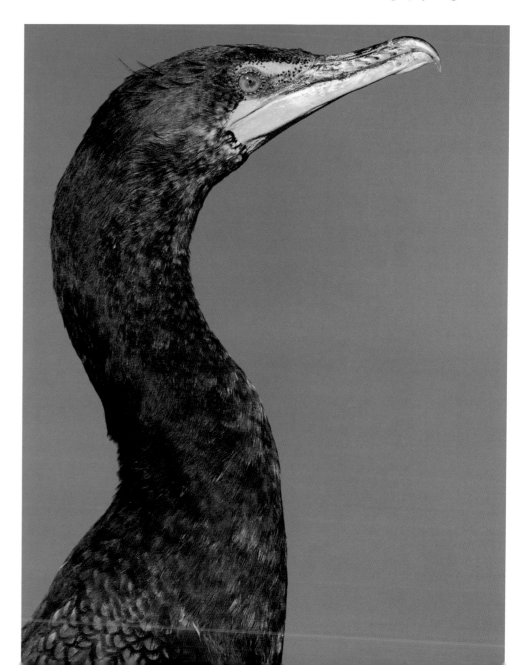

This is an excellent value, especially if you consider that a seminar can save you a lot of money and wasted time by showing you what works best to shoot the images you want. Since a large audience is needed to make a seminar financially viable, seminars are typically conducted in the largest cities. To find out about upcoming seminars in your area, check for ads in the largest circulation photography magazines in your country. For example, any issue of Outdoor Photographer or Popular Photography is certain to advertise many seminars conducted in the US.

Although you won't be shooting photos at a seminar, it is an excellent way to learn new photo techniques at a very reasonable cost. Be sure to match the seminar with your interests. A seminar on wedding photography won't be that useful to a nature photographer. If you are mainly interested in mastering PhotoShop, a seminar on digital nature photography that stresses field techniques won't hit the mark either. On the other hand, if your primary interest is obtaining the best possible digital image in the field, then a PhotoShop seminar may not be appropriate for you either.

ATTEND A PHOTOGRAPHY WORKSHOP

Photo workshops can vary from a 1-day workshop photographing wildflowers at the local park to a week-long workshop photographing the autumn color of the North woods. A field workshop involves shooting in the field early and late in the day when the light and weather conditions are most favorable. Skilled photographers guide the students in the workshop, helping them make the best possible images. The enrollment in workshops is limited so there is only about 8–12 participants per instructor. Avoid any workshop where there are more than 15 students per instructor. Since enrollment is much smaller than a seminar, expect to pay much more for tuition which can exceed $1000 per person for a week. Excellent workshop instructors take very few of their own images. Instead, they spend their time helping the students shoot the best possible images.

During the middle of the day when the weather is often unfavorable for shooting in the field, instructional programs are presented and images are critiqued. Super workshop leaders excel at deciding where the best photo opportunities are found in the area and carefully select the shooting sites so a wealth of great photo opportunities are present for the students.

A photographic field workshop is a blend of indoor learning (instructional programs and critiques) and field learning where students take many images in the field under the close supervision of the instructor(s). A well-run photography workshop is a terrific way to elevate your photographic ability to new heights! Do consider joining a photo workshop. You are certain to improve your ability to make fine images and may make some lifelong friends in the process.

TRAVEL WITH A PHOTO TOUR

A photo tour typically is led by a seasoned professional photographer to an exotic shooting location far from home. If you live in New York, joining a photo tour to Arches National Park is an excellent way to photograph the park. Perhaps you might even go on safari to Kenya or take a fabulous photo tour to Antarctica. Since it is expensive to travel to far away lands, photo tours tend to reduce the time spent teaching in the classroom in favor of giving the participants as much time as possible photographing the special subjects they have traveled so far to see and photograph. Some instruction may be offered in the field and tour leaders try to be helpful by answering questions and guiding their participants to the best shooting spots, but most tour leaders take their own photos while leading the tour since the opportunities are so special. Photo tours are most appropriate for those who are already quite skilled with their cameras, but are seeking the camaraderie of a like-minded group of people with a leader who knows where the best photos are found.

A well-planned photo tour is a terrific way to make many outstanding images of wildlife and landscapes that you may never see again. Since everyone on the tour is interested in photography, it is easy to run the tour to accommodate the unique needs of photographers. For example, bird photographers must have time and get close to the subject to make wonderful images. Trying to take bird photos with a birding tour is doomed to fail. Most birders want to see as many birds as possible so they use binoculars or spotting scopes to view birds from long distances. Once they spot a new bird, they spend very little time

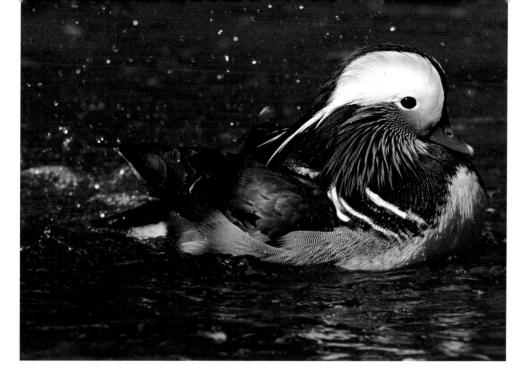

This non-native mandarin duck was courting female wood ducks on a pond in Lithia park in Ashland, Oregon. The excellent wood duck photography at the pond is expected, but this bird was a bonus.

hummingbird photo workshops in British Columbia as well as other hummingbird photo workshops that are taught by other photographers.

READ BOOKS ABOUT NATURE PHOTOGRAPHY

Hundreds of books are available on all aspects of photography. Be sure to look for titles that match your interests very closely. There are books on general nature photography like this one, landscape photography, closeup nature photography, wildlife photography, and many others. If you are interested in working on your nature images with software, then you will find some of the many books devoted to the digital darkroom quite helpful. Be careful about buying books on software programs because they rapidly go out of date since software is updated frequently.

COLLECT BOOKS FULL OF BEAUTIFUL IMAGES

It is helpful to look at books that are full of fabulous images that were shot by other photographers. Great images inspire you to take some of your own and suggest ideas that you might not have thought of. Perhaps you have not thought about the gorgeous opportunities that can be found on a frosty morning. If you buy a book that showcases several wonderful images such as a frost-covered goldfinch nest, red berry, or weathered oak leaf, you'll quickly learn to appreciate the magical opportunities offered by frost and seek them out for yourself.

with the bird, preferring to check the bird off the list and continue looking for more species. This strategy of viewing birds at long distances with spotting scopes and then moving on right away is completely unsuitable for good bird photography. Since the photo tour is full of like-minded people, these kinds of conflicts should not be a problem.

Photography field workshops and tours are advertised in photo magazines frequently. Many companies exist that specialize in offering programs of this type. Once again, the Internet is a great place to find them. Searching the World Wide Web

for Kenya and photo tour will certainly bring up many prospects. Sometimes tours, seminars, and workshops are used inappropriately. If a search of Yellowstone National Park and photo tour doesn't bring up what you want, try Yellowstone National Park and photo workshop or Yellowstone National Park and photo seminar. You will find most of the companies offering photo programs in the park by doing this. Perhaps you want to attend a photo workshop that specializes in a specific topic and you don't care where it is located. Searching the Web for hummingbird and photo workshop will pull up my

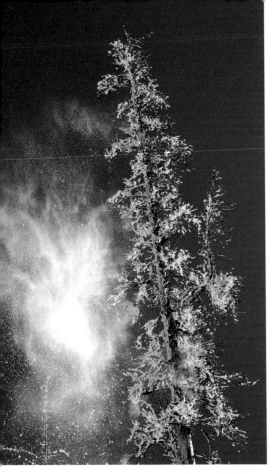

Frost blows off a dead lodgepole pine one frigid morning. We used a cable release to trip the shutter at the decisive moment.

Don't worry about copying someone else's idea. Few ideas are unique and you never find exactly the same shot under the identical weather conditions anyway. Working a theme such as frost or icicles in winter or dew in summer is a way to find your own magical images and helps you develop your style.

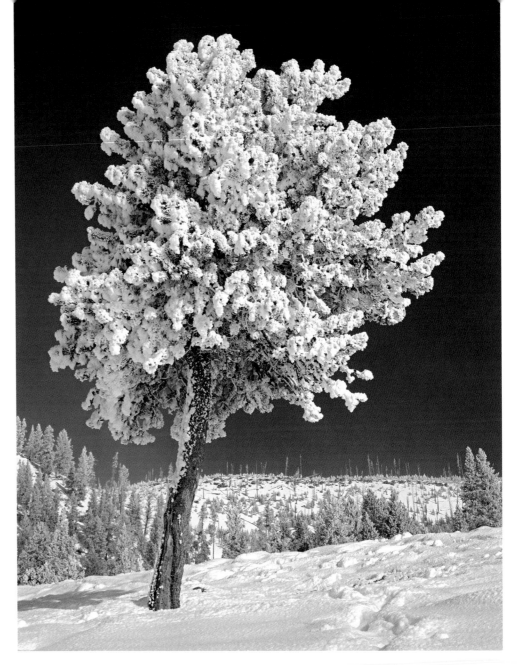

A low camera angle was used to isolate this frosted lodgepole pine against the blue sky.

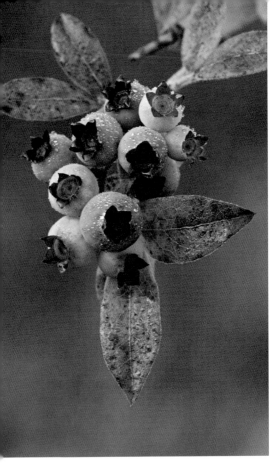

Blueberries cloaked in dew drops are especially beautiful to photograph when they are maturing so you get various shades of pink and magenta along with the blue colors.

A dewy grasshopper conveniently poses on top of a leatherleaf bush so it is easy to make the background clutter disappear with a long macro lens.

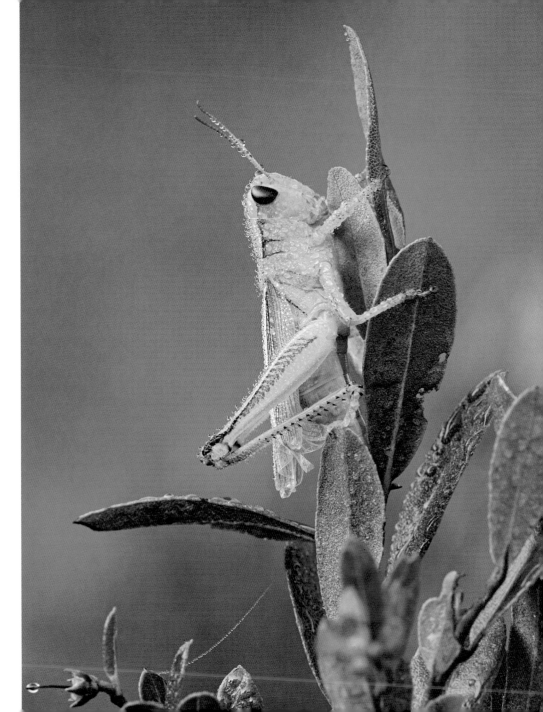

If you have a favorite subject, collect pretty picture books (coffee table books) of that subject too. I love Kenya, Antarctica, the Sonoran Desert of Arizona, Yellowstone National Park, and hummingbirds to name a few subjects. Therefore, I collect books on all of these topics and own virtually every book published on the topic if it contains great images that are nicely printed. Even bad images can encourage you to visit outstanding places to make your own wonderful photos. Many years ago, I saw a photo of a rocky shoreline in Pictured Rocks National Lakeshore that had great potential, but the high noon light didn't do it justice. Since I lived only 20 miles from the site, I visited this special rocky outcrop along the south shoreline of Lake Superior at dusk when it was bathed in the red light of the setting sun. It was truly gorgeous and I made many images I still love today. It is one of my favorite spots and I was encouraged to seek it out due to a bad photograph!

To find books of gorgeous images on your favorite topic, try searching www.amazon.com or check out the largest bookstore in your area. Being a huge hummingbird fan, I search www.amazon.com once or twice a year to locate any new books on hummingbirds that have been published.

Perhaps you have a favorite photographer or two. Collect books that are full of their images. I especially like landscape photography so I own books by many landscape photographers. Four of my many favorites include Tom Till, Ian Adams, David Muench, and Jack Dykinga.

USE THE INTERNET

The Internet is loaded with information that will help you become an excellent photographer. It is a wonderful source of detailed information about all the camera gear you own or wish to own since every equipment manufacturer has a web site that is loaded with information. You can ask questions on most web sites to get specific answers to questions.

There are tons of information about places to go to take images, how to get there, where to stay, and when to visit.

Many web sites specialize in helping you learn about photography. While some charge fees for this service, most of them are free and offer plenty of information. Some web sites such as www.naturephotographers.net and www.photo.net offer instructional articles and forums that discuss many topics in detail. Asking a question that hasn't been asked before on the nature photography forum of www.photo.net will yield many responses. Just be sure to search the archives first to make sure your question hasn't already been answered.

Reading and contributing to photography forums is a way to solve problems too. Be sure to follow the guidelines that all forums have posted specifying how to ask or reply to questions. Always carefully and clearly write any question you wish to post on the forum. You might answer questions that are posted by others too. Just make sure you really do know the correct answer.

Using forums to get answers does work quite well. I use it from time to time myself. Always be courteous on the forums.

Digital photography offers a number of web sites that provide great advice, equipment reviews, and forums. Some of the better ones for digital include www.dpreview.com and www.robgalbraith.com.

SHOOT PHOTOS

You can read, study, and participate in online photo forums all you want, but you'll really never become an excellent photographer unless you put what you learn into practice. Spend as much time as possible actually taking photos using the best technique you know. Shooting photographs is both fun and humbling. You'll soon discover your flaws as you carefully edit your images and strive for quality. But, shooting images also reveals those areas you have mastered so you can spend more time on your weak points. Perhaps you are great at composition and know how to get consistently good exposures with the aid of the histogram, but you have trouble "seeing" the light. If a lot of your images are made in light that is unsuitable for the subject matter, you know you need to develop your skill at seeing the light.

ALWAYS STRIVE TO IMPROVE

Avoid falling into the trap where you think you know everything there is to know because you'll stop trying to learn. It is impossible to know everything about

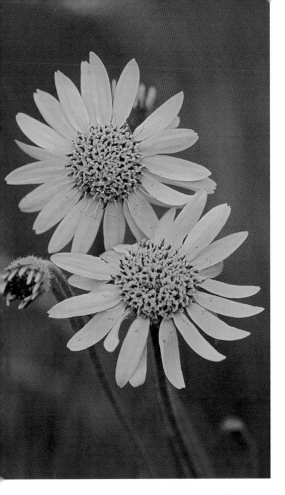

Mules-ear Wyenthia grows on dry slopes in late June around our home. This group of two blossoms and a bud makes a pleasing triangle.

photography. You can always learn more and improve your photographs. Every excellent nature photographer constantly strives to improve their skills and knowledge about photography.

There are two major ways to expand your photographic knowledge. If you already love photographing wildflowers, try photographing all of the wildflowers you find from spring through fall in the nearby meadows and forests. In addition to expanding your knowledge about the wildflowers of your area, you will discover new ways to get the best possible image quality in terms of sharpness, composition, color combinations, and exposure. In this case, you are perfecting an area that you already have a good deal of knowledge. If you set a goal of photographing well at least 100 wildflowers that grow nearby and follow through on it, you will become a better wildflower photographer and enjoy them more.

The second way to expand your natural history and photographic knowledge is to pursue a new kind of nature photography that requires the use of equipment you haven't used before to make images of subjects that are new to you. In my case, I have always enjoyed birds and especially hummingbirds. About 17 species can be regularly found in the US. I only knew a few species when I first tried to photograph them with high-speed flash in 2000. Now I am adept at using multiple high-speed flash to photograph hummingbirds in flight which required me to learn a whole set of new skills, plus now I am familiar with all of the hummingbird species in the US.

ENJOY THE PROCESS!

Becoming an excellent nature photographer is a process that never ends. You'll always be able to learn more about nature and photography so strive to get better and enjoy your journey.

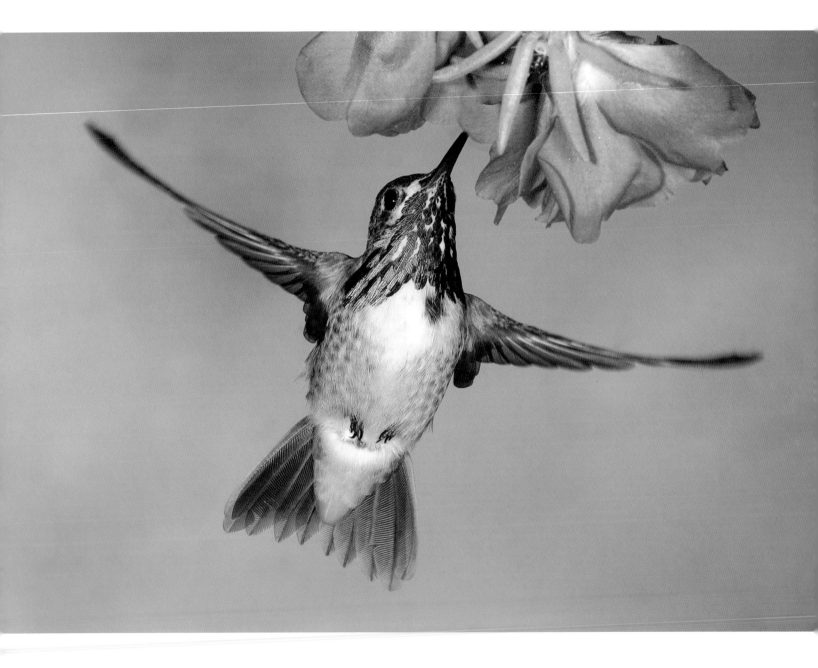

Choosing Your Digital Camera

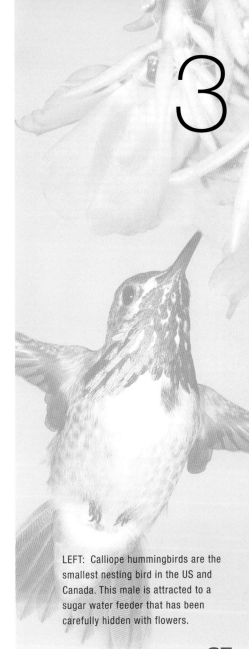

The advances in digital technology and cameras has been truly breathtaking. Only a few years ago, digital cameras cost many thousands of dollars, yet produced images that were inferior to less expensive film cameras. Today the price of terrific digital cameras has dropped tremendously while the quality they produce has risen dramatically. This explains why digital cameras became so widely accepted among amateurs and professionals alike as the camera system of choice in the 2003–2006 time period.

DIGITAL ADVANTAGES

Digital single-lens reflex (D-SLR) cameras enjoy many advantages over film cameras. While the initial cost of a quality digital camera might be slightly higher than a film camera, the cost in the long run is much less since there is no ongoing film and processing cost. Being able to immediately review the images you shoot with a digital camera is an enormous benefit. Problems with exposure, composition, light, and sharpness are detected right on the spot and adjustments can be made while the subject is still present. This helps everyone get it right in the first place and encourages you to take more images. Due to the instant feedback, nature photographers learn quicker and have more fun in the process. Immediate feedback also makes it easier for nature photography instructors to guide their students so they get better images more rapidly.

Digital is much easier to travel with. Airport x-ray machines can easily damage film, but have no effect on digital cameras and storage media. No longer must photographers carry hundreds of rolls of film on an overseas photo trip. It is wise to carry your camera gear on the

LEFT: Calliope hummingbirds are the smallest nesting bird in the US and Canada. This male is attracted to a sugar water feeder that has been carefully hidden with flowers.

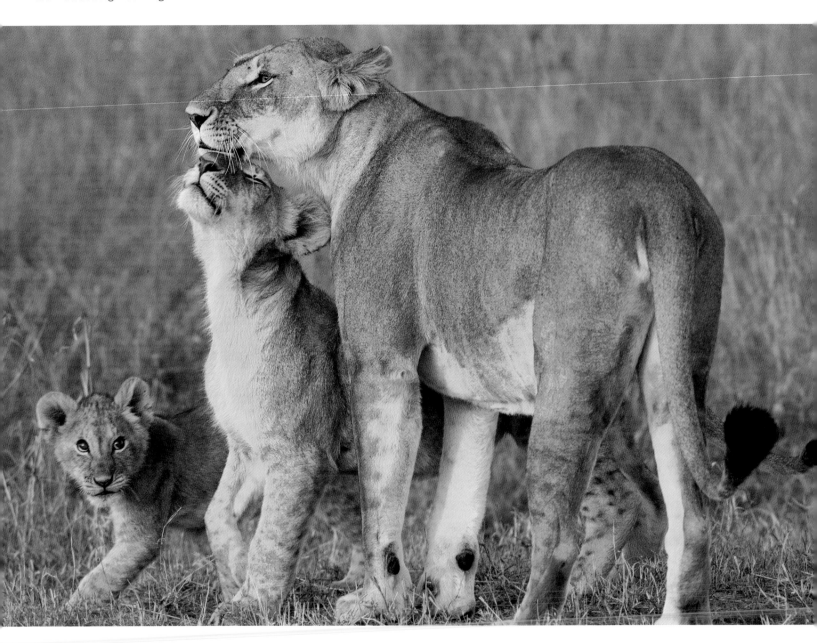

airplane because there is much less chance of having it damaged or stolen. Since most airlines limit you to one carry-on and a computer or purse (be sure to check the rules before flying), it is easy to carry on your camera bag (if you don't overdo it) and the digital storage devices that can hold thousands of images in a compact space.

Only in the past couple of years have D-SLRs produced images that were capable of making prints just as good as 35 mm slide film. Using software, digital images can be optimized to produce incredible prints. During the first three decades of my nature photography career, hardly anyone made their own prints. Spending hours in a darkroom working with toxic chemicals was not appealing. Very few photographers made their own color prints. Now the entire process is back in the hands of the photographers who do everything. They make the initial digital capture in the field, optimize the file, and print gorgeous images in the digital darkroom at home or in the studio.

In the old days (2003), most photographers edited their slides on a light-table with an 8x magnifying loupe. Examining all of the slides with the loupe was tedious work. This is no longer necessary with digital. Now each image is reviewed on a large computer monitor so the image is huge compared to a 35 mm slide.

LEFT: The interaction of these two lion cubs with the adult lion makes this image especially appealing. Adorable images are well received by viewers and eagerly sought by photo buyers.

Digital offers tremendous control over white balance, exposure, color, saturation, and contrast. The list of advantages goes on and on, but since you are reading this book, you are already sold on digital.

CAMERA CHOICES

Nearly everyone owns a compact point and shoot digital camera. These small cameras are easy to carry with us all of the time. They are highly automatic so it's simple to capture splendid candid images of family and friends. The quality is quite good too, but they are limited in what they can do well. This book is intended for those who want to make high-quality images with D-SLRs cameras. These cameras accept many different lenses and other accessories making them ideal for photographing a wide range of subjects from flowers to landscapes to birds.

PRO VERSES AMATEUR CAMERAS

There was a huge difference between pro level film cameras and ones designed for amateurs. However, now that digital cameras are really miniature computers, the difference between cameras designed for amateurs and pros isn't huge in terms of features, just in price. This means you can buy a D-SLR for less than $1000 and get nearly all of the features of a camera costing thousands more.

You'll need a camera and lens to begin taking nature photographs so let's select one. A number of excellent companies make D-SLR cameras today. This list includes Nikon, Canon, Pentax, Olympus, Sony, Fujifilm, Sigma, and others. If you are shooting one of these systems and have a number of lenses already, then you might want to stay with that system. But, if you are just starting out or don't mind buying all new equipment, then carefully select a camera system because you may be staying with it for a long time. While all of the companies listed make fine equipment, some make a lot more than others. Nikon and Canon are the clear leaders in D-SLR cameras today. Both companies spend lots of money researching and developing their product line. You want to have choices in camera bodies and lenses. Having many lenses to choose from is especially important if you are a versatile nature photographer who photographs landscapes, closeups, and wildlife since all three subjects require entirely different lenses to do well.

While I would like to be diplomatic and say all systems are equally good, having many choices is a huge benefit. Although any of the current camera systems might work for you, you certainly can't go wrong by going with either Nikon or Canon. I happen to shoot the Canon system while Barbara shoots Nikon. We are happy with both systems and I am certain each would work well for you too.

TERRIFIC CAMERAS

Listing the current cameras in various price ranges that are superb for nature photography is a bit of a problem in a book. New cameras arrive frequently so any suggestions I make here become outdated quickly. As I write this in early 2007, excellent

cameras such as the Canon 30D or Nikon D200 can be purchased new in the $1500 price range. Most companies offer D-SLR cameras below $1000 such as the Nikon D80, Canon EOS Digital Rebel XTi, Pentax K10D, Samsung GX-10, and Sony Alpha 100. These cameras produce 10 megapixel plus files so each is capable of excellent images. Of course, you can spend more money too. The high-end Nikon D2Xs is about $5000 while the top of the line Canon 1Ds Mark II is $8000. By the time you read this, all of these cameras might be replaced by cameras that offer more speed, megapixels, and other bells and whistles for less money.

ESSENTIAL CAMERA FEATURES

Once you have decided on what camera system to own, it's important to select a camera with features that are especially useful in nature photography. Here's a list of features I feel are important for nature photography.

High-Megapixel Count

Your camera should have at least 8–10 megapixels. An 8-megapixel camera can easily produce gorgeous 16 × 20 inch color prints. What does 8 megapixels really mean? It means you have eight million effective pixels which is the smallest unit of a digital image. These eight million pixels are arranged in a regular pattern of little squares on the sensor in the back of the camera. When you take a photograph, light strikes the sensor and each pixel

records how much light (photons) strikes it. In most cameras, each pixel is sensitive to only one color due to red, green, and blue color filters. Each pixel records information about the brightness of the color it can measure. This means the pixel with the blue filter can only measure blue light and so on. If you enlarge a digital image

on the computer enough, you will see the square individual pixels.

Several expensive cameras produce image files of 12 megapixels or more. Is it worth spending thousands of dollars to get 2–6 more megapixels? These cameras aren't worth the money if you plan to make 16 × 20 inch prints or smaller. However, the extra

When fast action is about to happen, it's important to set the camera to shoot as many images per second as possible. This crocodile is hunting wildebeest that are swimming across the Mara River by the thousands.

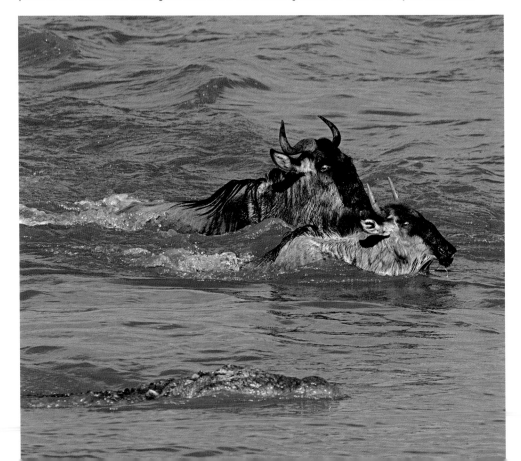

megapixels come in handy if you want to make really huge prints such as 20 × 30 inch wall murals. More pixels are useful if the image file needs to be cropped quite a bit. The disadvantage of cameras that produce super large files is fewer images fit on the storage media and the cameras cost more. It takes longer to transfer large files to the computer too.

Large Buffer and Fast Write Speed

A large buffer and fast write speed is crucial if you enjoy photographing action. Suppose the camera can shoot four RAW images per second and the internal buffer can store 6 images. This means if a swan is flying toward you, it is possible to take six images in 1.5 seconds. When the buffer is full, you can't shoot another image until at least one shot is transferred to the memory card. Obviously, if the buffer could store 12 images or the write speed to the memory card was faster, you could shoot more images at the peak of the action. If you seldom photograph wildlife action, but prefer wildflowers, landscapes, or perching birds, then buffer capacity and write speed aren't critical.

This crocodile let hundreds of wildebeest swim by before grabbing this youngster. Having a camera that can write data to the memory card quickly is crucial.

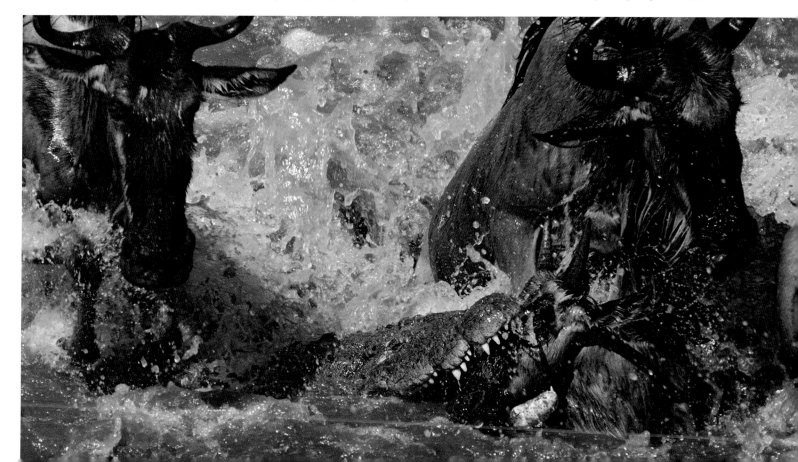

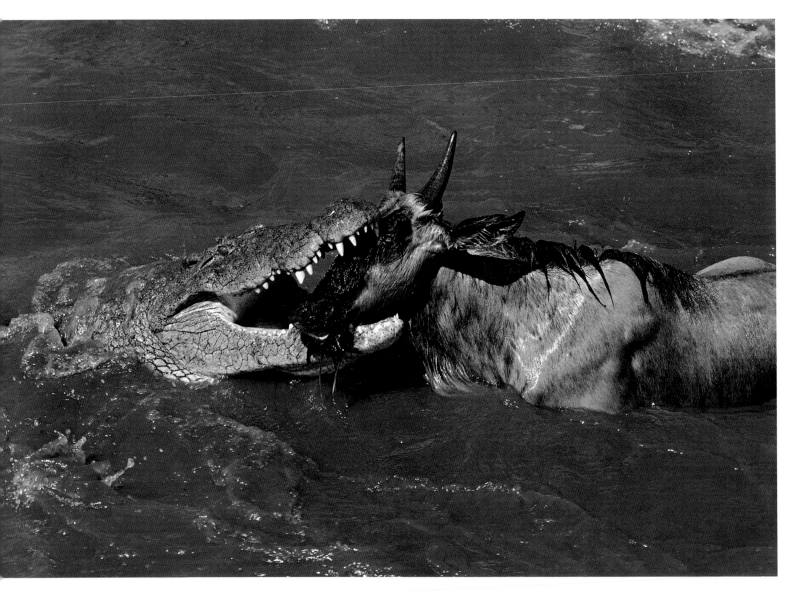

The crocodile pulls the wildebeest out of the herd which is still swimming by. It soon submerges to drown it's victim. The entire sequence was over in about 15 seconds.

Mirror Lockup

Mirror lockup capability is crucial for making sharp images in the shutter speed ranges of 1/8 to 1/30 second. The upward action of the mirror jars the tripod mounted camera causing a slight loss of sharpness in that shutter speed range. Using shutter speeds faster than 1/30 second or slower than 1/8 second greatly minimizes or eliminates fuzziness caused by the motion of the mirror.

Adjustable Self-Timer

Using your finger to trip a camera that is supported on a tripod will cause images to be less sharp at slow shutter speeds of 1/60 second and below. The best way to trip the shutter is to use a cable release or self-timer. It is helpful to have a self-timer that can be set to various intervals. A 10-second delay gives you time to get into the photo too. However, since most nature photographers don't want to be in the photo, a 10-second self-timer delay is a long time to wait for the camera to fire. When photographing any still subject such as a wildflower or landscape, using the self-timer to fire the camera is effective for getting the sharpest image. Many cameras (but not all) offer a 2-second delay so this is something to look for.

When using a sturdy tripod, you will get the sharpest possible image if the mirror is locked up prior to the exposure when photographing any motionless subject such as these shadows on the snow.

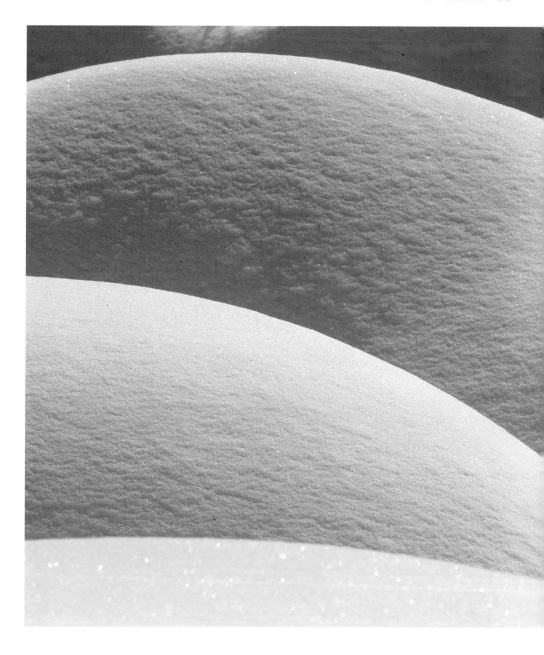

Orange Spring Mound is colored by bacteria that grow in the warm water. Since it doesn't move or blow in the wind, it is effective to use mirror lockup and the two-second self-timer to fire the camera rather than use a remote release.

Accepts a Cable Release

Using a tripod most of the time is necessary to consistently shoot sharp images. There is no point in using a tripod if you trip the shutter with your finger at speeds below 1/30 second. The pressure of your finger is certain to jar the camera causing a loss of sharpness. A cable release attaches directly to the camera. By pressing the button on the end of the release, the shutter trips and the image is taken. The cable separates your quivering body from the camera. Some releases don't attach directly to the camera. Just point the remote device at the camera and push the button to take the image. Both systems work well.

Why do you need a remote release when your camera already has a self-timer since both the self-timer and the remote release separate your body from the camera? If you are photographing a waterfall, both systems work equally well. However, wind is a huge problem for nature photographers. If you are photographing a wildflower blossom that is swaying to and fro in the breeze, you must wait for a calm period so you can fire the camera when it is perfectly still. This is a time when using the self-timer is not effective because there is no way to know if the subject will be completely still a few seconds later when the camera fires. By using a remote release, you can take the image as soon as the subject stops swaying in the breeze. It's much easier to shoot a sharp image with a cable or remote release when dealing with motion caused by wind. Here's another situation where the remote release works better than the self-timer.

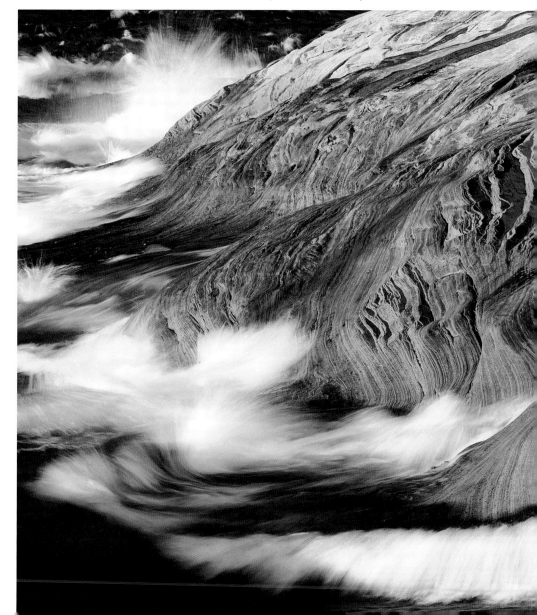

Photographing waves as they crash into the rocks doesn't work well with a self-timer because you want to catch the peak of the action. Use a cable or remote release to trip the shutter instantly.

Let's suppose wind is not a problem. You are photographing waves crashing on a rocky shoreline. It's best to photograph the peak action as the wave explodes on the rocks. A remote release lets you shoot instantly to catch the action. A self-timer delay, even if only two seconds, misses the peak action most of the time.

Choice Between RAW or JPEG or Both

Make sure the camera offers the choice of shooting JPEG or RAW files or both at the same time. Unless you are certain you want only JPEG images or RAW files, it makes sense to set the camera so that both files are captured at the same time. JPEG images are processed by the camera. RAW images are files that contain the raw data collected by the sensor. Using software, a skilled person using a raw converter can often get the best possible quality from a RAW file. We will discuss these issues later on.

Large LCD Monitor

The LCD monitor is found on the back of the digital camera. This monitor is used to change many camera settings and to see images. LCD monitors that are easy to view are most helpful. Currently, LCD monitors that are 2 inches in size are typical and 2½-inch monitors are becoming more common. You'll love a 2½-inch monitor so bigger is better.

Spot Meter

A spot meter measures the light from a tiny portion of the scene. It is quite useful in tricky lighting situations and exposing subjects that are dark or light. It does take experience and practice to master. You can get by without a spot meter, but if you are the precise type, then having one might be worthwhile. Unfortunately, many cameras don't give you a true spot meter so if being able to meter tiny portions of your subject appeals to you, then make sure your camera comes with one. In the interest of full disclosure, my wife and I use matrix metering 50% of the time and spot metering the rest.

Back-Button Focus

Modern cameras offer a variety of autofocus controls. Cameras are setup so pressing the shutter button down part way initiates autofocusing. This is effective for hand-held photography. However, when shooting on a tripod, it is often better to remove autofocus from the shutter button and transfer it to a button on the back of the camera. Back-button focusing gives you enormous control and lets you switch instantly from continuous to one-shot focusing. Many cameras are able to do this by setting a certain custom function. Make sure your new camera has this capability. Back-button focusing will be discussed in great detail later.

PROTECTING YOUR CAMERA

Think of your camera as a miniature computer. It doesn't like water, shocks, or being abused in anyway. Do everything you can to keep the camera and lenses dry.

Shooting photos in the rain with an unprotected camera is asking for a punishing repair bill. Protective covers are made to protect the camera if you do shoot in the rain. It is possible to shoot under an umbrella to stay dry. You might wonder why anyone would shoot in the rain anyway. Wet subjects tend to have more saturated colors than when they are dry. By using a polarizing filter to reduce glare on wet surfaces, many subjects such as fall color or wildflower blossoms photograph quite nicely when wet. However, a few snowflakes or drops of water shouldn't do any harm. On a cool morning, it's possible for dew to form on the camera body when the sun begins to heat the air. I photograph a lot on dewy mornings and haven't had any damage yet. Do not drop your camera in water!

Condensation on your camera body and lenses can be detrimental if you get too much of it. Don't take your camera gear inside a warm room after it has been outside in the cold. Taking cold equipment inside a warm room causes the air next to the equipment to reach the dew point so moisture in the warm room condenses on it. Moisture can get inside the camera or lens causing wet spots in the optics that can take days to disappear.

RIGHT: Shaggy Mane Mushrooms spring from the ground following wet cool days in early October in northern Michigan. This group of four is nicely surrounded by freshly fallen maple leaves.

DEALING WITH COLD AND HOT TEMPERATURES

Do enjoy using your camera in cold or winter conditions. Snow, ice, and frost are wonderful subjects. Avoiding condensation is easy. While still outside in the cold air, put your camera bag in a plastic bag, squeeze out any extra air, and seal the plastic bag so warm indoor air can't reach the camera bag. Now put the bag on the floor in a cool room. Leave the bag alone for a couple of hours so the camera gear can warm up slowly before getting it out and exposing it to warm air. On our Yellowstone winter tours, some people don't leave their gear in the bag long enough. When they take it out, huge amounts of water form on the inside and outside of the lens. Once moisture forms inside the lens, it takes awhile to evaporate. One person couldn't use their zoom lens during the following morning because the moisture inside the lens froze making zooming impossible.

Just the opposite problem happens when photographing in warm, humid regions. If it is hot outside and you store your gear in an air-conditioned room, condensation quickly forms if you take your cool equipment into warm air. This happens frequently in the Galapagos Islands which is famous for approachable and unique wildlife. The ocean air at sea level near the equator is typically hot and muggy. The plastic bag trick works here too. Put your camera bag in the plastic bag, squeeze out excess air and seal it up. Put the bag in the shade on the deck and give it an hour or more to warm up to outside temperatures.

LEFT: It's bitterly cold when these trees on Two Top Mountain in eastern Idaho become entombed in snow. Always put cold camera gear in a plastic bag when you take it into a warm room to prevent moisture from condensing on it.

DON'T SHOCK YOUR GEAR

Shocks probably destroy more cameras than any other cause. Modern cameras are delicate so they don't like to be dropped or banged into things. Bouncing camera gear on anything hard is likely to generate a huge repair bill so always be careful.

I have seen plenty of camera gear destroyed in field workshops and tours. Here's some of the ways camera equipment has met its demise. Some people try to hold two cameras at once, and one slips away smashing on the rocks. There is nothing like the sound of a $1000 crunch to get your attention. Another frequent mishap is most advanced photographers use quick release plates to mount their camera on a tripod. Once in awhile, they think they have slid the quick release plate properly into the clamp. They tighten the clamp on the tripod head, but only one side of the plate is in the clamp so the camera or lens isn't actually attached to the tripod head. As soon as they let go of the camera, it crashes to the ground. This happens a lot so be careful. Cameras mounted on unattended tripods are blown over by wind or knocked down by waves. Other participants in workshops knock over unattended tripods too. If you are shooting in a park where other visitors may come close to you such as on a viewing platform, watch your gear carefully and be protective. Tourists and especially children are quite oblivious to expensive camera gear so protect it diligently. Be careful to secure camera gear in vehicles too.

CAMERA STRAPS

Either you like camera straps or you don't. Since they come with most new D-SLR cameras, surely they must be useful. However, nearly every serious photographer I know doesn't use them. Especially when shooting on a tripod, camera straps are always getting in the way. There is no right or wrong way here, just a matter of preference. Even though camera straps may have come with your camera, it doesn't mean you have to use them.

KEEP YOUR LENSES CLEAN!

Some brilliant soul once said, 'an ounce of prevention is worth a pound of cure.' They are so right. Grit and dust can ruin your camera gear and reduce the quality of your images. It's absolutely critical to protect your camera gear from the evils of dirt. Dust is a huge problem for digital photographers in many ways. First, always store camera lenses with their front and rear caps on. This prevents the expensive glass from being scratched needlessly. Make sure your lens surfaces are free of dust and smudges. Check both the front and rear glass elements to make sure nothing is on them every time you use them. Most of the time, you will need to do some cleaning. By carefully handling your lenses,

These sand dunes in Death Valley National Park are fun to photograph. Be careful to keep sand out of your camera equipment and always keep the lowest leg lock on your tripod out of the sand too!

you should never get a finger print on the glass. But, you may still get smudges from dried water drops from time to time.

Here's a safe and effective way to clean a lens. Never grab a lens cloth and start rubbing the glass! If tiny bits of dirt are on the glass, you can easily scratch the glass. Instead, always use a soft photo brush to gently clean off the glass surface to remove any grit. Be sure to point the lens down while doing this so dirt falls away from the lens. If you point the lens up, you may move the grit around the lens without removing it. Now examine the glass carefully to see if all grit and dust is gone. If not, do it again until perfectly clean. See if you have any smudges from dried water drops or fingerprints. If you do, then the brush won't remove it. A terrific way to remove smudges is to use a micro fiber cloth that is made for optical glass. Rubbing this over the lens beginning in the middle of the lens and working outward in a circular motion should work. If the smudge persists, try putting a small amount of lens cleaner directly on the cloth, never the lens, and rub the glass gently again. Following these steps should give you a perfectly clean lens.

KEEP THE CAMERA AND SENSOR CLEAN!

Keep dust and grit out of the camera body too. Dirt that settles on the sensor is an

enormous problem for digital photographers. When a bit of dust adheres to your image sensor, the dust spot shows up on every image you take. While dust spots can be removed from the digital image with software, it's far better to remove dust on the sensor before shooting. An effective way to reduce the amount of dust inside your camera body is to always keep a lens or body cap on the camera. Never leave a camera body sitting around where the insides are exposed to floating dust.

Changing lenses is necessary and hazardous. But, you still need to change lenses from time to time since that is the whole point of having a D-SLR. Turn the camera off when changing lenses since this eliminates sensor charge that attracts dust. Always change lenses as quickly as you can and point the camera body down so dust can't easily fall inside it. Avoid changing lenses in dusty environments, especially if it is breezy.

CLEANING THE SENSOR

No matter what you do, you can be assured of getting dust on the sensor. Here's how to look for it. Take a photograph of anything that is uniformly colored like the blue sky or a yellow wall. Load the image into your computer and blow it up to 100%. Now move around the image looking for dust spots that readily show up as black specs or spots on the computer monitor. Carefully follow the recommendation for removing the dust in your cameras instruction manual. All of the digital cameras I have seen lately have some sort of cleaning mode. Most cameras don't really clean

the sensor (although some now vibrate dirt off the sensor), they just move the mirror up so you can see the sensor. Use an inexpensive Giotto rocket blower to blow the dust off the sensor. Be careful though. Never touch the sensor with the tip of the blower since the sensor is delicate and easily scratched and don't let the shutter close on the end of the blower either. Never use canned air since it could spray liquid on the sensor causing real problems. Normally using the Giotto rocket blower works well. Often it takes two or three attempts to blow all of the dust from the sensor. If dirt remains on the sensor, take the camera to a professional camera repair place to have the sensor cleaned. However, that can get expensive so using specially made cleaning swabs that are designed to clean the camera's sensor is another way to conquer dirt on the sensor. You must be exceedingly careful to avoid scratching the sensor. Most camera companies don't recommend cleaning the sensor yourself, but it can work well if you are careful. You'll have to decide if the risk of cleaning the sensor yourself is worth it or not.

CAMERA BATTERIES

Most digital cameras come with a rechargeable battery and charger. Always order at least one extra battery. You need a spare since rechargeable batteries tend to work fine for quite awhile and then suddenly fail with little warning. If you go on any expensive or time-consuming photo trips, take three or four spare batteries with you. How many shots can be taken with a single battery depends on many variables. Using

autofocus, image stabilization, and viewing the LCD monitor all consume battery power. If you are getting short on battery power, turning off some of these will make the battery last longer.

Cold temperatures lower the ability of a battery to run the camera. In cold weather, if your battery fails and you don't have a spare, try putting the battery inside your coat to warm it up. Once the battery is warm, it should continue to operate the camera, until of course, it gets too cold again. Temperatures below zero are common in Yellowstone National Park during late January and early February. Rechargeable batteries work better than many people expect. Of course, it is wise to have at least one spare battery stored inside your coat staying warm in case the battery in the camera fails.

DIGITAL FILM

You'll need memory cards in your camera to store your images. A number of different kinds of cards are made. This list includes CompactFlash (CF), XD Memory, Micro Drives, SmartMedia, Memory Stick, and Secure Digital (SD) to name a few. Your camera won't accept all of these cards so your choice is limited to what your camera will accept.

Most D-SLRs accept either CF or SD cards. Be sure to check your cameras instructional manual to find out exactly what storage device must be used. Both of these memory cards are durable and transfer data quickly. SanDisk and Lexar are two of the best known manufacturers,

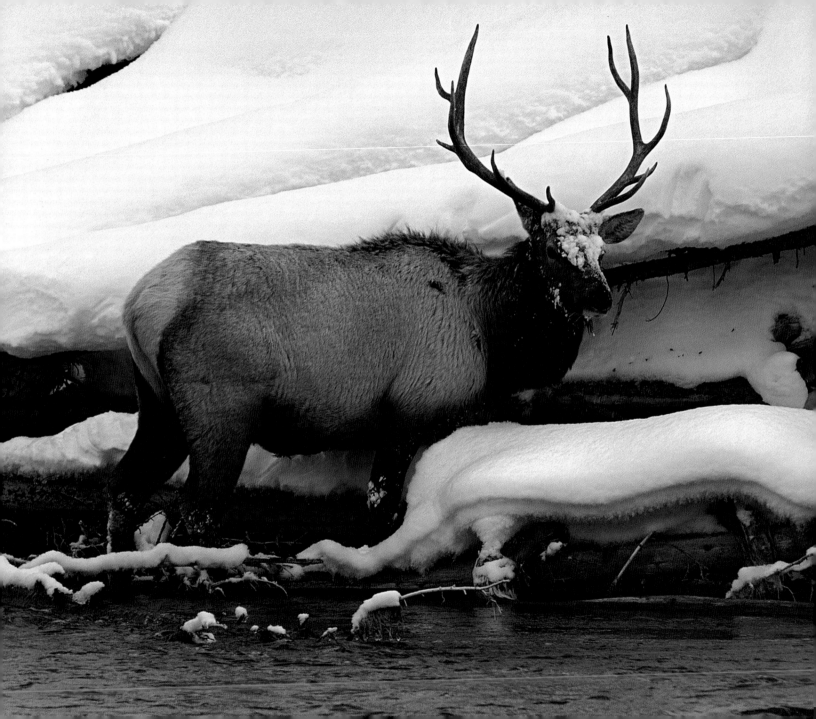

but there are others. Storage capacities are going up and prices are falling. Presently you can buy 4 GB CF cards for about $150 and 2 GB SD cards for less than $100. There was a time when micro-drives were popular due to lower cost, but the other memory cards have dropped so much in price that there is no longer any reason to buy them. Micro-drives have moving parts so they are more fragile than other memory cards. For this reason, it is wise to stay away from them.

Barbara and I currently use SanDisk 4 GB Extreme III CF cards in our cameras. This card holds 220 images from my camera that produces 16 MP RAW files and the read/write speeds are fast. Since these cards read fast, the buffer in the camera empties rapidly so more images can be shot.

CF and SD memory cards come in a variety of capacities. I wouldn't consider anything less than 1 GB to start with. Larger capacity cards of 2 GB are available for both types of cards. Presently, CF cards are made with higher capacities than SD cards which top out at 2 GB. CF cards are available in 1 GB, 2 GB, 4 GB, 8 GB, 12 GB, and even 16 GB sizes. As the amount of storage space goes up, so does the price.

What memory card is right for you? The answer depends on how much you want to spend, how big your image files are, how fast you need to write to the card, and how many images do you want to risk on a single card. The nice thing about memory cards is you can reuse them over and over so they are quite cheap in the long run. Therefore, consider buying memory cards with at least 2 GB of storage capacity. If your camera shoots files larger than 10 megapixels, 4 GB memory cards are desirable. Of course, the more photos you put on one card, the more images you lose if the card malfunctions so safety is a consideration too. If you do a lot of action photography where you want that buffer to clear quickly so you can keep on shooting, then buy memory cards that read data from the buffer quickly. The more expensive Lexar 133x and SanDisk Extreme III memory cards are fast so they are preferred by action photographers.

BUYING A CAMERA

Perhaps the best way to buy your new camera is to purchase it from the local camera store. You get to see the camera and feel how it fits in your hands. Is it too heavy? Do the controls seem intuitive or hard to manage? Your salesman is able to answer all of your questions. If you buy the camera from the store, they will answer future questions regarding the equipment you purchased from them. The biggest drawback to buying locally though is the camera will probably cost more than from a large mail order camera store which advertise in the back pages of the major photo magazines.

LEFT: This snow-capped bull elk is finding small bits of vegetation to eat along the river. It helps to have a second set of batteries inside your coat keeping warm so they are ready to go in case the first set fails in the low temperatures.

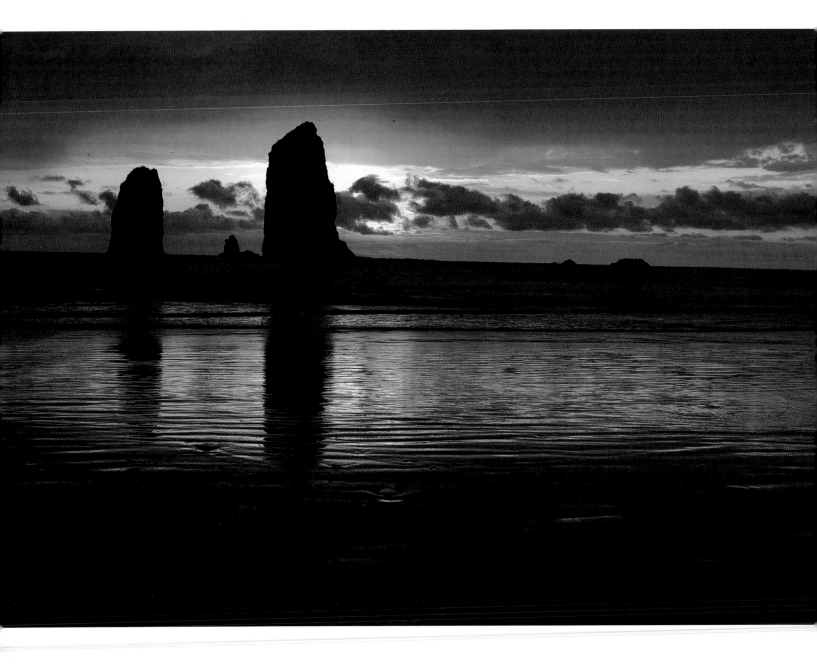

Exposure Essentials

Proper exposure is critical to shooting excellent nature images. The correctly exposed digital image avoids overexposed bright areas, has few noise problems in the shadows, and the pixels capture enough light so the colors are accurate. The cameras light meter working together with the lens aperture and the shutter determine the final exposure. However, there are times when the camera needs help to get the best exposure, so you must learn to do that too.

Fortunately, digital exposure is much easier than exposing slide film. Digital cameras let you see the image immediately so you can judge the exposure with the highlight alert and histogram. No longer do you wonder if the exposure "turned out" because using the highlight alert and histogram proves that it did. Although exposure with digital cameras is easier, it is still helpful to master exposure fundamentals. Understanding aperture values and shutter speeds and how they work together is necessary. Knowing the advantages and disadvantages of different metering patterns is essential. You must learn why some subjects need exposure compensation and how to do it.

Digital exposure requires you to keep detail in most highlights (specular reflections that have no detail anyway are exceptions) while retaining detail in the dark sections of the image too. The dynamic range is the difference between dark and light areas that can be successfully recorded with a digital sensor. It is about 6 stops of light. Since digital exposures can be instantly monitored with the highlight alert and histogram, it is easy to adjust the exposure while the subject is still present until you get exactly what you want. You could even bracket exposures widely, especially in tough situations, and then delete inferior exposures later with no cost. Both JPEG and RAW digital captures can be optimized with software to improve an exposure that is close, but not perfect.

LEFT: These sea stacks along the Oregon coast make beautiful silhouettes at sunset. The wet beach is reflecting the colors of the magenta sky.

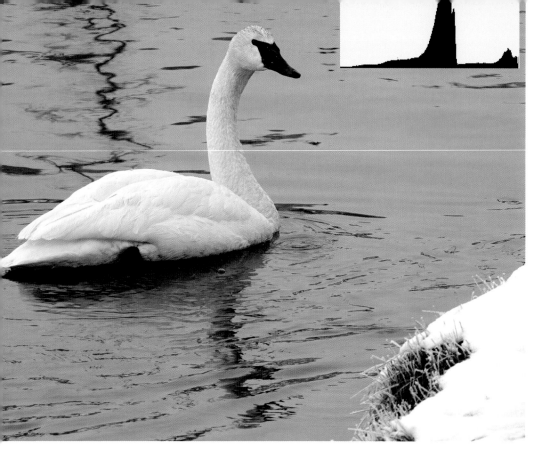

Keeping detail in the white feathers of this Trumpeter swan is crucial to the digital photographer. Make sure the histogram data begins close to the right side without clipping.

debate is interesting, there is no wrong answer. A case can be made for both. Let's look at the advantages and disadvantages of each before deciding what may be best for you.

JPEG Advantages

- JPEGs are processed by the camera so time is saved.
- They take up less space on the memory card.
- The cameras buffer empties quicker so you can keep shooting.
- Since JPEGs are smaller than RAW, the maximum burst rate is much higher which is good for action.

JPEG Disadvantages

- Data is thrown away when the JPEG is first made and each time you save it thereafter.
- JPEGs are limited to 8 bits of data which can cause posterization. This means you may lose continuous tones which cause banding, especially if you work on the image extensively with software.
- The processing parameters such as color space, white balance, contrast, exposure, saturation, and sharpening are locked into the file. This reduces your ability to make adjustments later with software.

RAW Advantages

- Since these files contain unprocessed raw data from the sensor, you have tremendous control over white balance, sharpening, contrast, color, saturation, and exposure.
- RAW files are more than 8 bits so you have more head-room (less chance of losing continuous tones) when using software to optimize the image.
- RAW converters offer excellent adjustments for noise control and lens defects.

RAW AND JPEG IMAGES

Before we discuss exposure in detail, it's important to decide what kind of files you want to shoot because properly exposing the two is slightly different. Two common file formats are JPEG and RAW. A JPEG is a lossy file format that is processed by the camera for sharpness, saturation, white balance, contrast, and color space. A RAW file is unprocessed data from the sensor.

RAW really refers to a family of file formats. Each manufacturer has their own proprietary RAW format. My Canon camera uses .CR2 and CRW, Barbara's Nikon uses NEF, Olympus has .ORF, Fuji uses .RAF, and the other camera makes use different ones too. A RAW file must be converted with software to get the best quality.

There is a huge debate about which file format is the best one to use. While the

RAW Disadvantages

- These large files fill memory cards fast.
- The number of images that can be shot in a continuous burst is greatly reduced.
- They must be processed by a RAW converter so this takes plenty of time.

WHAT FILE TYPE SHOULD YOU SHOOT?

The answer depends on your needs. If you want quality and don't want to spend time processing RAW files, then a high-quality JPEG is the best choice. Of course, make sure you nail the exposure and set the white balance properly since it isn't easy to adjust later once you shoot the shot. Cameras offer a variety of JPEG choices depending on the quality you want. It is best to select the highest quality. If you need a lower-quality JPEG for use on the web, it is easy to convert a high quality one to the size you need. If you love working on computers and want the finest quality image possible for making large prints, then shooting RAW images is clearly the way to go. RAW offers far more control for adjusting exposure, color, contrast, and white balance.

Just so you know, we shoot large JPEGs only when photographing friends, parties, and other subjects where the absolute best quality isn't necessary and we intend to give the images away anyway. For serious nature photography, we only shoot RAW images. We shoot a lot of images, edit them ruthlessly, and keep only the very best. For example, Barbara was photographing two Reticulated Giraffes fighting in Samburu National Park. She held the shutter button

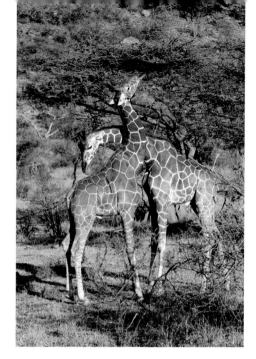

These two reticulated giraffes were literally banging heads together. Wildlife interacting with each other frequently provides the chance to shoot exceptional images.

down and took more than 200 images before the fighting stopped. By editing tightly, she only kept about 15 images from the series. In no way do I wish to imply that pros don't shoot JPEGs. Professional sport photographers mainly shoot JPEGs because they need to use the images quickly to meet deadlines and the higher burst rate is helpful to properly photograph action.

PROPERLY EXPOSING JPEGs

JPEGs really need to be perfectly exposed when you shoot the image. Due to the small bit depth, trying to make a JPEG image lighter or darker can cause all sorts of problems such as losing continuous tones. If at all possible, try to avoid clipping the right and left sides of the histogram. For most scenes, it is best to have the right side of the histogram graph begin close to the right side. It doesn't have to be right on the edge, but hopefully the data is somewhat right of the center of the histogram. If the contrast in the scene is so great that you can't avoid clipping, let the image clip on the left or black side of the histogram, preserving highlight detail on the right.

PROPERLY EXPOSING RAW IMAGES

Unlike JPEGs where the exposure needs to be right on when you shoot the image, RAW files offer tremendous latitude for exposure adjustments. Exposures that are no more than 1 stop overexposed or 2 stops underexposed can be improved with software. Essentially, RAW image files are like film negatives. By adjusting RAW files with software, it is possible (within limits) to make the exposure almost as good as if it had been exposed perfectly in the first place.

Although RAW files can be optimized for exposure, this still takes time and you may suffer some loss of quality. It is still best to perfectly expose the RAW image too. By using the histogram, it is easy to know when you have the perfect exposure. Your goal is to make the data on the histogram graph begin as close to the right side of the graph as possible without climbing the right side. A spike on the right side is called clipping and reveals pixels that have

little or no detail because they are over-exposed. If the pixel has no detail, there is no way to give it detail. Also, try to avoid getting a spike (clipping) on the left-hand side if possible. Obviously, if you have some completely black areas in the image, they may show up on the left side and that is fine. For most images, your histogram should begin at the right edge without clipping and end before it gets to the very left edge. This method of exposing RAW images is often called "exposing to the right". By exposing RAW images this way, your digital file has the greatest flexibility and most detail. The sensor measures the light more accurately when you do this which reduces digital noise problems and the signal-to-noise ratio is much better. I could go into a long discussion about digital noise and signal-to-noise ratios, but if you shoot your RAW images so the histogram is snuggled up to the right side without clipping any detail, you really don't need to know a lot about these.

EXPOSURE THEORY

You'll learn how to get terrific exposures soon, but first let's go over some exposure fundamentals that you need to know. If you already know this, then skip ahead a bit. But, if you don't, you owe it to yourself to master exposure fundamentals.

Photographers have spoken the language of stops since the beginning. A stop is a quantity of light. All stops of light are the same amount of light. The two controls determining how much light strikes your digital sensor is the aperture and the shutter speed. Both of these can be divided into stop intervals.

Aperture Values

Here's the standard aperture series.

1	1.4	2.0	2.8	4.0	5.6	8.0	11
16	22	32					

These numbers are derived by dividing the focal length of the lens by the diameter of the lens effective aperture. You don't need to know the math though. Here's what you do need to know! Memorize the standard series of f-numbers that is listed above. If you remember the first two numbers, 1 and 1.4, and then alternately double those, you'll generate the entire series of numbers. Most lenses start at f/2.8 or f/4 and go to f/22 or f/32. The aperture controls your depth of field which is the zone of acceptably sharp focus in the image. The depth of field is very small at f/2 or f/2.8 for example, but increases as you "stop down" to f/22. The aperture in the lens is largest when the f-number is smallest and smallest when the f-number is large such as f/22 or even f/32. This relationship confuses beginning photographers because it is counterintuitive. Big f-numbers refer to small apertures so bigger numbers like f/22 mean less light. The best way to get used to this relationship is to memorize the f-number series. Remember that as the f-number gets bigger (f/8 to f/11 for example), depth of field increases, but the size of the aperture decreases so less light passes through the lens. Moving the aperture to a bigger f-number subtracts light. Conversely,

moving the f-number from f/16 to f/8 permits more light to pass through the lens, but you lose depth of field.

Now let's talk the language of stops. Each of the numbers in the f-number series varies from its nearest neighbor by 1 stop of light. For example, f/4.0 is 1 stop from f/5.6 and f/2.8. The nice thing about stops is they are easy to add and subtract. If the aperture is set at f/8 and you want to add 2 stops of light, what aperture do you select? If you say f/16, you have moved the aperture 2 stops, but f/16 is a smaller aperture so you didn't add 2 stops of light, you subtracted them. The correct answer is f/4.0. Your goal is to become comfortable using f/stops so you know what direction to go to increase or decrease the amount of light passing through the lens.

Be sure to understand the numerical relationship that exists. Each 1 stop move on the standard full stop scale is a doubling or halving of the light. Moving the aperture from f/8 to f/5.6 doubles the light striking the sensor. Moving the aperture from f/8 to f/11 is halving the light. Moving to f/16 is halving the light again so only 1/4 of the light that passed through the aperture at f/8 is available at f/16.

There is one final point. Remember that f-numbers are ratios between the focal length of the lens and the diameter of the aperture. Take a 24 mm and a 300 mm lens and stop the lenses down to a shooting aperture of f/16 with the depth of field preview lever or button. If you shine a light into the front of each lens you can easily see the apertures, are they the same size? Although both lenses are set at f/16, the

300 mm has a larger aperture than the 24 mm lens, yet both lenses pass the same amount of light. Remember that aperture size varies with the focal length of the lens. This information is helpful later on when we discuss how to shoot sharp images.

Shutter Speed Values

Shutter speeds are exposure controls too. The shutter is found right in front of your sensor. The speed of the shutter as it opens and then closes determines how long light can strike the sensor so that photons can be captured by the pixels. Here's the standard shutter speed series in 1 stop intervals.

Shutter Speeds in Seconds

8	4	2	1	2	1/4	1/15	1/30	1/60
1/125	1/250	1/500	1/1000					

Each shutter speed listed varies from it's nearest neighbor by 1 stop of light. This series doubles or halves the light from 1 stop to the next too. Naturally, the longer the shutter is open, the more light that is recorded by the sensor. Changing to a longer shutter time such as 1/8 to 1/4 second adds 1 stop of light to the exposure.

Moving to a faster shutter speed reduces or subtracts light. The shutter speed determines your ability to freeze action or to show motion. A fast shutter speed of 1/1000 second can sharply record a large flying bird if you pan with it. On the other hand, if you like the silky look in a waterfall, then you need an exposure time in the 1–4 second range to permit the cascading water to blur.

F-stop intervals

There is one more thing you must know. The f-number and shutter speed series listed above is for one full stop intervals. Nearly all cameras offer ½ stop intervals and many of them can be set for 1/3 stop intervals too. These interval choices are usually made using a custom function. What is the best interval choice to use. One stop intervals are too large for digital capture. One-half stop intervals are excellent, especially if you use the typical luminance histogram. One-third stop intervals are best if you are a control freak and you use the RGB channel histogram display that is offered on a few cameras.

Equivalent exposure (reciprocity)

F-numbers and shutter speeds work together to properly expose images. This is called the "Law of Reciprocity". Suppose you are photographing a gorgeous mountain landscape. The camera is set on aperture priority and indicates proper exposure is 1/125 second at f/8. Since the landscape has a near foreground and distant background, depth of field is needed to get

Continuous autofocusing and fast-shutter speeds in the 1/1000-second range can crisply record this Ruppell's Vulture dropping in to feast on the scraps of a lion kill in the Masai Mara. The histogram shows some pixels that correspond to the white neck are near the right edge without clipping.

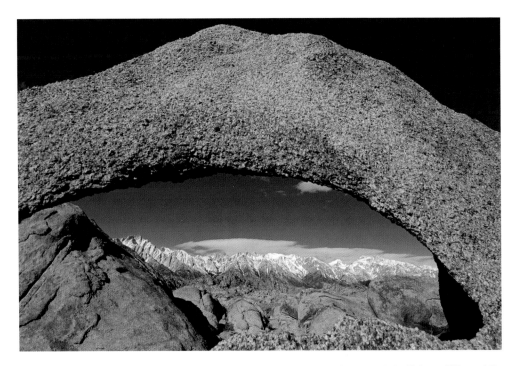

Stopping down to f/22 is necessary here to keep both the arch in the near foreground, the Alabama Hills, and the Sierra Nevada Mountain Range all in focus.

everything sharp so set the aperture to f/22. You subtracted 3 stops of light by going from f/8 to f/11 to f/16 to f/22. To maintain proper exposure, the shutter speed must be adjusted to compensate for subtracting 3 stops of light with the aperture. Since the initial shutter speed is 1/125 second, slowing the shutter down 3 stops to 1/15 second maintains the best exposure. The original exposure of 1/125 at f/8 is exactly the same as 1/15 second at f/22 and the reciprocity law works. On aperture priority, the camera automatically makes this adjustment for you. If you were using manual exposure, you have to make the adjustment yourself.

UNDERSTANDING THE EXPOSURE METER

The companies that make digital cameras want you to shoot excellent images and they work hard to design the camera to do exactly that. Yet, nobody has figured out a way to make an exposure meter deliver perfectly exposed images every time. Digital cameras have through-the-lens metering systems that often produce excellent results. Light travels through-the-lens aperture, is measured by the exposure meter, the shutter opens, pixels record how many photons hit them, and the shutter closes sending the sensor into darkness once again.

Ambient Light and Reflectance Problems

Your through-the-lens reflective light meter is a technical marvel and does a fine job, but it does have one major flaw. The problem with all reflective light meters is the reading they suggest is influenced by two variables. The amount of light reflected from any scene or subject is determined by how much ambient light is present and the inherent reflectance characteristics of the object being metered. The meter does its best to determine how much light is present to properly expose the subject. Obviously, there is more light illuminating a Canada goose on a bright sunny day than a dark rainy day. More ambient light is present on a sunny day. Ambient light varies depending on weather conditions such as cloud cover or time of the day. Ambient light varies a lot so the meter attempts to determine how much is out there so you'll get a well-exposed image. But, there is another variable that influences how much light reflects from a subject. Suppose it is a sunny day and a white gull is fighting with a black crow over a scrap of food. Both birds are illuminated by the sun so each has the same amount of ambient light striking them. Yet the crow comes out much darker in the image than the white gull because the crow reflects a smaller percentage of the ambient light than the gull. This second

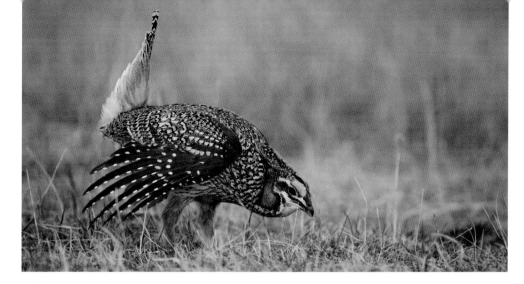

This male sharp-tailed grouse is dancing on a lek in central Nebraska during April. The sun hasn't risen above the horizon yet so the light is dim.

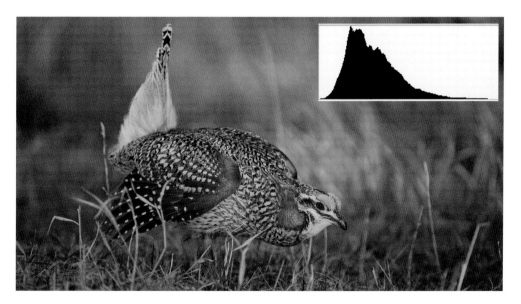

A few minutes later, this grouse is bathed in golden sunshine. Notice how the light is warmer and higher in contrast. The reflectance values of the grouse remain the same, but the amount of ambient light is much greater.

variable is subject reflectance. Given the same amount of ambient light, white subjects reflect more light to the sensor than dark subjects. Now we have two variables, subject reflectance and ambient light. The camera meter attempts to solve the exposure equation with its sophisticated metering system. But, you might remember from high school math class it is pretty tough to solve an equation with two unknowns. The camera meter struggles with this too.

The Problem with Your Camera's Meter

Since the exposure equation can't be solved with two variables, camera manufacturers decided to say one variable, subject reflectance, doesn't vary and is a known value. Now the meter can solve the equation for the ambient light variable. Therefore, camera meters are programmed to believe everything they "see" is middle tone which is known as 18% reflectance. Notice middle tone is not 50% reflectance. As it turns out, 18% reflectance is the middle tonality between pure white and solid black. Since the meter "knows" everything reflects 18% of the light, it can set the aperture and shutter speed automatically to yield great exposures. Many people say cameras are calibrated for 18% middle tone gray. Actually, the color gray has nothing to do with this. Middle tone could be 18% reflectance blue, red, green, brown, or even orange.

Since camera meters believe that everything they look at is 18% reflectance, why does it have a problem? You run into metering problems anytime you meter a

The soft brown fur of the young bighorn sheep is close to middle tone reflectance so a meter reading off the fur should produce a fine exposure.

subject such as a black raven in a snow-covered landscape where the actual reflectance varies considerably from 18%. Let's suppose a black raven and an 18% gray Canada goose is standing in clean white snow. Everything is illuminated by the same amount of ambient light. If you meter the middle tone Canada goose, it will be perfectly exposed. If you meter the black raven, it will be overexposed. The camera makes it 18% reflectance so it lightens up the raven way too much. If you meter just the white snow and shoot, the snow comes out with 18% reflectance so it is too dark. Your exposure meter is not smart. The meter has been programmed to believe that everything it "sees" is 18% reflectance. Since most things are not 18% reflectance, the meter knows one thing which is wrong most of the time. The meter only knows how to expose middle-tone scenes well. The meter tries to make whatever it "sees" to be middle tone in reflectance which sometimes is not the best exposure. We'll learn how to compensate for subject reflectance shortly to get the best exposure.

Metering Choices

Digital cameras offer choices of metering patterns. Depending on the model and manufacturer, the names for similar choices may be different and the number of choices vary as well. My Canon-1Ds Mark II offers four metering choices which include Evaluative, Partial, Spot, and Center-weighted averaging. Barbara's Nikon D70 has three metering choices that include Color Matrix, Center-weighted, and Spot.

Evaluative or Color Matrix Metering Mode

These choices are similar. They divide up the image into many sectors which are analyzed by the camera using complicated algorithms to determine the exposure. The camera compares the brightness of the subject and the background, compensates for backlighting, and other variables. If you are going to use automatic exposure, this sophisticated mode is an excellent choice.

Center-Weighted Averaging

This metering mode meters the entire scene, but puts emphasis on the middle of the image because that is most likely where the subject is. It works well when bright sky is near the top of the frame because the sky doesn't influence the meter much. Center-weighted averaging works okay, but evaluative or color matrix metering really does a better job handling most situations.

Partial Metering

This mode uses the center of the frame to determine exposure. It is most effective when bright areas surround the frame. Since the meter only considers the center of the frame, it ignores white clouds at the top of the frame that might cause the camera to underexpose the main subject.

Spot Metering

This metering mode measures the light only from a small area in the middle of the frame which makes up about 2–3% of the viewfinder. It is the most precise way to meter, but requires a good deal of practice and study to really master. You must meter carefully, learn to judge reflectance values, and know how to compensate the exposure. Spot metering is the best way to expose slide film, but may be overly precise for many digital photographers due to the slightly wider dynamic range digital can capture and the use of the highlight alert and histogram metering aids.

The partial or spot metering pattern works best at Morning Glory Pool. We would spot meter the orange foreground, add one stop of light and check the histogram to be sure that compensation is correct.

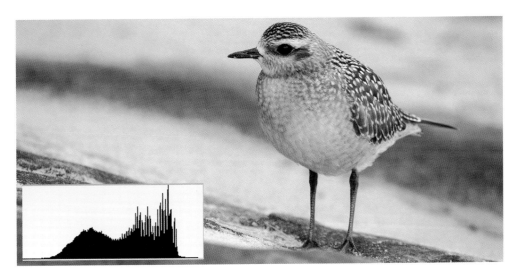

Aperture priority keeps the aperture set at f/8 so the background is nicely thrown out of focus while maintaining decent sharpness on this American Golden-Plover.

Nevertheless, we use spot metering with the camera set on manual for nearly all of our landscape and closeup images while using evaluative for most wildlife photography.

Shooting Mode Choices

The Canon EOS 20D body offers numerous autoexposure modes that include landscapes, flowers, sports, closeups, aperture priority, shutter priority, program, manual, and automatic depth of field to name a few. The modes that are most useful to serious nature photographers are aperture priority, shutter priority, and manual exposure.

Aperture Priority

This shooting mode is the most widely used choice among nature photographers. This automatic exposure choice let's you determine the depth of field by selecting the aperture. If you are photographing a landscape where you have a nearby foreground and distant background, set the camera to f/16 or f/22 to cover the depth in the scene. On the other hand, if you were taking a wildflower or deer portrait, it is effective to isolate the subject against an out-of-focus background so setting f/5.6 to reduce the depth of field might be best.

The aperture priority mode keeps the aperture you select while allowing the shutter speed to vary to maintain the exposure. If the ambient light changes, the camera automatically adjusts for changing light levels by selecting a different shutter speed so the aperture can stay where you set it. The aperture has priority over the shutter speed.

Shutter Priority

This mode works in the same way. You set the desired shutter speed and the camera adjusts the aperture. It is not as widely used as aperture priority, but does have it's place. Photographing flying birds is a good place to use it. Suppose you are at Bosque del Apache in New Mexico during December. This wildlife refuge is famous for hosting thousands of wintering sandhill cranes and snow geese. It is a terrific place to photograph these birds in flight. By panning with the birds, it is quite easy to use autofocus and get sharp images if you have a shutter speed of 1/1000 second. By using shutter priority, you could set the camera on 1/1000 second so the aperture varies to keep the best exposure. Some photographers know they need high shutter speeds to record the birds sharply on the sensor, so they use aperture priority and set the lens aperture wide open at f/4. Let's say proper exposure for the lighting conditions with ISO 400 is f/8 at 1/1000 second. Setting the camera on aperture priority and picking f/4 forces the camera to use f/4 at 1/4000 second. The very fast shutter speed of 1/4000 second does freeze the flying birds, but so does 1/1000 second. Using 1/4000 second is unnecessary. It's desirable to use a shutter speed of 1/1000 second because you'll get more depth of field at f/8 to sharply focus each bird in the flock.

Using manual exposure to meter the caps of the mushrooms and adding one stop of light should work fine. Since these shaggy mane mushrooms aren't going anywhere, there is plenty of time to check the histogram and highlight alert.

I use shutter priority when photographing wildlife in Kenya. Since I use a bean bag from the safari vehicle all of the time, I am confident of getting sharp images if I maintain a shutter speed of 1/250 second. By forcing the shutter to stay at 1/250 second, the aperture adjusts for changing light and frequently gives me more depth of field to use. The extra depth of field I get because I don't needlessly using shutter speeds higher than necessary makes it easier to sharply photograph a group of giraffes on the horizon or a herd of wildebeest.

Manual Exposure

This is our preferred choice when photographing non-wildlife subjects. This method requires you to adjust both the aperture and shutter speed while looking at a metering scale inside the viewfinder to get proper exposure. Used in conjunction with the cameras through-the-lens spot meter (not all cameras have one), it is a precise way to get the exposure you want. But, there is a learning curve. You must learn to adjust the shutter and aperture controls and understand the metering scale in the camera in detail. You also must judge reflectance values and learn how to compensate for them and this takes practice.

AIDS TO HELP YOU GET THE BEST EXPOSURE
Histogram

The histogram is the key to making sure you get the best exposure. While the histogram might seem to be difficult to understand at first glance, it actually is a very simple bar graph of your exposure. It's a graphic representation of the exposure. The graph shows 256 shades of gray along the horizontal axis, beginning with solid black with a value of 0 on the far left to a pure white value of 255 at the far right. The vertical axis shows how many pixels there are at each of the 256 possible values.

If you overexpose the image, you'll see a spike at the far right side of the histogram. This spike represents pixels that are overexposed. Normally you want to avoid overexposed pixels because they have little or no detail. However, some specular reflections from metal or water have no detail anyway so it is okay to have a small spike on the right-hand side if your scene includes these brilliant highlights.

Try to avoid spikes on the far left side of the histogram too. A spike here reveals pixels that have no detail because the light was so dim that these pixels didn't record much data about the light. However, many scenes have deep blacks or dark shadows so do expect some pixels to show up on the left side of the graph. While the exposure can be darkened or lightened with software, having many dark pixels can become a problem due to digital noise which are pixels that show up as unexpected colors or brightness values from neighboring pixels.

Spikes of pixels that appear on the far left or right of the histogram are said to be clipped. It is important to reduce clipping as much as possible because clipping indicates detail may be lost. Clipping can be minimized or eliminated entirely by making the appropriate exposure compensation. However, don't be alarmed if you see a spike in the histogram that goes up to the top, but isn't on the left or right edge. This is not clipping! It merely means a lot of pixels have exactly that value. This happens anytime you photograph something that has many similar tones. A set of cottontail rabbit tracks in the snow creates a histogram that goes off the top of the graph because many of the tones in the image are the same.

Histogram Shapes

There is no such thing as a perfectly shaped histogram. The shape depends on the tones that make up the image. Try photographing a meadow full of wildflowers where some flowers are white, but most of the meadow is light and dark shades of green, with a few black shadows thrown in. The histogram looks like a mountain range where a few tones appear in the black and white portions of the graph and then the tones gradually rise up toward the middle where the majority of the tones in the scene are found.

Try photographing a dark subject in the snow such as a bison in the snow at Yellowstone. Most of the tones are either very light or very dark with little else in-between. You'll get a histogram that has two dominant hills of data. One hill represents dark pixels and the other shows the light pixels. You may see gaps in the middle of the histogram, but don't be alarmed. These gaps merely show tonal values that don't exist in the image.

There is no such thing as the perfectly shaped histogram. The histogram is dependent on the tones in the scene. You can expect two clumps of data if you properly expose this bison in the snow. One hill of data will be near the right side for the white snow and the other near the left side for the dark fur with little in-between.

Highlight Alert

Digital cameras offer a highlight alert or warning function to help you avoid overexposing the image. You may need to turn this feature on before it operates. The control is normally listed on a menu. When the highlight alert is turned on, any pixels that are overexposed blink off and on when you view the image on the cameras LCD monitor. Many photographers refer to flashing pixels as the "blinkies". Try to reduce or eliminate blinking pixels since these represent pixels with no detail. There are times when it is fine to have a few blinkies though. While photographing Scott Fall, I noticed the whitest part of the waterfall where water struck the plunge pool was blinking. Dark rocks surrounded the waterfall. If I reduced the exposure enough to eliminate blinking pixels, the dark areas were clipped on the black (left) end of the histogram. Since there was no detail in the foamy white water anyway, there was no reason to be overly concerned about overexposure. It would come out white in the print with no detail, just as it looked in real life. By allowing a few pixels to be overexposed in the white water, more detail could be captured in the rocks.

Problem Situations for Autoexposure

While evaluative metering works nicely, there are times when manual exposure and spot metering are better. I was photographing gorgeous Colonnade Falls in the backcountry of Yellowstone National Park. This waterfall is seldom photographed due to its remoteness so I composed as many compositions as possible. I composed a tight shot with my constant aperture 24–70 mm f/2.8 L lens. Using the camera on evaluative metering, I took a shot and checked the histogram which showed I needed to give the scene more light so I set my cameras compensation dial to +1 to get the best exposure. The large amount of white water the meter "saw" caused the underexposure problem. Then I composed a shot so less white water appeared in the image and more dark pine trees. When I took the picture, my highlight alert immediately showed I was overexposing some of the white water so I set the camera to zero compensation to get an excellent exposure. Then I made

Using autoexposure with a zoom lens was a disaster here. As I zoomed in and out composing different shots of Colonnade Falls, the camera constantly changed the exposure since the meter was reading varying amounts of white water and dark trees.

the waterfall even smaller by zooming in to 35 mm and again the highlight alert came on so I made another adjustment. Every time I changed the focal length, a different percentage of white water and dark trees occupied the frame so the meter kept changing the exposure even though ambient light wasn't changing. This forced me to constantly adjust the exposure with the compensation dial.

Finally, I decided to use manual exposure and spot metering. I metered the whitest water only and compensated for the reflectance by adding 1.5 stops of light with the shutter speed. The histogram showed this was the best exposure. Now I could zoom in and out all I wanted and the best exposure wouldn't change unless the ambient light level changed.

A Serious Autoexposure Problem

When using a tripod to shoot landscapes and closeups, your eye isn't normally peering through the cameras viewfinder. This means light can enter the viewfinder which could make it impossible to get a good exposure. This problem commonly occurs when you are using a device that cost you light such as a polarizing filter, macro lens focused at high magnification, extension tube, or teleconverter. If the viewfinder is pointed at a bright source of light such as the sun or bright sky, you may have a serious underexposure problem when using any automatic exposure mode. Using the exposure compensation dial won't help either. In this situation, light enters the viewfinder and the meter measures it along with light coming through the lens.

The meter doesn't care where the light is coming from so it considers all of it and sets the exposure. However, light from the viewfinder doesn't record on the sensor since the mirror blocks this light causing underexposure. Most cameras have a way to block the viewfinder by placing a plastic cover over the viewfinder or closing a built-in curtain. This solves the problem! Unfortunately, you have to do it with every different shot. It gets monotonous closing and opening the viewfinder. Holding your

Robber fly
In some situations such as high-magnification closeup photography where you lose a lot of light through the lens, autoexposure can be thrown off by light entering the viewfinder causing underexposure.

hand closely in front of the viewfinder solves the problem too, but you have to do it every shot. If you meter on manual, light entering the eyepiece is not a problem at all. For this reason, you may want to use manual exposure anytime you shoot images where your eye isn't up to the viewfinder.

EXPOSURE COMPENSATION

Using automatic exposure is a proven way to effectively take many wonderful images. Since you know meters have problems with subject reflectance, it is necessary to learn to compensate the exposure. You'll find that at least half the time you need some exposure compensation to get the very best exposure. Fortunately, exposure compensation is easy to do, especially when you have the histogram and highlight alert to guide you.

Exposure compensation is most likely necessary anytime you photograph a subject that has bright highlights and very dark shadows. Backlighting also tends to create a need for compensation. In both cases, extreme contrast causes the need to compensate. Photographing anything where the scene is full of tonal values significantly more reflective than 18% or less reflective than 18% needs to be compensated too. For example, the sand dunes in Death Valley National Park are more reflective than 18%. You'll find you need to compensate for the reflectance of the sand by adding 1 to 1.5 stops of light to the exposure. Snow scenes are even more reflective so they might need +2 full stops of compensation to get the best exposure. A landscape image of a pine forest might

be darker than middle tone due to the dark bark and shadows present in the scene so −0.5 stops of light could be the perfect compensation.

Digital cameras have an exposure compensation dial or button somewhere on the camera body. Study your manual to find out where it is. Be careful though, most cameras have an exposure compensation dial for natural light which is what you want to find right now, plus another one for flash. Don't get the two confused! Adjusting the flash compensation control won't do anything for your natural light exposures and vice-versa.

Use the histogram to determine when exposure compensation is needed. For example, if you set your camera on aperture priority and evaluative and photograph a mostly white snow scene, your exposure will be too dark. Since most of the scene is white, the meter tries to make it middle-tone so the pixels representing the lightest areas are too far from the right side of the graph. To get the most detail in a RAW image, move the right side of the data so it is snuggled up to the right edge of the graph without clipping any of the pixels. If you were shooting a JPEG, you still want to move the histogram to the right, but not all the way to the right edge. To compensate the exposure, set the natural light compensation control to +1, block the viewfinder, and shoot another shot. Check the right edge of the data and make sure it is close to the right side of the histogram. If it isn't close enough, then try +1.5 stops of compensation and keep checking until it is where it should be.

Understanding the Exposure Compensation Button

This control is quite easy to use once you get used to it. The compensation button is set up in stops of light just like your apertures and shutter speeds. Depending on the camera, the stops might be 1, ½, or 1/3 stop intervals. The scale you see has a negative direction (less light) and a positive direction (more light). To move the pixel values to the right, you must add more light by setting positive compensation. If you are getting blinking pixels as shown by the highlight alert and clipping the pixels on the right-hand side, then compensate the exposure by setting negative values to reduce the exposure. Normally, all it takes is one or two adjustments with the exposure compensation control to get the perfect histogram.

Compensating Manual Exposures

If you decide to use manual exposure and meter with your through-the-lens spot meter, that's a great way to go to. But, you still need to compensate the exposure on manual. In the manual mode, most cameras show an exposure scale inside the viewfinder. This scale may be divided into full, ½ or 1/3 stop intervals. Be sure to check the scale carefully so you know exactly what you have. Depending on the camera, the scale might cover a range of 1 stop, 2 stops, and even 3 stops in some cameras. The middle of the scale is zero compensation. When you manually meter using your through-the-lens spot meter, it's effective to adjust the shutter

speed and/or aperture so the exposure indicator lines up with the zero point. From there you can adjust for subject reflectance. In the case of a snow scene or white flower, try spot metering only the white area and move the shutter speed or aperture so the exposure indicator that you see inside the viewfinder lines up at the +2 position. If you were photographing a black bear, meter the dark fur of the bear and compensate for the reflectance of the dark fur by moving the aperture or shutter speed so the meter lines up on the −1.5 stop position. Of course, always check the histogram and highlight alert to guarantee you have the best exposure.

Exposure Bracketing

Viewing the LCD monitor to check the histogram and highlight alert is a problem in bright ambient light. Rather that struggle trying to view the monitor in bright light, it's effective to use auto bracketing in situations that don't involve catching the decisive moment. Any digital image such as a wildflower portrait, landscape, or closeup of a dewy spider web can be handled quite nicely with auto bracketing.

Depending on the camera model, it may have a number of ways to set up the auto bracketing feature. Autoexposure bracketing means the camera automatically adjusts the exposure from one shot to the next, depending on the parameters you set. For example, my Canon cameras can be set to shoot three exposures that vary from each other by ½ stop intervals. The first exposure is what the meter thinks is the best. The second exposure is ½ stop darker

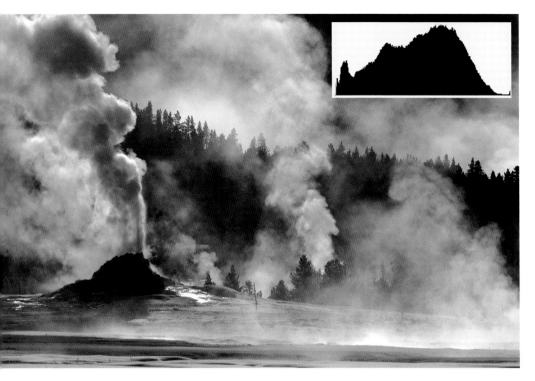

White Dome Geyser backlit is a tough one to meter. Use the histogram in the field to get close and then bracket the exposure so you can select the best one on the computer.

and the third is ½ stop lighter. As auto bracketing suggests, the camera automatically brackets the exposure a set amount which you choose around the exposure that you set manually or what the camera sets automatically. Rather than struggle trying to view the LCD monitor in bright ambient light, at times it is smarter to get the best exposure by letting the camera bracket the exposure. Then download the images to your computer and use your software program to select the best exposure by checking the histogram of each image in the bracketed series of three.

By having the camera bracket the exposure ½ stop (or 1/3 stop if you like smaller exposure increments) either side of what you think is the best exposure, it is easy to get at least one excellent exposure, especially if you use the compensation dial too (when necessary) to get the exposure close in the first place.

ISO CONSIDERATIONS
Digital Noise

ISO stands for International Organization of Standards. It was originally used by film manufacturers to rate the speed of their film. In theory, any film that was rated ISO 100 would have a similar exposure to any other film with the same ISO rating. An ISO 50 film was considered slow while ISO 400 was a fast film. You might think the higher speed films were more useful because fast films permitted using higher shutter speeds to stop action or stopping down the lens more for depth of field while still maintaining higher shutter speeds to get sharp images. However, nature photographers shunned high-speed film. High-speed films were less colorful and worst of all, the light sensitive silver grains in the emulsion were larger than slow-speed films. These large particles tended to appear in the image as tiny bits of sand called grain. While grain sometimes had a moody appeal, normally it was a distraction in a print and made the image appear soft.

Film has grain. Digital does not. All the pixels on a sensor are the same size. Yet ISO values are still used. A digital sensor has a native speed or ISO. This means when the sensor is made it has a specific inherent speed. Digital cameras typically have a native speed of ISO 100 or ISO 200. These cameras permit you to vary the ISO from the native setting. They do this by changing the sensitivity of the sensor circuits. You want to take advantage of the ISO choices offered by your camera. For example, a Canon EOS 20D offers a choice of ISO 100, 200, 400, 800, or 1600. By using

a custom function, it is possible to select ISO 3200 for really dim light. Each of the ISO choices in this series beginning with ISO 100 is twice as sensitive to light.

Digital Noise

Since digital doesn't have grain, surely it is best to use ISO 1600 all the time. ISO 1600 provides plenty of shutter speed for sharp images and makes it easy to stop the lens down for more depth of field. However, digital noise becomes a problem. The more you amplify the electronic sensor data, the more "noise" problems you have. It also occurs during long exposures in the 1 second and longer range. Digital noise most frequently occurs in the dark areas of an image. Digital noise is individual pixels that are much brighter or darker than their neighbors or they are odd colors when all the neighboring pixels are a different color. Prints made from a digital image that have a lot of noise appear to have grain.

To get the best image quality, use the cameras native ISO speed whenever possible since digital noise is low. Some cameras have a digital noise reduction feature when shooting at long shutter speeds in the 1 second and longer range. This does work well so do use it. However, it may double the time to take an exposure. With a 4-second exposure, it may take the camera twice as long to take the image due to the noise reduction feature so you must wait a bit longer between shots.

ISO SHOOTING STRATEGIES

There are times to use other ISO settings besides the native one in nature photography. Using a 500 mm lens to photograph wildlife is a good time to choose a higher ISO. Long lenses magnify the animal as well as any camera movement that happens when you shoot. High shutter speeds reduce this problem so many nature photographers routinely use ISO 200 when using long lenses, even in fairly bright light. In really dim light on a cloudy day or very early or late in the day, using ISO 400 or even ISO 800 may be necessary to reach fast enough shutter speeds to shoot sharp images. While you may see some noise at the higher ISO settings, it still is better to get sharp images with some noise artifacts than fuzzy images using the native ISO with no noise problems.

Being able to change the ISO on a digital camera from shot to shot is a huge advantage. It is easy to adjust the ISO on a digital camera to suit the light conditions. You should set the ISO to suit the light conditions to get the shutter speed you need. To blur a waterfall, a shutter speed in the one second range is necessary. To photograph a waterfall with a long shutter speed, put on a polarizing filter which absorbs about 2 stops of light, stop the lens down to f/22, and set the lowest ISO setting offered by your camera. On a dark cloudy day, that combination should put you in the desired shutter speed range of 2–4 seconds. These long shutter speeds permit the water to blur during the exposure imparting a silky look to the water.

If you want to sharply photograph a flamingo or sandhill crane flying past, then shoot the lens wide open at f/4 and set the camera to ISO 200 or even ISO 400 to get more shutter speed. There are times to push the ISO up to get more depth of field too. If you were photographing a colony of penguins or flock of birds in flight, using ISO 800 and setting the camera to f/8 or even f/11 if the light is bright enough gives you enough shutter speed to make a sharp image while having enough depth of field to cover the subject adequately.

FINAL THOUGHTS

Always use the histogram and highlight alert to fine tune the exposure. Avoid the temptation of judging the exposure by how the image appears on the LCD monitor. Looking at the image on the cameras monitor is worthless for judging the exposure because the brightness of the image depends on the angle you view the monitor. By changing the viewing angle, you can make a perfectly exposed image look too dark or too light. Plus, many cameras let you make the monitor brighter or darker so how can you judge an image for exposure. Avoid this common mistake of using the LCD monitor to judge exposure. Use the histogram! It's the perfect tool for judging exposure because it tells you exactly how your pixels are exposed. Do not judge the exposure by how bright the image appears on the computer monitor either. Once again, brightness controls in the computer, ambient light levels in the room, and viewing angles all play a part in how bright the image appears. If you always use the histogram to judge exposure, you will know when it is correct.

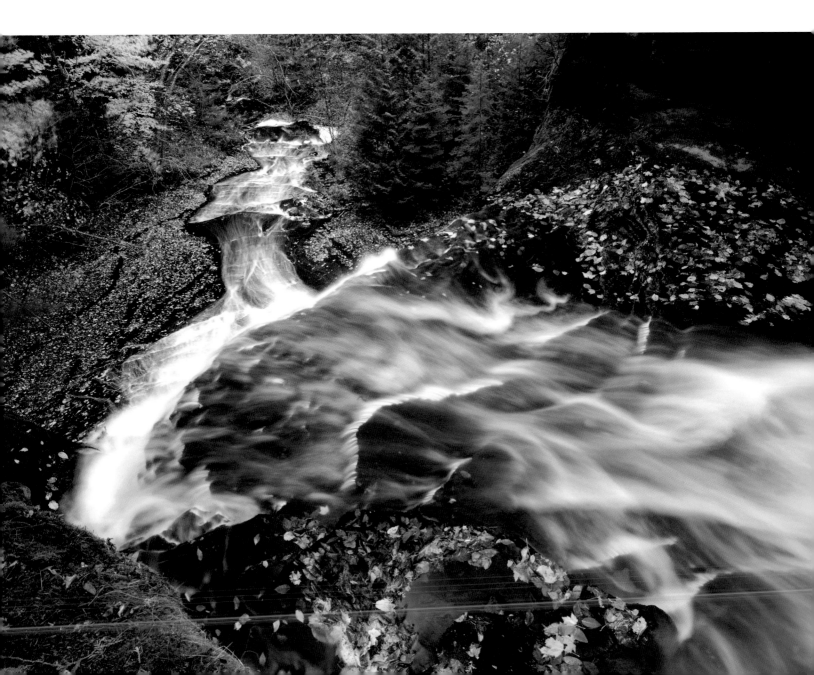

Using Lenses Effectively

HOW LENSES WORK

Lenses focus and direct the light to the imaging sensor. Since there is a bewildering number of lenses being made today, deciding what lenses to purchase is a problem for most of us. However, once you know what to look for, having many choices makes it easier to buy lenses that match your needs and budget.

FOCAL LENGTH

All lenses have a focal length which is defined as the distance between the optical center of the lens and the sensor when the lens is focused at infinity. This distance is listed in millimeters. The focal length determines the lens angle of view or what the lens "sees". The longer the focal length, the smaller the angle of view. The shorter the focal length, the wider the angle of view. For example, a Canon 50mm macro lens has an angle of view of 46 degrees while the Canon 180mm macro has a much smaller 14-degree angle of view. If you photograph a wildflower at the same magnification with both lenses, the wide angle of view of the 50mm macro "sees" far more background than the 180mm macro so you are more likely to have problems with distractions in the background. If cluttered backgrounds are ruining your images, always remember to try a longer focal length lens to get a smaller angle of view.

However, the large angle of view that short focal length lenses have is helpful at times. A short lens such as a 24mm might be just what you need to photograph a cactus which include a dramatic sky full of beautiful clouds or perhaps a rugged mountain. If the background is appealing, then use the short focal length lens to include it in the image.

LEFT: Extreme wide-angle lenses permit shooting from the top of Chapel Falls which is an unusual and pleasing viewpoint.

MAXIMUM APERTURE

The lens aperture is determined by dividing the focal length by the optical diameter of the aperture. The maximum aperture is important because it determines the light passing ability of the lens. Lenses can have a variety of maximum apertures, even within the same focal length and made by the same company. For instance, Canon offers a 300 mm f/2.8 and a 300 mm f/4.0 lens. The 300 mm f/2.8 lens is said to be one stop faster than the 300 mm f/4.0 lens. Lenses with maximum apertures of f/2.8 are considered fast. A lens with a maximum aperture of f/8 would be called a slow lens because it doesn't pass as much light. As you look at the list of lenses you can purchase for your camera, you will find many lenses that have the same focal length, but different maximum apertures. Let's look at the advantages and disadvantages of maximum apertures.

Benefits of Fast Lenses

- The viewfinder is brighter which makes composing and manual focusing easier.
- Faster shutter speeds are possible for sharp images.

LEFT: Using a 180 mm macro lens is effective for eliminating clutter and distracting details behind this sphinx moth caterpillar that has been parasitized by wasps.

RIGHT: Using a 24 mm wide-angle lens very close to this cactus produces an interesting foreground that leads you all the way to the Sierra Nevada Mountain range in the distance.

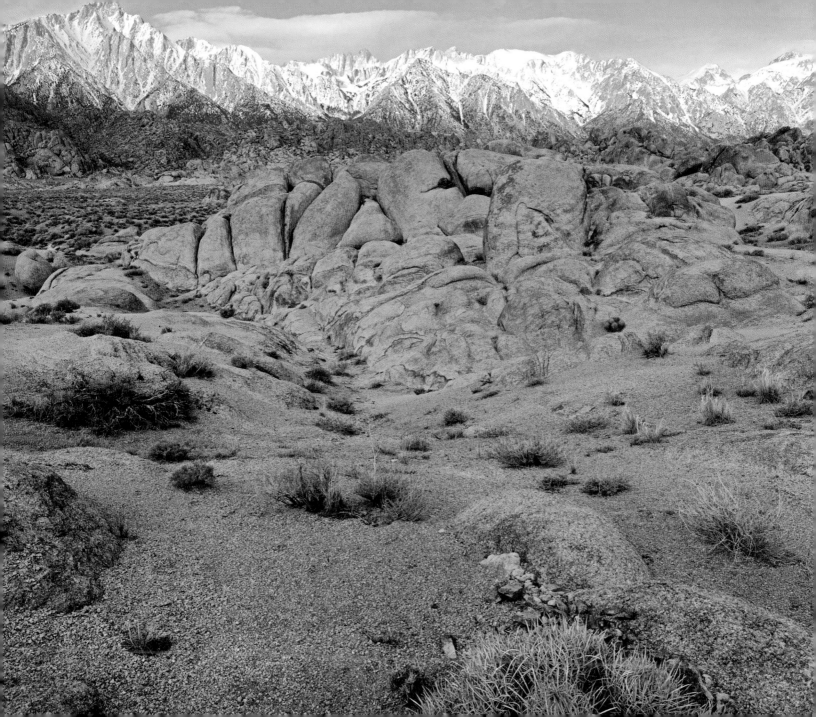

- The camera may autofocus faster and more accurately.
- It is easier to throw the background out-of-focus.
- Less depth of field for selective focus is available at the widest aperture.
- It is more likely autofocus will still work if you use teleconverters, filters, or extension tubes.

Drawbacks of Fast Lenses

- Expensive.
- Heavy.
- Requires larger filters which are also bigger and more expensive.
- Harder to carry with you.
- May require a heavier tripod to support it.

DEPTH OF FIELD

This refers to the sharpness zone that extends in front of and behind the focal plane. Although the sharpness zone is truly a single plane, we think of it as a zone where details appear sharp to our eyes even if they may be slightly soft. This sharp zone increases as you stop down the lens from f/8 to f/16 for example. The depth of field decreases when you increase magnification. With any lens, shooting with a small f/stop such as f/2.8 and increasing the magnification by moving closer to the subject reduces depth of field which is desirable if you wish to make the background out-of-focus. Capturing wildflower or animal portraits is a wonderful use of this technique. If you what maximum depth of field, stop the lens down to f/22 and move away from the subject. This reduces magnification which increases depth of field helping you get everything sharp in the image.

Using a 500 mm lens fairly wide open at f/8 provides a sharp portrait of the Masai Ostrich while throwing the background completely out-of-focus.

CROP FACTORS

In the old days, 35 mm single-lens reflex (SLR) cameras shot photos that were 24 × 36 mm in size because all cameras needed to be built to accommodate the popular film of the day. Digital cameras don't need to be made for a certain size of film so digital sensors can be made in a variety of sizes. The only requirement is the image circle cast by the lens needs to be larger than the sensor. Since lenses were made to cover the dimensions of 35 mm film (24 × 36 mm), digital sensors can be made that size or smaller. In early 2007, very few digital cameras offer a sensor that corresponds to a 35 mm slide. Instead, the vast majority of digital cameras have a sensor smaller than 24 × 36 mm because the quality is still fine and it lowers the price of the camera. Using a smaller

Using a 300 mm telephoto lens on a camera with a 1.5x crop factor makes the lens seem to have the reach of a 450 mm lens. This makes it easy to fill the frame with a small bird like this Gray Jay.

sensor is like cropping a 35 mm image which leads to a crop factor. This factor is derived by dividing 50 mm by the length of the diameter of the sensor. For example, 50 mm divided by 31 mm equals a factor of 1.6 which is the crop factor of the Canon 30D.

The crop factor is good and bad. It depends on what you want to do. One huge advantage is long lenses are now available to everyone, not just pros or wealthy amateurs. A crop factor of 1.6x effectively turns a 300 mm f/4 lens into a 480 mm (300 mm × 1.6x) lens that still has f/4 lens speed. The working distance of the 300 mm lens remains the same, but you get more apparent magnification. This 300 mm lens with the crop factor is more than $4000

cheaper than a prime Canon 500 mm f/4 lens and it weighs 5.9 pounds less! Now everyone can own and carry a lens in this focal length to fill the frame with wildlife. The crop factor works nicely on a zoom lens too. A 100–400 mm zoom becomes a 160–640 mm lens (with a 1.6x crop factor) and it doesn't lose any light like it would if a teleconverter was used. Plus, the closest focusing distance of the lens remains the same so it is easier to fill the frame with a small subject. To fill the frame with a small bird like a house sparrow, an extension tube must be used between a 500 mm lens and the camera body to make it focus closer. But, a 300 mm lens with the 1.6x crop factor handles this subject quite nicely without the extension tube. The crop factor

is advantageous in macro photography too. A 100 mm macro lens that can focus to life-size (1x) offers higher apparent magnification. High magnification closeups are easier to do with the crop factor.

On the down side, the crop factor really isn't more magnification. It is a crop of the image that once was 24 × 36 mm in size. You could do the same thing with a 35 mm slide by scanning the slide and then cropping the image. With the full-frame sensor in my Canon 1Ds Mark II, I commonly crop the image and don't mind having a bird or mammal a little smaller in the frame than I would like if I can't move closer because I can easily crop the file later. Of course, the more pixels you use to record the subject, the more options you have later for making large prints from the file. A sensor with a crop factor won't have as many pixels (picture elements) as a full-frame sensor but the pixels it does have are recording light information from the central areas of the glass elements where lens imperfections have been greatly minimized as opposed to the outer edges of the glass in the lens. You are using the "sweet" parts of the lens to capture the image so this mitigates the reduced number of pixels somewhat.

The crop factor effect on wide-angle lenses is the most serious problem. A 1.6x crop factor converts a 24 mm wide-angle lens into a 38.4 mm lens which is getting close to a normal or standard 50 mm lens. A 17 mm lens is a wonderful wide-angle lens to use, but it becomes a 27.2 mm lens with the 1.6x crop factor. Be aware that digital cameras can have other crop factors

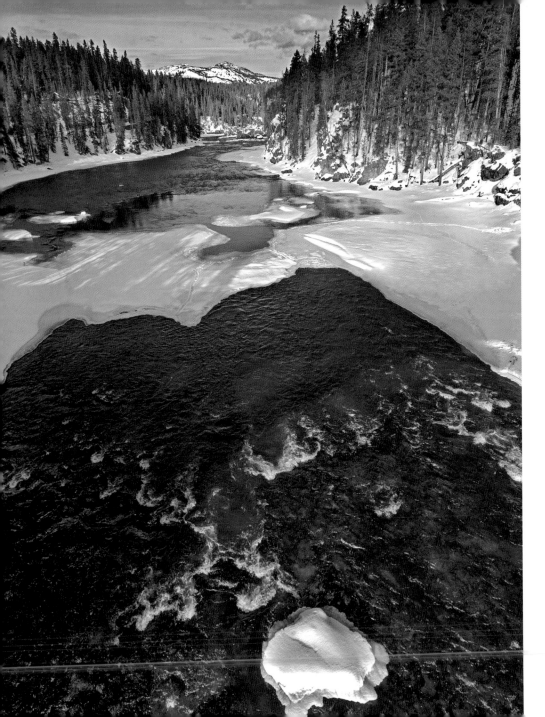

too such as 1.3x, 1.5x, and 2x or something else so it all depends on the camera body you own. If you love shooting wide-angle images, this is a frustrating problem. Fortunately, camera manufacturers have heard the uproar and now make wide-angle zoom lenses for their cameras that have the crop factor. A recent addition to the Canon line is the new 10–22 mm f/3.5–4.5 zoom. It's made for their camera bodies that have a crop factor. It cannot be used on a digital camera with a full-frame sensor because the lens doesn't throw a large enough image circle to adequately cover a full-frame sensor. Nikon recently came out with 12–24 mm f/4 to solve the same problem and the other fine camera lines are doing the same. Lenses that can only be used with cameras that have the crop factor include Canons EF-S and Nikons DX ED-IF series. Since these lenses don't need to throw such a large image circle, they can be made smaller and lighter.

IMAGE-STABILIZED LENSES

These lenses are built so you can use slower shutter speeds hand-held and still get sharp results. Canon calls these lenses image stabilized (IS) because a special group of lens elements can shift its position to compensate for camera shake producing a sharper image. Nikon lenses that

Barbara's Nikon 12–24 mm lens worked beautifully to capture this winter scene of the Yellowstone River from a bridge.

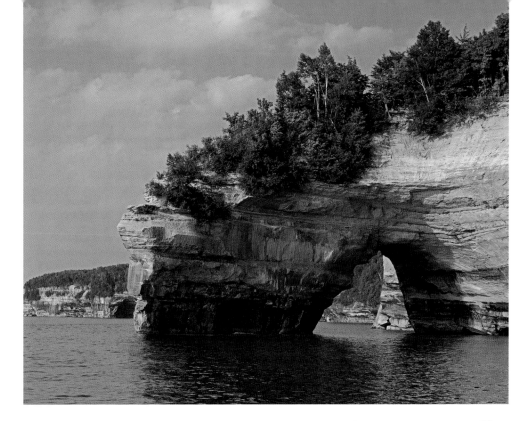

Tripods are useless for photographing from a rocking boat. By using Canon IS and Nikon VR lenses, using ISO 200 instead of ISO 100, and more intermediate apertures of f/11, we have plenty of shutter speed to shoot sharp images of this arch along Pictured Rocks National Lakeshore.

for instance. However, we still use tripods whenever possible. In most cases, it is recommended to turn off this technology when shooting on the tripod.

PERSPECTIVE

Perspective is a visual effect that determines how close or far away the background appears to be from the subject. Often we use lenses to control perspective to simulate depth when a three-dimensional scene is reduce to two dimensions in the image. Telephoto lenses tend to compress the scene. They make the foreground and background look closer together. Wide angles tend to expand the feeling of depth. They make the foreground look bigger than the background when you physically move closer to the foreground. Since objects in the background are smaller relative to the foreground, wide-angle lenses increase the sense of depth, especially in landscape images. Perhaps that is why they are so widely used by landscape specialists. Therefore, to emphasize the foreground, use a wide-angle lens and move close to it. To make the background more dominant, use a longer lens and move away from the foreground.

LENS CHOICES
Zoom and Prime Lenses

Prime lenses have a fixed focal length. The Canon 24 mm f/1.4, 300 mm f/4, and 400 mm f/2.8 are examples. These lenses cannot change their focal length. Prime lenses frequently have more lens speed that zooms covering that range and may be slightly sharper. However, the quality

do this are called vibration reduction (VR) lenses. It seems all the lens manufacturers are coming out with some lenses that have image-stabilizing technology. Some camera systems such as Sony, Pentax, and Samsung have sensor-based stabilization systems so all lenses used on their cameras benefit from the anti-shake treatment.

This anti-shake technology does work fairly well. Without this feature, it was thought a stable photographer could effectively hand-hold a camera and make sharp

images if they used a shutter speed that was equal to 1/focal length. With a 30 mm lens, a shutter speed of 1/30 second was sufficient. With a 200 mm lens, a shutter speed of 1/200 second was necessary to account for the increased magnification of the longer focal length. Of course, this depends on the photographer. Some are steadier than others. We have several Canon and Nikon lenses that have this technology and do use it when we must hand-hold the camera when shooting from a rocking boat

differences between prime and zoom lenses has closed considerably. If you can afford it, always buy a zoom lens that is built with special low dispersion glass which improves image sharpness. We use prime lenses a lot, but there is a disadvantage of being unable to change the focal length which makes composing a bit more difficult at times.

Zoom lenses are enormously handy because the focal length can be changed over a certain range. A few Nikon examples include the 12–24 mm f/4, 18–200 mm f/3.5–5.6, and 200–400 mm f/4. Zoom lenses permit you to change the focal length to anything within their range. For example, the 18–200 mm f/3.5–5.6, lens starts at 18 mm, but can be zoomed all the way out to 200 mm which includes every focal length between the two. Zoom lenses are useful because it is so easy to change composition without changing the camera to subject distance. Another zoom lens advantage is one filter such as a polarizing filter covers all of the focal lengths on the lens. A Canon 100–400 mm zoom requires a 77 mm polarizing filter which works for every focal length between 100 mm and 400 mm. If you were to buy a fixed 100 mm, 200 mm, and 400 mm lens, you might find you need three different sized filters to fit all of the lenses. Since you only need one filter

The 17 mm lens on the Canon 1Ds Mark II which has no crop factor offers a nice perspective of Laughing Whitefish Falls. The rock and leaves in front are only a couple feet from the lens so the huge looming foreground grabs your attention and the flow of water guides you up the falls.

size for the zoom, this saves you money and weight, plus you spend less time cleaning filters and putting them on and taking them off the lens. Zoom lenses are popular with amateurs and pros because they work so well. We happily use zooms with excellent results.

Constant and variable aperture zooms

There are two types of zoom lenses, constant maximum aperture and variable aperture. The Nikon 18–200 mm f/3.5–5.6 is a variable aperture. The lens starts out with a lens speed of f/3.5 at the shortest focal length and gradually becomes a somewhat slower f/5.6 lens as it approaches the 200 mm focal length. Variable aperture zooms are smaller, lighter, and less expensive to make so they are quite popular. Constant maximum aperture zooms such as the Nikon 200–400 mm f/4 do not change to a slower lens speed when the lens is zoomed out to the longest focal length. This make the lens bigger, more expensive, and heavier. However, we prefer to use constant maximum aperture zooms because they keep their fastest lens speed which permits us to use higher shutter speeds for sharp images. Having a constant maximum aperture is especially important for photographing wildlife with longer focal length zoom lenses.

A "slow" variable aperture zoom lens was a serious problem when most nature photographers shot film in the ISO 50 range. However, digital cameras produce beautiful results using ISO 400 so lens speed is now less of a factor than it once was. Zooms are more prone to flare problems than fixed focal length lenses because they are more complex.

Zoom lenses are made in two ways. Many zoom lenses are the push–pull variety where you pull the lens out to zoom to a longer focal length or push it in to switch a shorter focal length. These work quite well, but they do tend to permit dust to get inside the lens elements which requires a trip to the repair shop for cleaning. You may also have a problem shooting straight down when the lens is mounted on a tripod. Gravity can cause the lens to zoom out all by itself making it impossible to get a sharp image. Some of the best zoom lenses such as the Canon 100–400 mm f/4.5–5.6 have a locking ring so you can

Barbara used a Nikon 80–400 mm f/4.5–5.6 lens to capture this lion cub being moved from one patch of bushes to another. The zoom lens permitted her to constantly recompose as the lion approached and finally ambled past her landrover.

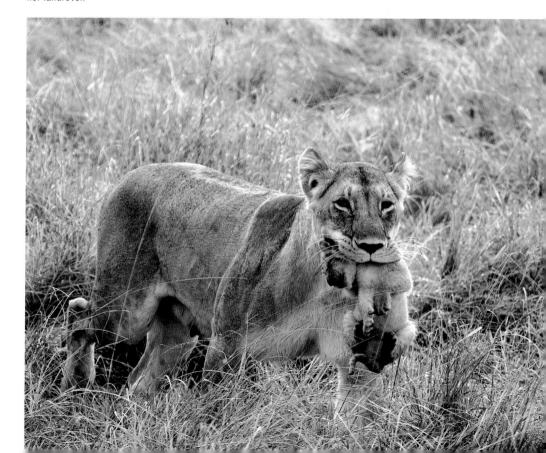

lock the lens at whatever focal length you desire to avoid this problem.

The second and more common type of zoom lens uses a ring that you turn to change focal lengths. Most serious photographers prefer these because they are easier to use on a tripod (no gravity problem) and dust getting inside the lens isn't a serious problem.

Using zoom lenses in the field

The advantages of zoom lenses over fixed lenses can be huge when it comes to making images. While leading a photo safari in Kenya's famous Masai Mara, Barbara's driver spotted a lioness carrying a cub directly at her landrover. It was still a hundred yards away so she had time to put her Nikon 80–400 mm f/4.5–5.6 zoom on her camera. She zoomed out to 400 mm and waited for the lion to march within range. As the lioness filled the frame, she put her autofocus sensor right on the forehead and let continuous autofocus track the cat producing sharp images. As the lioness continued to approach, she kept zooming to a shorter focal length and shooting until she was all the way to 80 mm when the huge cat ambled past her landrover only a few yards away. She managed to get three dozen shots off and nearly all of them were sharp and well composed. If she had a fixed focal length lens such as a 300 mm, she would have only shot a few images between the time the lion was big enough in the frame till the lion was too close. Zoom lenses give you time to quickly change compositions to make the most of any shooting opportunity. Using a zoom lens is often the difference between many excellent images and very few. Being able to change focal lengths quickly is a huge advantage!

Wide-Angle Lenses

These lenses "see" the world differently than you do. Wide-angle lenses work wonders for creating images with dramatic foregrounds. They fall in the focal length range of 10–35 mm. Some examples of wide-angle lenses include 15 mm, 16 mm, 20 mm, 24 mm, 28 mm, and 35 mm lenses. Many wide-angle zoom lenses such as the 17–35 mm, 17–40 mm, and 24–70 mm are excellent for nature photographers too. The 24–70 mm lens begins in the wide-angle range, but extends to the short telephoto range at 70 mm. For cameras that have a small sensor, special wide-angle lenses are made such as Nikons's 12–24 mm and Canon's 10–22 mm to counteract the crop factor so true wide-angle images can be made with these cameras too.

Wide-angle lenses are terrific when you have a gorgeous near foreground such as a patch of wildflowers and a huge sky or mountain background. By moving in close to the wildflowers, it is easy to make the wildflowers dominate the foreground which leads you into the background. Wide angles are terrific for making wildlife landscape images anyplace where wildlife is especially approachable such as penguin colonies in Antarctica or the Falkland Islands. Since wildlife in these places is so unafraid of humans, it is quite possible to approach a penguin colony close enough so you can fill the foreground with King Penguins for instance and include the fabulous landscape in the background. These lenses are effective for photographing waterfalls too. By setting up near the stream at the base of the waterfall, you can include the stream leading up to the waterfall in the background. Another fun image is to use a super wide-angle lens such as a 15 mm or 17 mm, lay on the ground, and shoot straight up in a deciduous forest ablaze with autumn color or during winter when the branches are fringed with heavy frost or snow. You need the super wide lens to include as many trees as possible.

Wide angles work well for making sunstar landscape images. This works best with wide angles if you stop the lens down to f/22 or f/32. F/22 offers plenty of depth of field, but the real reason you want to use it is you need a tiny aperture to turn the sun into a star. As you know, the f-number is a ratio. F/22 is a much smaller hole in a 17 mm lens than a 300 mm lens, although they pass the same amount of light. The reason the smaller aperture of f/22 on a wide-angle lens works so well to create the sunstar effect is due to diffraction. As light passes through the tiny hole, a percentage of the light touches the edge of the hole and bends causing diffraction which turns the sun into a star. The aperture at f/22 on a 300 mm lens is much larger so a smaller percentage of light strikes the edge of the aperture reducing the star effect on the sun.

Wide-angle lenses may be the most difficult group of lenses to learn to use well. Many effective wide-angle shots require you to get very close (measured in inches) to an interesting foreground to have a stunning

and unusual viewpoint. This is not a position that people naturally assume. Since wide angles cover a wide field of view, you'll find it is easy to include unwanted elements in the images such as telephone poles, wires, fences, tripod legs, and other manmade objects that you would rather exclude. Try lying on your back in the forest shooting straight up at the trees with a 15 mm lens. If you aren't careful, your feet or even your belly may appear in the image so watch the edges of the frame to exclude unwanted objects. Of course, the digital image is easy to crop later if you do find distractions on the edge of the image.

You want a wide-angle lens or two in your camera bag. To help you decide what would be best for you, here is what we do. I shoot a Canon 15 mm lens in tight locations where I need to push the subject back and shooting up at trees. Not everyone needs this focal length, but it is a fun lens to use. My workhorse wide angle is a 17–40 mm f/4 zoom. This lens nicely covers the wide-angle range. However, the camera I primarily use has a full-frame sensor so I don't have to contend with the crop factor. If your camera does have a crop factor, consider buying one of the extra wide zoom lenses that are made for cameras with small sensors such as the two mentioned earlier. Barbara's Nikon cameras have the crop factor so she uses Nikons fine 12–24 mm with excellent results.

Turn the sun into a star by including the sun in the image, use the widest lens you have (a 15 mm here), stop the lens all the way down to f/22, and underexpose the sky to make the sun more dramatic.

Wide angles have other problems too. They are extremely prone to creating flare which are hot spots in the image from light bouncing around inside the lens. Always use a lens hood (shade) that is made for the lens to reduce this problem. Using a filter such as a polarizer may cause vignetting which reveals itself by making the corners of the image dark. This happens because the extremely wide angle of view sometimes let's the lens "see" the edge of the filter. Special thin filters can be purchased for wide-angle lenses to reduce this problem. If you use a camera with a crop factor and use a wide-angle lens that is designed to be used on a full-frame sensor or 35 mm camera, then you probably won't have this problem because the sensor is cropping out the corners already. If the lens is designed for use only on cameras with small sensors, then vignetting is more likely.

Standard Lens

The 50 mm lens is known as a standard lens. These are often included when you buy a new camera as a kit. These lenses are inexpensive, but deliver high-quality results. Some of these have extremely large apertures such as Canon's 50 mm f/1.4 lens. The large aperture is excellent for shooting hand-held with available light and the shallow depth of field at f/1.4 easily throws the background out-of-focus. These are fine lenses, but so many zoom lenses cover the 50 mm range that most photographers (including us) haven't owned one in years.

Medium Telephoto Lenses

These lenses include focal lengths in the 85–135 mm range. They are terrific for portraits because they offer extra working distance and the smaller angle of view makes it easier to isolate the subject from the background. They work well for landscapes and wildflowers. Most nature photographers don't own prime lenses in this range anymore because so many quality zoom lenses cover this range and more. These focal lengths are important to have, but we cover it with 70–200 mm zoom lenses. There are many zoom lens choices that cover this range so take your pick. Some zooms such as the 28–300 mm lens cover an extremely wide range of focal lengths. While it is appealing to cover so many focal lengths with one lens, you are out of luck if the lens malfunctions. If you go on expensive photo trips, it is wise to have a couple lenses with overlapping focal lengths so you can keeping shooting should problems arise.

Telephoto Lenses

Focal lengths between 135 mm and 400 mm are included in this range. These lenses are incredibly useful in nature photography because the longer focal lengths magnify the subject giving you bigger images of wildlife. Telephoto lenses let you shoot down on the landscape to isolate a small section of the scene too. While many photographers feel you must have super telephoto lenses to photography wildlife, this is not true much of the time. There are lots of places in reserves and parks where wildlife is habituated to humans so they can be approached easily. Some animals such as moose and elk are easy to photograph with these lenses from a good distance away because the animal is so large. If your camera has a crop factor and most do, then this makes your telephoto lens into a super telephoto lens. Plenty of long zoom lenses are made that reach the 400 mm focal length. If your crop factor is 1.6x, this makes the lens give you the magnification of a 640 mm (400 mm \times 1.6)

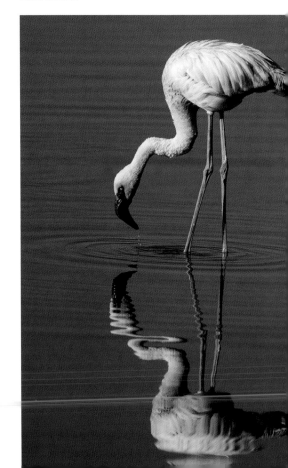

Long telephoto lenses in the 500 mm range are terrific for wary animals like this Lesser Flamingo at Lake Nakuru.

lens! Of course, the lens really doesn't have a focal length of 640 mm because the apparent magnification is really a cropping of the image due to the small sensor. Still, it is comforting to see big images of your wildlife subjects in the viewfinder and the image quality is terrific.

Here's how we cover this range. I use Canon's 100–400 mm f/4.5–5.6L lens. It works well and is acceptably sharp at all focal lengths thanks to the special glass used in the lens. However, I do wish it wasn't a push/pull zoom and would prefer a constant maximum aperture f/4. Barbara uses Nikon's 80–400 mm f/4.5–5.6 with excellent results. These lenses cover a wide range of image possibilities and they are superb in Kenya for wildlife photography where you must stay in the vehicle or be eaten by lions, a strong incentive to stay in the vehicle. Anytime you must remain in a fixed position such as a vehicle or hide (blind), a zoom lens is terrific so focal lengths can be easily changed as wildlife moves closer or further away. Another wonderful Nikon lens that covers this range that Barbara uses (and I wish Canon made) is the 200–400 mm f/4 zoom. This constant maximum aperture f/4 lens is fast at all focal lengths and sharp. It auto-focuses quickly too which is important in wildlife photography. Unfortunately, it is expensive, heavy, and won't work with my Canon cameras or I would be using it too.

You don't need to buy the most expensive lenses or cover every focal length either. Much less expensive lenses that deliver quality images include 70–300 mm, 75–300 mm, 100–300 mm, and 135–400 mm. Many zoom lenses are made to cover these focal lengths so there are plenty of choices to accommodate all budgets.

Super Telephoto Lenses

These huge and expensive prime lenses are used by most professional and serious amateur nature photographers. Super telephoto lenses begin at 400 mm and go up from there. These lenses gather lots of light with speeds of f/4 and sometimes f/2.8. The fast lens speed helps you shoot sharp images because it is easier to use fast shutter speeds in the 1/250 to 1/500-second range. Due to the large aperture at f/4, these lenses are terrific in dim light too. Super telephoto lenses greatly magnify the subject and provide plenty of working distance which is especially critical in wildlife photography. Working distance is the distance between the front of the lens and the subject. The more working distance you have between you and the animal, the less chance of frightening it.

Super telephoto lenses have lots of magnification. Divide the focal length of the lens by 50 mm to determine the magnification. A 500 mm lens magnifies the subject by 10x (500 mm divided by 50 mm equals 10) and a 600 mm magnifies by 12x. These figures assume you have a full-frame sensor. Since most digital cameras have a crop factor due to the small sensor being used, multiply the lens focal length by the crop factor and divide that by 50 to get the magnifying power of the lens. Here's the math with a 500 mm lens and a digital camera body that has a 1.6x crop factor. Multiply 500 by 1.6 which equals 800. Dividing 800 by 50 shows you have a 16x lens. That's a lot of magnification!

A field hide (blind) confines you to one spot. A fast focusing zoom lens that covers the 200–400 mm range is ideal for photographing these male prairie chickens fighting so you can change the composition quickly.

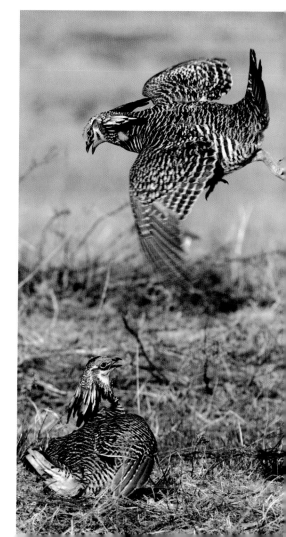

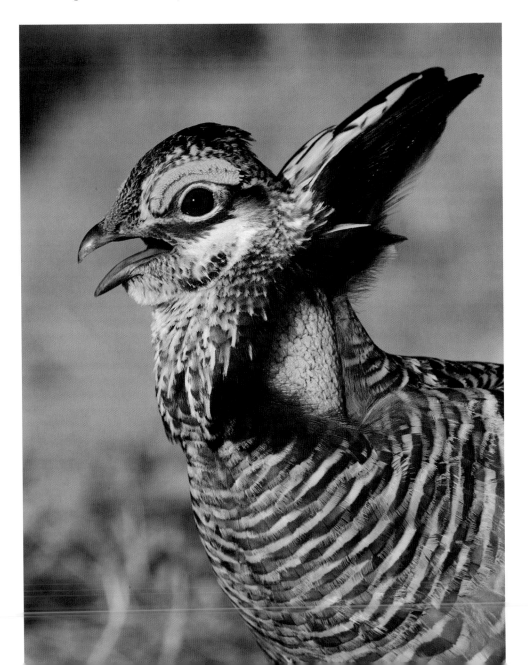

Unfortunately, high magnification also magnifies camera and lens vibration causing unsharp images. Your technique with these lenses must be flawless or you won't get sharp images. You'll need to use heavy tripods and heads, focus carefully, and favor high shutter speeds even on a tripod to consistently produce sharp images.

Both Nikon and Canon build 500 mm f/4 and 600 mm f/4 lenses. Canon offers three prime 400 mm lenses and Nikon has the enormous 400 mm f/2.8. These are ideal lenses for wildlife, especially for bird photography where the extra magnification comes in handy for small birds. Barbara uses Nikon's 500 mm while I use Canon's 500 mm lens for a great deal of our wildlife photography whether it is an elk bugling during the fall in Yellowstone, shorebirds on a Florida beach, or finches mobbing our spring feeders. Most other manufacturers don't make prime lenses in these focal lengths, but Sigma does offer a 500 mm f/4.5 that can be used with most camera systems. The large number of choices offered by Canon and Nikon is one reason their equipment dominates the wildlife photography field.

Special Lenses
Tilt/shift lenses

A few unique lenses offer view camera controls for digital SLR's. Canon makes three tilt and shift lenses that include the 24 mm,

Lenses that focus closely make it easy to take portraits of the prairie chicken when they are next to the hide. Back-button focusing is enormously useful for shooting sharp images.

45 mm, and 90 mm. Nikon makes an 85 mm perspective control lens too. These are expensive lenses in the $1000 range, but they offer benefits to the nature photographer that are important. These lenses are made so they can actually bend in the middle (tilt) and also shift position relative to the sensor. All of these lenses can tilt and shift which are two separate lens movements that solve different problems. One small drawback to these lenses (besides the price) is they do not autofocus.

Let's consider shifting a lens first. If you photograph a group of trees or perhaps a lighthouse by pointed the camera up, the vertical lines at the top of the viewfinder lean in. These leaning vertical lines are unnatural, distracting, and usually unwanted. Instead of pointing the lens up at the subject, point the lens so the optical axis is parallel to the ground. The top of the subject is cut off. Now shift the lens so the top is no longer cut off. Your vertical lines remain vertical. This effect and the amount of shifting that is needed are easily determined by watching the scene through the viewfinder.

I own Canons 45 mm and 90 mm tilt/shift lenses because the tilt feature is enormously useful in nature photography. Suppose you want to photograph a gorgeous field of sunflowers. If you are shooting at a 45-degree angle to the plane of the sunflowers in the field, you'll have trouble getting all of them sharp at f/22. Even if stopping down all the way to f/22 does provide adequate depth of field to cover all of the sunflowers, it forces you to use a fairly slow shutter speed. This makes it impossible

to shoot sharp images if it is breezy. A tilt lens easily solves this problem because it can bend in the middle or tilt. Normally you get the best use of your depth of field when the subject plane and sensor plane are parallel. But, tilting a lens rotates the plane of focus so it perfectly covers a field of flowers even when shooting at a 45-degree angle to the plane of the field. A tilt lens does not give you more depth of field. Instead, tilting the lens let's you decide exactly where you want the plane of focus to fall on the subject. By using the tilt control, these lenses are enormously beneficial for making sharp images of large patches of wildflowers, herds of wildebeest, autumn leaves floating on a pond, waves crashing on a beach, penguin colonies, shiny raindrops on a leaf, and many other subjects where you want to shoot at an angle to the main plane of the subject. As with the shift control, the separate tilt control is easy to adjust to get it perfect because you can see the effect though the viewfinder. It just takes a little practice.

As I mentioned, Canon makes three tilt and shift lenses which include the 24 mm, 45 mm, and 90 mm focal lengths. Which ones are most useful for nature photographers? In my opinion (which might not be right for everyone), the 90 mm tilt/shift lens is the most useful. The 90 mm is a short telephoto that magnifies the subject so depth of field is more limited which is solved by tilting the lens. I love photographing sand dunes at dawn or dusk such as those found in Death Valley National Park or waves crashing on a rocky shoreline. In both cases, the 90 mm tilt/shift lens is perfect for the

situation. The 45 mm is fine for landscapes and works wonders on penguin colonies, but how many penguin colonies do you expect to visit? The 24 mm tilt and shift lens already has a lot of depth of field because the short focal length reduces magnification so having better control of where the plane of focus lies isn't so critical. But, if you photograph a lot of buildings or tall trees, the shift feature is handy for keeping the vertical lines in the scene vertical in the image.

Macro lenses

These terrific lenses are specially made to focus much closer than other lenses making high magnification closeup and macro images easy to do. The common macro lenses available include 50 mm, 100 mm, and 200 mm. All of these lenses are designed to be exceptionally sharp at very close distances, although they can be used for landscapes as well. We'll cover these lenses in detail in a chapter on closeup photography.

ACCESSORIES
Lens Hoods

You'll get the best quality from your lens by using hoods to shade the lens all the time. Without the lens hood, light could strike the glass at an angle which isn't focused by the lens. Instead, it bounces around inside the lens creating unwanted flare which makes images appear washed out (fogged) or shows up as overexposed blobs (I think that is a technical term) with no detail. Whenever possible, always use a lens hood!

Many lenses arrive with a lens hood when you buy the lens. Unfortunately, some lenses don't come with a lens hood so find out if the lens hood comes with the lens anytime you buy a lens. If the lens doesn't come with the hood, be sure to order one because you need it. Always buy the lens hood from the lens maker if possible. Buying from them should eliminate mounting and vignetting problems that are possible with generic hoods from other companies. Don't use a hood on a lens it wasn't made for. If you mount a lens hood that was made for a 70–200 mm zoom on a 24–70 mm zoom, you most likely will find a vignetting problem at the short focal lengths because the angle of view at 24 mm "sees" the edge of the hood causing dark corners.

In addition to eliminating stray light, lens hoods do a lot to protect the lens from rain, sand, snow, twigs, and other obstacles that can scratch the lens. Lens hoods are good insurance for protecting the lens. Although it is wise to use lens hoods, there are times when it is best to not use them. If you must photograph in high wind (avoid if possible) and blowing sand is not a problem, consider skipping the lens hood because it catches the wind causing image softening vibration. By using only the lens on a sturdy tripod, hanging on to everything, blocking the wind with your body as much as possible, and shooting at the highest shutter speed possible, you have a chance to shoot sharp images. Another time when it is easier to skip the lens hood and not suffer any serious harm to your images happens when you are using a polarizing filter. If light is coming from behind you so it can't strike the lens from the side, it might be okay to omit the lens hood. Polarizing filters are the most useful filter to digital photographers so you want to use them a lot. However, to use them properly, they must be rotated while mounted on the front of the lens to get the right angle so polarized light is reduced. On some lenses, when the lens hood is attached, it is virtually impossible to reach in from the front and turn the polarizing filter. You have two choices. You might remove the lens hood, turn the filter to the best position, and put the lens hood back on which is what we do. You could also omit the lens hood in situations where the chances of flare are minimal.

Teleconverters

A wonderful way to own a super telephoto lens without buying one is to use a high-quality teleconverter (sometimes called tele-extender or extender) made by the lens manufacturer. Most camera systems make teleconverters for their lenses. Teleconverters boost the effective focal length of the lens they are put behind by the power of the teleconverter. Placing a 1.4x teleconverter between a camera body and a 300 mm f/4 lens converts the lens into a 420 mm f/5.6 lens. The 2x teleconverter doubles the focal length so the lens becomes a 600 mm f/8 lens. The quality is quite good, though you do lose some sharpness since you are introducing more glass to the optical path. Naturally, the 1.4x loses less sharpness than the more powerful 2x teleconverter. Unfortunately, you do lose lens speed too. The 1.4x teleconverter eats one stop of light and the 2x gobbles up two stops. Since the lens is slower, it is harder to use fast shutter speeds.

Let's look at the magnification produced by teleconverters a little closer. Does a 2x teleconverter double the size of the subject? Suppose you are photographing a robin singing on a rosebush. With a fixed 300 mm lens, the height and width of the bird on the sensor is 1/4 inch. Now add the 2x teleconverter and the height doubles to ½ inch. Is the size of the bird on the sensor twice as big. No! The 2x teleconverter doubles the width too. If the bird's image on the sensor was originally 1/4-inch wide, its size on the sensor is now ½ inch by ½ inch. The area is four times larger so the 2x teleconverter quadrupled the size of the robin in the image. The 1.4x teleconverter really tends to double the area of the subject while the 2x quadruples the area. I mention this because teleconverters magnify the size of the subject much more than you might first suspect. I think it is best to start with a 1.4x teleconverter to see if that is all you need. It will be sharper than the more powerful 2x teleconverter and probably less expensive too.

Teleconverters do have their drawbacks. They don't couple with all lenses and may not be compatible with zooms so make sure any teleconverter you consider buying actually works on the lens you plan to use it on. Also, teleconverters cost you light. This makes it more difficult to use the highest shutter speeds, the viewfinder is darker, and many lenses will not autofocus if too little light is passing through the lens which can happen, especially with 2x teleconverters.

MAINTAINING YOUR LENSES

The lens is literally your writing tool. It gathers the light and focuses it. The glass elements in the lens must be properly aligned and clean. Lenses are tough, but don't bang them into things and never drop a lens. Lenses are full of fragile parts so impacts cause damage.

Lenses are like cats, they both hate water. Never let water get inside the lens so mini-

Cameras don't like water, but many fine images can be made in the rain. This Gerenuk in Samburu National Park is waiting out the rain under the only cover it can find. Rain adds a wonderful mood to images so use it carefully whenever you can.

mize exposure to rain, condensation, and especially salt spray. All of these things are hazardous to the health of your lens. It is true you can let some water gather on the outside of the lens for short periods of time without any harm if you put the lens away dry. Lenses are rather impervious to dry snow (wet snow should be avoided) because it bounces off the lens.

Keep the glass in your lens perfectly clean. Preventing dirt from finding its way on the lens in the first place is much better than cleaning it off. Always use lens caps on both the front and rear when the lens isn't mounted on the camera body. Never let an uncovered lens point straight up for any length of time so dust can't settle on it. Never touch the glass with your fingers because the oil on your skin is more difficult to remove.

Every time you use a lens, always check the glass surface for any dust, smudges, or dirt. Most of the time you will find something on the glass that shouldn't be there so always clean it off. First, use a soft lens cleaning brush to remove loose grit from the surface. Point the lens down while gently brushing the lens to let gravity help you remove the dirt. Carefully check the lens again to make sure all of the grit is gone. If not, repeat the process. By the way, it helps to keep the brush protected from grit too. A plastic bag or it's own case works wonders to keep the brush clean. Using a small vacuum to suck dust off the brush from time to time is worthwhile too. If all of the dust and dirt is removed from the lens, go ahead and mount the lens hood and you are ready to shoot. If you notice any smudges on the

glass surfaces though, brushing the lens won't help. You'll need to use a micro fiber cloth to gently rub the lens beginning in the middle and work your way out to the edges of the lens. Move the cloth in a circular motion. A micro fiber cloth is specially made to clean optical glass surfaces and does a great job of it. If the smudge is still present, try using lens cleaner solution applied directly to the micro fiber cloth (not the lens surface) and rub again. This nearly always does the trick. A word of warning, never use the micro fiber cloth first to clean the lens. Always use the brush first because the last thing you want to do is use the cloth to grind the lens with a bit of grit. The lens has already been polished by the manufacturer, you paid good money for this service, and there is no need to "improve" on the process. You'll likely end up scratching the lens.

Don't forget about keeping equipment that you might add to the lens spotlessly clean too. Filters and teleconverters are used in the optical path so they must be clean. Many people use UV protection (or skylight) filters to keep dirt away from the lens and to protect it. These filters should be kept clean too. The UV filter does add some protection, but we haven't owned one in 25 years. Any glass filter degrades the image slightly which normally shows up as a slight loss of sharpness and contrast. By being careful, I have only damaged a couple of lenses (by dropping them) and a protection filter would not have helped. Besides, we normally are using polarizing filters anyway so that filter offers protection just like a UV filter would.

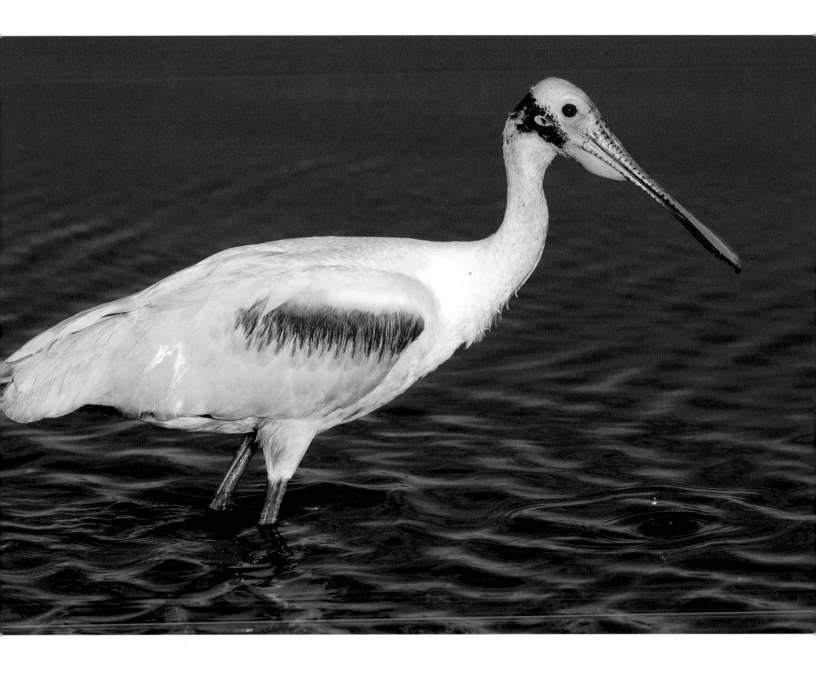

Shoot Sharp Images Consistently

Nature photography is an enormously fulfilling hobby. As your ability grows, you may decide you want to sell images to books, magazines, and calendars. Perhaps you want to enter images in the photo contest at the State Fair or the local camera club. To be successful, you'll need beautiful images that are sharp! Producing critically sharp images is harder than most photographers realize, so it is necessary to develop excellent shooting habits to succeed.

USE A TRIPOD

Tripods are needed by everyone to produce the best possible images. Unfortunately, far too many people buy inexpensive tripods that are difficult to use and not very stable. A bad tripod is really worse than no tripod at all. On the other hand, a good tripod is a joy to use.

Tripods enable you to shoot sharp images at any shutter speed whether it is a 4 or 1/125 second exposure. Using a tripod gives you choices. You can shoot in any kind of light no matter how dim. You can use any aperture to control the depth of field. Suppose you are photographing a dragonfly on a dewy dawn morning; the exposure might be 2 seconds at f/16. With a tripod, it is easy to shoot a sharp image.

Tripods are beneficial because they support the camera and lens. This frees your hands to hold a reflector, diffuser, or a flash to take the photograph. This simplifies manipulating the light with these devices to make the best image. Tripods do slow you down, but that is wonderful news! The more time you spend with a worthwhile subject, the more likely you'll discover the finest viewpoint or composition. Tripods give you time to study the composition in the viewfinder so you can be sure it's what you want.

LEFT: This gorgeous Roseate Spoonbill was feeding in a ditch in South Florida. Monitor the histogram and highlight alert to avoid overexposing the light feathers.

Dragonflies coated with dew are found only when the light is dim. A tripod must be used for sharp images and so the lens can be stopped down to f/11 or f/16 for adequate depth of field to cover the dragonfly.

TRIPOD CHOICES

Most nature photographers use Gitzo tripod legs or Manfrotto. Both of these companies are leaders in tripod technology and continue to improve their products. However, there are many companies making tripods so don't limit yourself to only these two.

RECOMMENDED TRIPOD FEATURES

1 Sturdy enough to support the largest lens you own
2 The legs must spread straight out so the camera can be supported close to the ground
3 The centerpost should be short
4 The legs locks must be easy to use and work smoothly
5 Fresh water should not damage the legs
6 When the legs are fully extended, you should be able to peer through the cameras viewfinder without stooping over

Your tripod should be sturdy so it needs to have some weight to support heavy lenses and camera bodies. Many good tripods are made from aluminum. However, some that are lighter, but still solid are made from basalt and carbon fibers. These are a joy to use, but more expensive than similar sized aluminum tripods. We have used Gitzo 1340 tripod legs for many years. A few years ago, we began using the more expensive Gitzo 1325 carbon fiber tripod with excellent results. Both tripods easily support 500 mm lenses. If you don't have a lens that big, then a similar model that is slightly smaller is fine for your needs.

Nature photography often involves photographing mushrooms, lichens, salamanders, frogs, insects, and tiny wildflowers.

All of these subjects tend to live on or near the ground. A tripod that permits you to photograph easily near the ground is absolutely necessary. Some tripods like the two mentioned above are designed so the legs can be angled straight out making it possible to lay the tripod right on the ground with the three legs splayed out flat. This permits shooting near the ground. Nature photographers must have this feature!

The tripod should have a short centerpost, rather than a long one, so it doesn't interfere with its ability to go close to the ground. If the centerpost is long, even if the three legs can be positioned straight out, you can't get near the ground because the long centerpost is in the way. A short centerpost or a long one that can be easily shortened (usually unscrewed) is the best way to proceed. The Gitzo 1325 and 1340 tripods work well because they come with a flat plate, so there is no centerpost at all.

However, due to the ease of stitching digital images together, many photographers now shoot panoramic images where they must be able to level the tripod first and then level the camera. It is tough to level the tripod on uneven ground. It can be done, but it takes a lot of fussing to do it. A quick way to level the tripod is to replace the flat plate with a Gitzo G1321 leveling base. This does have a short centerpost, but still works

This monarch butterfly spent the night sleeping on the gray-headed coneflower. All close-up subjects like this can benefit from the use of fill-flash or reflectors to lower contrast. Since the tripod is supporting your camera, you now have a free hand to hold a flash, reflector, or diffuser.

well for shooting near the ground and it is super for leveling the tripod.

The tripod legs should be able to be positioned at all different angles. This makes setting up the tripod on uneven ground much easier. The Gitzo tripods already mentioned have three different positions where the legs can be locked in place. If you are careful, you can use intermediate positions too.

The legs locks must be smooth and easy to use. The Gitzo 1325 excels here and it is the main reason we prefer this model over the Gitzo 1340. Some tripods, such as those by Manfrotto have a lot of nuts and bolts in the leg-locking mechanisms that tend to loosen up after awhile. These aren't quite as convenient to use since they need to be tightened from time to time.

It's helpful if you can use your tripod in fresh water. In the past, some parts of the locking mechanism on some tripods were made with cork which swelled up as soon as they got wet. This made it difficult to adjust the length of the tripod legs. Now most washers are made with materials that don't absorb water. Fresh water isn't too hard on tripods. However, salt water can ruin a tripod in short order. If you must use a tripod in salt water, consider using a junk tripod that is just good enough to get the job done. Since it is in bad shape already, the salt water doesn't do too much additional harm to it. Even then it is wise to rinse the tripod off in fresh water as soon as possible.

Tripods hate sand. Getting sand in the leg-locking mechanism is a sure way to damage your tripod. Always extend the lowest legs several inches first to get the leg locks out of the sand. Letting sand get into your tripod leg locks is going to cost you money! Please read that last line one more time and consider yourself warned.

Your tripod should have long enough legs so you can place the camera at eye level without having to use a center post. While you don't want to take every shot at eye level while standing, it is convenient not to have to stoop over to see through the viewfinder because the tripod legs are too short. However, you might want to consider a smaller tripod to reduce the weight if you do a lot of long-distance hiking or use horses to photograph the backcountry.

CARRYING THE TRIPOD

Some photographers attach their tripod to the camera bag which is designed as a backpack. We have tried it this way, but found the tripod banged around too much. We prefer wrapping bicycle handlebar tape around the upper section of the tripod. This rubber barrier reduces heat loss in our hands when carrying the tripod on a cold day. The soft tape also cushions our shoulder from the metal where it rests as we hike along.

SPECIFIC TRIPOD CHOICES

When deciding what tripod to buy, always try to see it first at a camera store. If you can work the tripod controls before you buy it, you are more likely to get one that is perfect for your needs. Excellent tripods aren't cheap, but they last a long time if you take care of them.

I have used Gitzo tripods my entire career with superb success. I currently use three tripods, but most photographers can get by with one. I have a beat up Gitzo 1340 model that I only use for salt water or other terrible situations. My favorite tripod and the one I use 90% of the time is the Gitzo 1325 carbon fiber model. When using horses to reach photo destinations in the mountains, weight is critical, so I take the much smaller Gitzo G1226 tripod. One tripod I don't own, but would consider buying if I owned a 600 mm f/4 lens is the Gitzo 1548 carbon fiber. This tripod is huge, but it supports enormous 600 mm lenses well.

Manfrotto tripods work well too. Many nature photographers use the 3221 model successfully. Manfrotto offers numerous tripod choices and accessories. It would be worthwhile to contact both Bogen and Gitzo to get an overview of everything they offer.

No single tripod is right for everyone. The tripod that is right for you depends on how much you are willing to carry, what features you like, how heavy the camera gear is that you want it to support, and how much you want to spend.

TRIPOD HEADS

These are designed to support your equipment and make it easy to adjust the angle to get the perfect composition. Tripod heads come in a variety of shapes and sizes so you have many choices.

Tilt/Pan Tripod Heads

The two major styles of tripod heads include 3-way tilt/pan heads and ball heads. Tilt/pan heads are quite common. These heads are made so loosening one

control allows the head to tilt front to back. Loosening a second control lets the camera tilt from side to side. A third control permits panning the tripod head right or left. These heads do work, but because they have three separate controls, they are a bit cumbersome to operate, though many photographers do like them well. Popular heads of this type include Manfrottos 3047 and Gitzos G1272M. If you do decide to get one of these heads, make sure it is made to accept quick-release plates. This is absolutely critical.

Ball Heads

These heads are by far the most popular style used by nature photographers. This simple head is made so a single control loosens a ball permitting the camera to tilt front to back, side to side, or panned left or right (when the camera is set for a horizontal shot). All good ball heads offer a second control so the camera can be panned when shooting vertical compositions.

Ball heads come in all sizes to handle everything from small cameras to heavy 600 mm lenses. Two companies that make wonderful ball heads are Kirk Enterprises and Really Right Stuff. We use Kirk Enterprises BH-1 and the slightly smaller BH-3 with excellent results. The BH-1 is necessary if you have a big lens to support, such as a 500 mm f/4 or 300 mm f/2.8. Since many digital nature photographers don't own such big lenses and don't need to with the digital crop factor they enjoy, the smaller and less expensive BH-3 works fine. Really Right Stuff builds a ball head that looks terrific, so check that out too. All of these ball heads are designed

for quick-release plates which are made by Kirk Enterprises, Really Right Stuff, Wimberley, and others.

Gimbal Heads

The Wimberley gimbal style head is the best for making images of wildlife action. The Wimberley head or Kirk Enterprises Cobra head are unusual looking heads that are heavy and expensive. However, you can fasten a 600 mm f/4 lens with a camera body to it and balance it so the head doesn't need to be locked. Once the lens/camera combination is in perfect balance, the head allows you to pan or tilt the camera easily, so flying geese are fairly easy to photograph well. If you let go of the camera, it maintains its position without locking the head!

However we seldom use these heads. Instead, we use the Wimberley Sidekick which converts the Kirk BH-1 ball head into a gimbal style head. This does the same thing as the bigger Wimberley Gimbal Head or Kirk Enterprises Cobra, but it is lighter and easier to carry. When photographing hummingbirds feeding on flowers, we always use the Wimberley Sidekick so we can easily move the camera left, right, up, or down to follow the hovering hummingbird as shown in the figure. The huge drawback in using the big gimbal style heads is they don't work very well with short lenses. A small ball head is far more suitable for photographing wildflowers.

If you plan to photograph wildlife action and other subjects, you need to carry a small head in addition to the huge gimbal

The Wimberley Sidekick converts our Kirk BH-3 ball head to a gimbal style head. When the camera is balanced on this type of head, you can move the camera left, right, up, and down without locking it in place. This makes it simple to track moving subjects like this male rufous hummingbird.

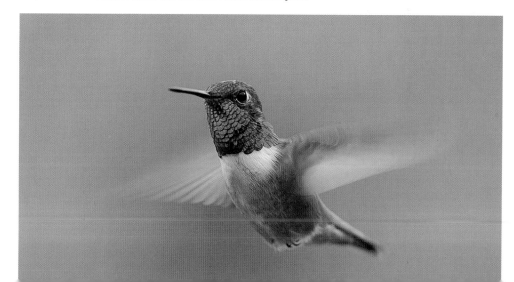

heads. It is too much to carry. Since we tend to photograph everything, we find it is best for us to use the Kirk ball head and carry the light Wimberley sidekick to use when we need it. If we only photographed wildlife, we would use the big gimbal heads.

TRIPOD ACCESSORIES
Quick-Release Plates

You'll enjoy using tripods more if the tripod head is made to accept quick-release plates. These plates fasten to the bottom of the camera body or to the lens collar that is found on some lenses. Once the plate is attached to your equipment, leave it there. Then it is a simple matter of sliding the quick-release plate into the locking jaws of the tripod head and tightening them so the equipment is solidly attached. Quick-release plates speed up the process of attaching or removing camera gear from the tripod.

However, a number of tripod heads and quick-release designs exist, so make sure the plates you get and the tripod heads are compatible. All of the plates we use are custom-made for a particular camera body or lens by Kirk Enterprises. Custom plates work better than generic plates that are designed to be used by everything. A custom plate is designed to let you access all of the nooks and crannies of the lens or camera body without having to remove

It is easier to shoot vertical images on top of the tripod head without flopping the head off to the side. The L-bracket works wonders for this purpose and greatly simplifies composing these autumn maples.

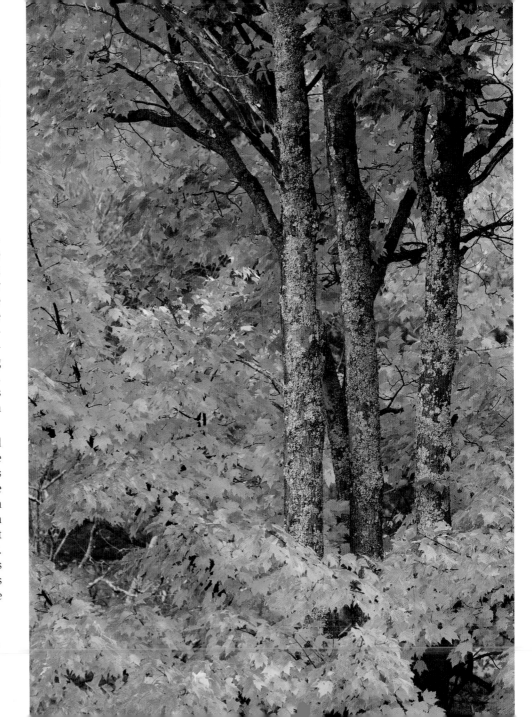

the plate. That is important. Imagine using a plate that had to be removed every time you need to change the batteries in your camera. Many plates have edges on some sides to prevent the plate from loosening when you use it.

L-brackets

This wonderful bracket is designed to attach to the bottom of the camera. Of course, it looks like an "L", but it really is a special quick-release plate that can be attached to the tripod with either side of the bracket. This makes it possible to mount the camera body vertically or horizontally on the tripod head, eliminating the need to flop the camera off to the side every time you shoot a vertical composition. This makes shooting vertical compositions much easier. Buy a custom L-bracket that is made specifically for your camera body so you have quick access to all of the controls on the camera. Kirk Enterprises makes many custom L-brackets for most of the popular camera bodies.

Tripod Problems

We have spent quite a bit of time exploring equipment that works well on your tripod. Although tripods help you shoot sharp images, you must use them properly in the field. Do not assume your tripod can't move. Setting up a tripod in a stream

When working around water such as Chapel Creek in northern Michigan, keep tripod legs on solid ground or rocks. Tripods are easily vibrated by flowing water causing unsharp images.

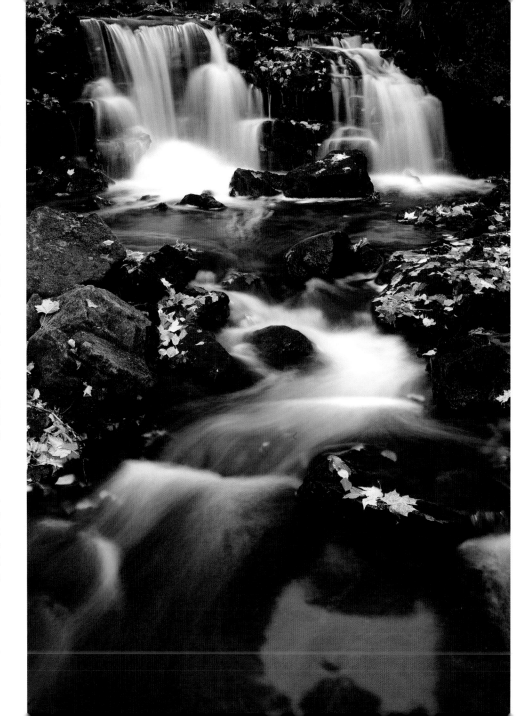

where the water is splashing against the legs causes the tripod to vibrate making sharp images impossible. It is fun to shoot in the middle of a small stream as shown in the figure, but set the tripod legs so they are either in calm water or on top of stable rocks or logs.

Wind makes tripods shake too. If you don't believe it, just set up a 300mm lens on a tripod in a 10mph breeze. Without touching the tripod, peer through the view-finder and you will certainly see the image shaking. This wind-induced vibration causes soft images. If you must shoot in the wind, it is best to turn on the image stabi-lization (if you have it), grab the camera and lens, and shoot with the highest shut-ter speed possible. The very act of grabbing the camera adds your body mass to the sys-tem which helps to minimize camera shake caused by the wind. By using fast shutter speeds such as 1/250 second, you have a real chance of getting sharp images.

Shooting Hand-Held

There are times when tripods are difficult or impossible to use. Shooting hand-held is necessary and can be effective. But, in no way do I want to convey the idea that tripods are really optional devices most of the time. They aren't, but there cer-tainly are times when you have to shoot without them.

Many wonderful images can only be made from a boat. Anytime you are pho-tographing from a boat that is rocking in the waves, forget the tripod. It makes the images even more unsharp. From leopard seals resting on ice in Antarctica to pho-tographing the gorgeous shoreline along Pictured Rocks National Lakeshore in northern Michigan, it is far more effective to shoot hand-held with fairly short lenses (if possible) while favoring high shutter speeds to minimize any negative effects from camera movement.

Tripods can often be omitted when shooting in deep snow too. Tripod legs don't penetrate the snow easily and they are prone to slipping. Do use a tripod any-way if you are shooting big lenses like a 300mm, but you can get away with shoot-ing short lenses in the wide-angle range without a tripod if you favor fast shutter speeds. I did a test and could find no dif-ference in sharpness between using a tri-pod or shooting hand-held when I use a 24mm lens to photograph a forest of snow-encased trees with a shutter speed of 1/125 second. As a result of that test, I commonly shoot wide-angle lenses hand-held if I have plenty of shutter speed. Due to the excellent results that digital cameras produce at ISO 200-400, it is easy to get enough shutter speed most of the time in bright light to shoot sharp images hand-held with wide-angle lenses.

Another place where it is necessary to shoot hand-held is high-magnification macro photography in the field. When pur-suing animated subjects like small insects or tiny frogs, often it is necessary to use flash and shoot hand-held. While the camera might be set to sync speed which is the fast-est shutter speed you can use with flash, the short flash duration (usually around 1/1000 second) eliminates camera movement.

Image-Stabilized Lenses

Most camera systems offer ways to stabilize the lens while shooting hand-held. Canon builds some lenses that have IS (image-stabilized) technology. Nikon offers lenses with VR (vibration reduction) capability to help you shoot sharp images without a tripod. These lenses are made so some optics move to counteract any movement of the camera producing sharper images. Other companies are beginning to offer this capability too. Some systems build camera bodies where the stabilization fea-ture is built in the body, not in the lens. All of these systems have merit and do work. Image stabilization helps all of us make sharp images hand-held at slower shutter speeds than would otherwise be expected. Normally, photographers consider it safe to shoot hand-held if the shutter speed is at least as fast as 1/focal length. To illustrate this concept, a 300mm lens should have a minimum shutter speed of 1/300 sec-ond while you could get by with a shutter speed of only 1/20 second with a 20mm lens. If you have this stabilizing technol-ogy, it is possible to achieve sharp results if you use a somewhat slower shutter speed. It is debatable, but some feel you can use shutter speeds three to 4 stops slower than you would normally use. For example, with a 300mm lens, you could shoot at 1/75 second if the image stabilization feature is being used.

Image-Stabilizing Techniques

Image stabilization is terrific for those times when you can't use a tripod. Since I often photograph from a rocking boat in

Michigan, my Canon IS lenses are helpful for shooting on the choppy waters of Lake Superior. But, this wonderful technology should not be used as a crutch. Too many people use image-stabilized lenses and shoot hand-held when a tripod could easily be used. It doesn't make any sense. The tripod not only helps you make sharp images, but it holds your equipment in place so you can compose thoughtfully too.

Generally, it is not advisable to have the image-stabilizing mechanism turned on when shooting on a tripod if the camera is perfectly still. Image stabilization is trying to minimize camera shake. If there is none, it may hunt looking for shake and cause some of its own. On the other hand, image stabilization works wonders on a tripod if wind is causing the camera to vibrate a bit. Be aware that image stabilization only helps to reduce camera movement, not subject movement. You'll need more shutter speed or flash to solve subject movement.

Getting Sharper Results

Lenses write with light, so buy the best you can afford. Your camera manufacturer offers excellent lenses. But, you can save money by buying lenses made by some independent companies such as Tokina, Sigma, and Tamron. Since they make lenses that can be used on different systems such as Canon, Nikon, Pentax, Olympus, Sony, and Sigma, they sell to a larger market so they charge less for their fine products. Using these lenses is a good way to go if you wish to save money or your camera maker doesn't build the lens you want.

Since lenses are designed with computers and lens makers have a lot of experience at making them, you can expect your camera manufacturer to offer quality lenses across the board. However, some lenses in your camera system may be more expensive because they are made with special glass that delivers exceptionally high quality. Canon designates their best glass with the letter "L" while other companies use different letters. Is it worth the extra money for these lenses? It is unlikely the vast majority of photographers could tell if an image was shot with a regular lens or the fancy lens with the finest glass. Unless your technique is flawless, you probably couldn't tell. I tend to buy the best glass, though, because I hope it will help me. These lenses often have a larger maximum aperture, focus faster, and focus closer which are all appealing to me.

Keep Lenses Clean

To get the very best quality, your lenses should be as clean as possible. You'll get better contrast and sharpness if your lenses are spotless. Make sure no smudges from your fingers or dried water drops are present on the glass surface too. Keep everything clean!

Avoid Using Protection Filters

Any glass filter inserted into the optical path is bound to slightly reduce image sharpness. Most serious photographers don't use UV (protection) filters to keep the lens from getting damaged to avoid a small loss of sharpness which becomes more noticeable if you mount another glass filter, such as a polarizer on top of the "protection" filter. Unless it really gives you peace of mind, perhaps it is wise to eliminate protection filters. Just be careful and use a lens shade to protect the glass on the front of the lens.

Sharp Apertures

Not all apertures on the lens deliver the same quality. Most lenses are sharpest in the middle of the f/stop range around f/8. If you shoot at the widest apertures on the lens, such as f/2.8 or stop down to f/22 or f/32, you lose some sharpness due to optical limitations that all lenses have. This does not mean that you should not use these apertures, but you will get sharper images if you use intermediate apertures. If you don't really need maximum depth of field to photograph a subject, then use the sharpest apertures on your lens which fall in the f/5.6 to f/11 range. From my tests, sharpness is most greatly compromised by stopping down the lens too far. I avoid f/22 with short lenses because diffraction is so bad that quality is noticeably reduced and I would never use f/32 if your lens can be stopped down that far. However, f/22 isn't so bad with longer focal lengths because the physical size of the aperture is bigger which reduces the negative effects of diffraction.

Mirror Lockup

This is useful any time you are using a tripod to photograph a still object. Many cameras let you lockup the mirror prior to taking a photograph. You might be wondering why? When you want the

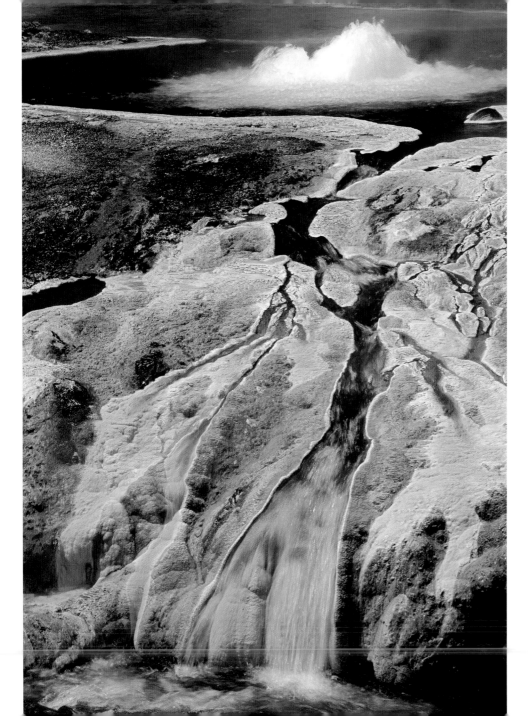

sharpest possible image, even the action of the mirror when it moves out of the way so the light can pass to the sensor causes the camera to vibrate a tiny bit that does reduce sharpness at certain shutter speeds. Years ago, I ran a test to determine how bad the "mirror-slap" problem was as it was called back in 1980. By shooting a series of images at different shutter speeds from 2 to 1/60 second and using a stamp with fine detail for a subject, I found the worst shutter speed for mirror-induced vibration was 1/15 second. The 1/8 and 1/30 second shutter speeds weren't too wonderful either. But, at higher shutter speeds like 1/60 second or slower speeds at 1/4 second and longer, the images got sharper. Can you explain why?

Let's suppose the movement of the mirror causes the camera to vibrate slightly for 1/15 second. With a 1/15 second exposure, the camera is vibrating during the entire time (100%), the image is being recorded by the sensor. If you use a faster shutter speed such as 1/60 second, the shutter is so quick that it freezes the vibrating camera so the images are sharper. Surely, the image is less sharp during a 1-second exposure. If the camera vibrates for 1/15 second from mirror-slap, and then settles down to be perfectly still for the duration of the 1-second exposure, the image is sharper because the camera is only vibrating for a portion

This colorful hot spring in the backcountry of Yellowstone National Park is a joy to behold. Locking up the mirror prior to the exposure and using the two-second self-timer delay delivers sharp images.

of the exposure. This means that during a 1-second exposure, the camera vibrates for about 7% of the exposure. Then the camera is perfectly still during the remainder of the exposure which represents 93% of the time, so the image is sharper.

If your camera doesn't have mirror lockup, then your best bet is to avoid using shutter speeds in the 1/8 to 1/30 second shutter speed range or use flash as the primary light source. Shutter speeds that are faster or slower are fine to use. Do read your camera manual carefully to see if mirror lockup is possible. Often a custom function controls the mirror lockup function.

Firing the Camera

In most cases, when photographing subjects that are still such as a mushroom or landscape, it is worthwhile to use mirror lockup to eliminate camera vibration caused by the motion of the mirror. With the camera mounted on the tripod and mirror lockup enabled, it does you no good if you trip the shutter with your finger. Your quivering body will impart vibrations to the camera causing soft images again. Fortunately, there are a couple of easy ways to separate your body from the camera at the moment of exposure. One excellent way to do this is to use the self-timer. When the self-timer is activated, the camera counts a number of seconds such as 8 or 10 and then trips the shutter. The 10-second timer is fine if you want to be in the photo too. But, 10 seconds is a long time to wait if you want to photograph a landscape or mushroom and don't wish to be in the image. Fortunately, many cameras offer a choice of

self-timer delays such as 2, 4, or 8 seconds. We use the self-timer (set on 2-second delay) all the time to photograph anything that holds perfectly still. It is easy to do once you get used to it and sharper images are your reward for taking the time to do it.

Self-timer Problems

There are times when the self-timer isn't so effective though. Anytime you photograph where you are waiting for lulls in a steady breeze so the wildflower or dew-laden spider web you have selected is finally holding perfectly still, a self-timer becomes unworkable. Wind is the arch enemy of nature photographers. If you are waiting for a flower blossom to stop swaying in the breeze and it finally does, pressing the shutter to activate the self-timer won't help you much because there is no way to know if the flower will still be holding still seconds later when the self-timer finally runs down and the camera fires. You need the shutter to trip as soon as the subject holds still.

Cable and Remote Releases

Most cameras have a remote way to trip the shutter. Usually it is an electronic cable release that connects to the camera. With the cable release, watch the subject carefully until it is perfectly still. Then press the trigger on the cable release and the

The slightest movement of wind makes this Indian Paintbrush wiggle. Watch the wildflower carefully and use a cable or remote release to instantly trip the shutter when it is perfectly still.

image is taken instantly. Since the cable is flexible, any movement of your hand (within reason) when the release is tripped is not transmitted to the camera.

It is possible to get a remote release for some cameras where it isn't attached to the camera. These work well too and permit you to fire the camera quickly to take advantage of still conditions. Remote releases that don't connect to the camera are quite small and easily lost, so be careful with them.

RAW and JPEG Considerations

As discussed earlier in Chapters 3 and 4, your digital camera offers a choice of RAW and JPEG image files. Your choice does affect image sharpness. Shooting your cameras RAW file format gives you the most detail in the image because it is unprocessed data that hasn't been compressed. All JPEGs are compressed files that throw out some of the information collected by the sensor to make the files smaller. While image sharpness won't be that different between RAW and the highest-quality JPEG setting for small prints, it does make a difference if you want to make huge prints.

We always shoot RAW images, but sometimes we set our cameras to keep a RAW and the largest quality JPEG at the same time. Then we have a choice of either file. You can't go wrong in terms of image sharpness if you shoot RAW or both RAW and JPEG. If you decide to shoot JPEGs only, select the highest quality your camera offers. For instance, the Canon 20D camera offers seven different quality settings which include Raw, Large Fine JPEG, Large Normal JPEG, Medium Fine JPEG, Medium Normal JPEG, Small Fine JPEG, and Small Normal JPEG. Large Fine JPEG is the highest quality setting and Small Normal JPEG is the most compressed file so it is the lowest quality setting. Of the six JPEG settings, what do you choose? You could go with the lowest quality setting if you are desperately short of memory. But, if you have plenty of storage memory, does it make any sense? Perhaps it does if you know that all the images you take are going to be used where you don't need the highest

quality possible. Images that are used on a web site or emailed work with low-quality settings since you want the images to load fast and they still look good for these uses. However, high-quality image files are easy to convert to low-resolution files for use on the web so you have plenty of flexibility if you shoot high-quality (less compressed JPEGs) images to begin with. If you shoot the images with a low-quality JPEG setting, there is no way to accurately recreate detail that was discarded when the file was compressed. If you happen to get a terrific shot when shooting a low-quality JPEG, it is difficult to make a gorgeous large print because too much detail is missing. It's better to get the details first to preserve your options for using the image later on.

FOCUS CAREFULLY

It seems obvious that focusing is critical to producing sharp images, but poor focusing is one of the leading factors for soft images. Digital single-lens reflex cameras (SLRs) offer numerous ways to achieve sharp focus and you must be thoroughly familiar with the autofocusing features offered by your camera to make the most of them.

With most camera systems, there are two ways to focus the lens. You can rely on autofocusing or go to manual focusing. Autofocus is effective in most situations (but not all) and is the preferred way to focus among the majority of photographers. While I hate to admit it, autofocusing is more accurate and faster than I am and probably you too. You'll find autofocusing is the best way to obtain sharp focus for the vast majority of your images.

MANUAL FOCUSING

Before getting into the details of autofocusing, let's consider manual focusing. There are times when focusing the lens manually is the only way to effectively focus the subject. Some special lenses, such as the tilt/shift or perspective control lenses made by Nikon and Canon don't offer autofocus because the lenses are made to "bend" in the middle making it difficult to build a lens that can autofocus. Many cameras lose their ability to autofocus when too little light passes through the lens. This could happen in dim light or if you use an accessory, such as a teleconverter or extension tube that makes the maximum aperture too small. Another place where autofocus fails miserably is shooting in low-contrast situations such as a foggy scene. The autofocus mechanism must see contrast so it can focus on the edges. If the contrast is too low, the camera isn't able to autofocus. Shooting through vegetation is a huge problem for autofocus because it focuses on the first thing it detects such as the grass, rather than the face of a rabbit hiding in the grass.

Manual Focusing Techniques

Check the camera manual and look in the section under focusing to find out how to set the camera or lens to manual focus. Some systems have an autofocus on/off switch on the lens while others put the

RIGHT: Autofocus often focuses on objects in the foreground such as the grass in front of this marsh rabbit. Go to manual focus and carefully focus on the eyes of this bunny.

switch on the camera body. Once you have autofocusing turned off, you have to focus the lens manually.

Here are some tips for manually hitting sharp focus. Many cameras have a diopter adjustment for the viewfinder so the image is sharpest for your vision just like glasses. Be sure to adjust this control, so the image in the viewfinder is as sharp as possible. Manually focus the lens by turning a ring on the lens. The most common mistake many make is focusing on the whole subject, instead of an important part of the subject. Rather than focus on the overall shape of a mushroom, bird, or wildflower for instance, it is far better to carefully focus on the most important part of the mushroom, or the eye of the bird, or perhaps the stamens of the wildflower. Manually focusing on the most important part that needs to be sharply focused forces you to consider what is important and improves precision. Developing this habit of carefully focusing greatly improves the chances of securing sharp images. Unfortunately, the older we get, the more difficult it becomes to focus manually since our eyes don't work quite as well. This problem can be minimized somewhat by using faster lenses that have a maximum aperture of f/2.8 or more. The viewfinder is 2 stops brighter with a f/2.8 lens than a f/5.6 lens. Brighter viewfinders make manual focusing easier, plus the shallow depth of field you see in the viewfinder at f/2.8 makes the subject either pop into sharp focus or go instantly soft if you aren't focused properly.

Autofocusing

Good autofocusing lenses today are extremely fast and accurate. It's wonderful technology that makes some images, such as running cheetahs or flying birds fairly easy to photograph well. There is a lot more to autofocusing that you might think. I strongly recommend that you read the section about focusing in your camera instruction book carefully. It is full of information that is enormously useful.

Cameras generally have two ways to autofocus. They can focus on a subject and then stop focusing until you take the picture. Canon calls this one-shot AF while Nikon refers to it as Single Servo AF [S]. This works great for stationary subjects. Canons AI Servo AF or Nikons Continuous Servo AF [C] is terrific for sharply photographing moving subjects because the lens automatically tracks the subject keeping it in focus. This mode is by far the best for flying birds, running animals, and all other wildlife actions. Not only does it work well on moving subjects, but it is superb when you are moving too. If you are photographing from a drifting boat, continuous autofocus stays locked on the subject as the boat moves closer or further away from the subject.

I was photographing this Beisa Oryx standing under an acacia tree at Samburu using back-button focusing. Since my camera is always set on continuous autofocus, holding the back-button focusing control in gave me immediate continuous autofocusing so I could photograph this running oryx as it galloped to catch up to the rest of the herd.

USEFUL FOCUSING TECHNIQUES
Single Shot AF

Cameras that are set up in the default configuration which is what you get from the factory use the shutter button to initiate autofocusing. If the camera is set for single shot AF, all you need to do is point the active autofocus sensor that you see in the viewfinder (assuming you only have one selected) at the most important thing in the scene that should be in sharp focus and press the shutter button down half way. The lens instantly autofocuses on that spot. To take the photo, just press the shutter button all the way down. In most cases though, you will want to change the composition a bit. Continue to hold the button down half way, recompose the image to your liking, and then press the shutter button all the way to take the shot. This system works nicely if you are hand-holding the camera.

This method isn't nearly as convenient or useful on a tripod because you need to focus first, recompose, and then lock the tripod head into position so it slows you down. A bigger problem occurs when you trip the shutter of the camera. With many cameras, if you focus on the spot where you demand sharp focus such as the eye of a deer, recompose, and trip the shutter with a cable release, the image won't be sharp. The reason for this is recomposing may move the autofocus sensor off the face of the deer to a spot in the background. When you trip the shutter with the cable release, the autofocus is activated again and quickly focuses on the

background sending the deer way out-of-focus. Be aware of this possible problem and check your own equipment to see if using a cable release or remote device to fire the camera causes the camera to autofocus. If it does, the problem is easily solved by turning the autofocus switch off just prior to the exposure. It is easy to do, but turning the autofocus switch on and off all of the time is a nuisance. Your camera may (hopefully) have a better way to handle this which I will discuss shortly.

Continuous Autofocus

This mode is perfect for tracking moving subjects because the lens constantly changes focus as the subject moves closer or further away. Usually continuous autofocus is set someplace on the camera body. It could be a switch or selected by pushing a series of buttons. Continuous autofocus is also initiated by the shutter button. Let's say we are photographing Ruppell's Vulture descending on a lion kill in Kenya with a 300 mm telephoto lens. Set the camera to continuous autofocus, put the center autofocus spot on the bird as it approaches, and pan with it while keeping the autofocus spot on the bird. As the bird fills the viewfinder, hold the shutter down to take multiple images. Since the camera automatically adjusts the focusing distance as the subject distance changes, your chance of shooting a sharply focused image increases enormously. Just be sure to use a shutter speed such as 1/1000 second to freeze the action. Panning with a subject improves with practice. If the autofocus sensor "sees" the clouds behind the

subject, it focuses on the new target sending the bird way out-of-focus.

This panning technique works fine with a big lens mounted on a tripod such as a 600 mm f/4. Super telephoto lenses are too bulky and heavy for most of us to hand-hold effectively so mounting them on a tripod is necessary. Suppose you are photographing snow geese and sandhill cranes at Bosque del Apache wildlife refuge in New Mexico during early January. By using a heavy tripod to support all of the weight of a monster lens and using a gimbal style head (Wimberley or Cobra), it is possible to perfectly balance the weight of the camera and lens on the tripod head so you can pan in all directions without locking up the head. As the sandhill cranes approach, keep the activated autofocus sensor on the birds and press the shutter button all the way down when you see the composition you want.

I enjoy photographing birds in flight. It isn't that hard to do well if you practice a bit and use continuous autofocus to help you stay sharply focused. There is one common mistake that many people make when they try it though. Suppose Canada geese are flying out at dawn from a refuge right toward you. But, first they must cross a field that is off limits to human entry so they have 100 yards to go before they come within camera range. Most people start tracking the geese with autofocus lenses as soon as they begin to fly close which is an excellent idea. As the birds approach, pan with the birds until they are nicely composed and fire off several quick images with the camera set for the fastest possible shooting speed.

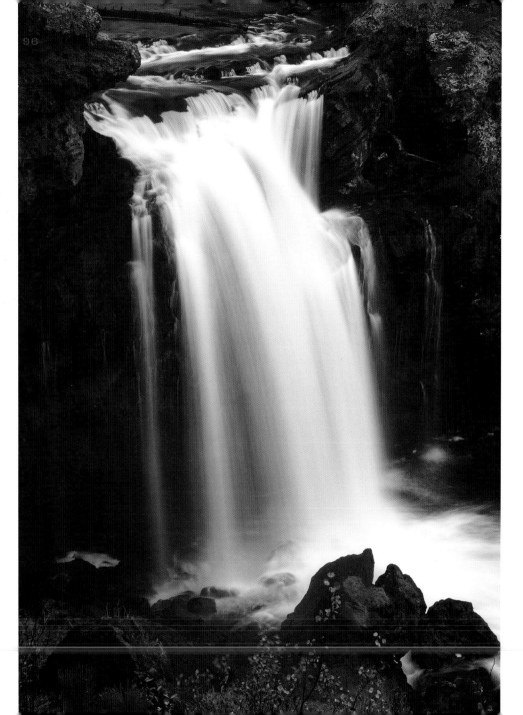

So what is the mistake? It is human nature to assume a balanced stance when you first begin to pan with the birds. Unfortunately, by the time the geese are close enough to photograph well, you are off balance so it's more difficult to maintain your panning speed and keep the autofocusing sensor on the bird. Since you know where you really want to photograph the birds, you are better off to perfectly balance your body while pointing the camera at the spot you want to photograph the birds, then pivot your legs and upper body toward the direction the birds are coming from. You are bit off balance at first, but as you follow the birds, you regain the balanced position when you actually shoot the images.

Many cameras offer a number of auto-focus sensors in the camera to help you stay focused on erratically moving subjects which is often called dynamic focus. These do have merit, but I find I do better if I select only one sensor (usually the middle one) and keep it on the subject by panning.

LEFT: Back-button focusing is perfect for Moose Falls. With only the middle autofocusing sensor activated in the viewfinder, point it at the upper right edge of the waterfall so the sensor "sees" some white water and some black rock, push the back-button to make the lens focus on the spot, let up on the button, recompose the scene, and take the image.

RIGHT: Autofocus works fine here if you point the activated sensor at the top of the trees so it can "see" the contrast between the top of the pine trees and the dawn sky.

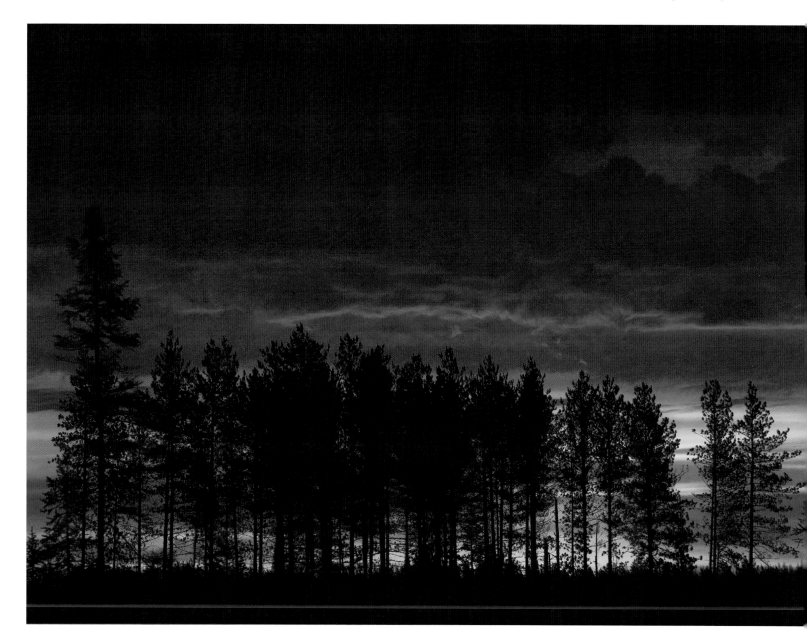

Suppose your camera is set on one-shot AF to photograph a Canada goose resting quietly on a pond. Suddenly the goose begins to run across the water and take flight. This is a wonderful opportunity to photograph a Canada goose flying with water flying in all directions. But, if you are set on one-shot AF, the bird is out-of-focus because you didn't have time to refocus or switch the camera over to continuous autofocus.

Back-button Focusing

The Canada goose situation is easily solved by using a little known technique called back-button focusing. Many cameras have a button on the back of the camera that can initiate autofocusing and removes it from the shutter release button. Now the shutter release only activates the metering system and trips the shutter. This function is typically controlled by a custom function which varies depending on the model of the camera. With many Canon cameras, custom function #4 controls it. With a Nikon D70, it is custom function #15. Study your custom functions carefully to find the one you need.

While it may sound inconvenient to use a button on the back of the camera to control autofocusing, it solves many autofocusing problems. I use back-button focusing on my Canon cameras nearly all the time and usually leave it on continuous autofocus. Barbara does the same thing with her Nikons. This gives us instant access to one-shot AF or continuous AF. Here is how it works. Suppose you are photographing a waterfall. Point the activated autofocus sensor at the most important part of the waterfall and press the back-button focusing control to focus the lens. Once you are in focus, let up on the button and the focus stays locked at that distance even with the camera set to continuous AF. Now you can recompose, squeeze the cable release or activate the self-timer, and take the image without any chance the camera will refocus.

In the previous example with the Canada goose, you could point the autofocus sensor at the head of the goose, press the back button to make the lens focus, let up on the button, recompose, and take the image. If the goose begins to fly, just hold the back-button focusing control in while panning with the goose. Since the camera is already set for continuous autofocus, there is a good chance you'll get sharp images. Essentially, you can instantly switch from one-shot AF to continuous AF by using the back focus button to initiate autofocus. Another place where back-button focusing works well is low contrast scenes or shooting through foreground vegetation. If you have a low contrast scene, point the autofocus sensor at part of the scene that has the most contrast, perhaps a tree trunk in the fog, press the back button to autofocus and check the viewfinder to see if it looks like the lens focused properly. Now let up on the back button, recompose, and take the photo. With an animal peering though grass such as a lion, point the sensor at a part of the lions face that doesn't have any grass in front of it, press the back button to hit focus, let up on the button, recompose, and take another sharp image. This focusing method works tremendously well once you get used to it. It is easily one of the best techniques we have adopted in the past 10 years.

The small drawback to this system occurs when you are photographing action. You have to hold the back button in while pressing the shutter button at the same time. It is easy to do with practice, but I admit it is still easier to set the camera to continuous AF and keep the control on the shutter button so one finger controls autofocusing and tripping the shutter. This is exactly what we do if we know we will be photographing only action.

RIGHT: Red Fox commonly hunt mice and ground squirrels around our barns. This one has become so accustomed to us that it comes when we call it. On page 180, you see John with the fox sitting in our plowed driveway which isn't a good spot to photograph it. By tossing a small scrap of meat up on the bank, the fox quickly pounces on it which puts it in a much more photogenic spot. Now the fox is surrounded by untracked snow and it is slightly above Barbara so she could shoot up at it which is a viewpoint we both like.

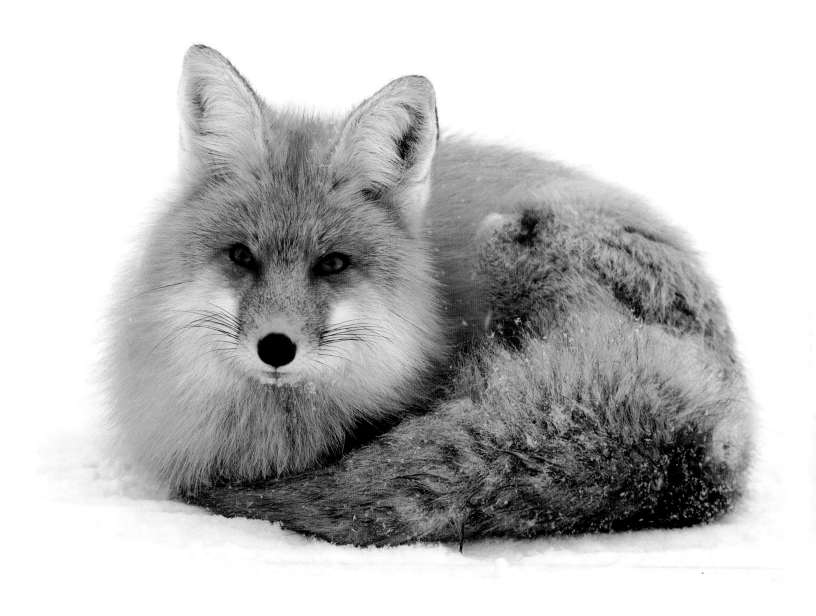

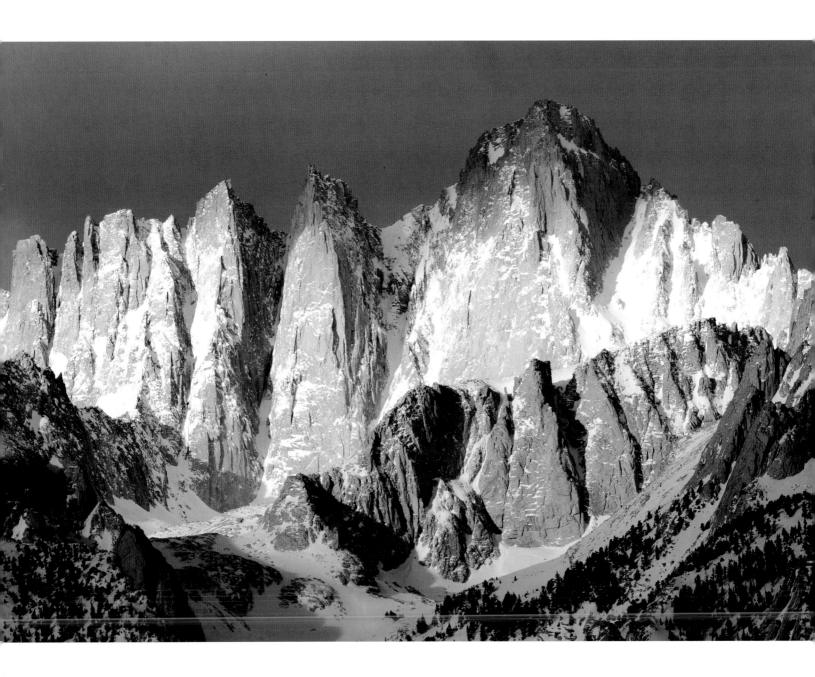

The Magic of Light

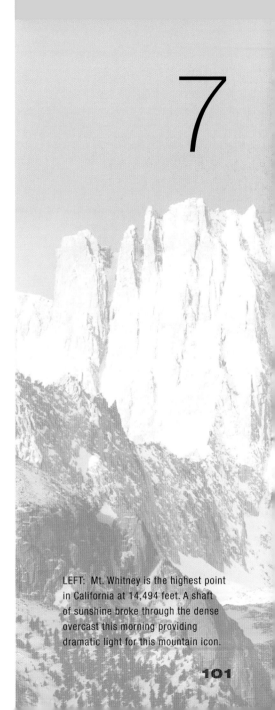

7

The path to shooting excellent nature photographs is easier to follow if you truly understand how crucial light is to making extraordinary images. If you photograph a hawk, wildflower, or landscape, you are not capturing the subject with your digital sensor. No matter how hard you examine the sensor, you won't find the subject hidden in it somewhere. Yet, you can produce an image of it so something had to be captured. Photographers capture the light that illuminates the subject. Information about the light regarding intensity and color is captured by pixels. This data is processed to reconstruct an image of the subject.

Light provides plenty of information about the subject. It reveals the color and shape of the subject. Certain kinds of light such as the soft light of a foggy morning or the red light of dawn create mood. Light can show texture and suggest depth in an image. Some photographers say there is good light and bad light. Actually, I think all light is good, but some light is better for making certain types of photographs. Even poor light for photography can be modified to become beautiful light. Understanding those factors that make light photogenic is the key to using light well. I cannot stress this enough! If you learn to photograph using the best possible light for the subject, your photos improve quickly and you will certainly achieve the pleasure and success you are seeking from nature photography.

FANTASTIC LIGHT CAN BE FLEETING

Before we examine the qualities of light and methods to influence the light on the subject, I want to emphasize that it is critical to master your camera and make it your friend. When the weather conditions and the sun interact to create truly extraordinary light, it often doesn't last very long. You must be able to react instantly to rapidly changing natural light that is often created by small openings suddenly appearing in cloud cover, only to disappear minutes later. If you are struggling with a tripod that is difficult to use, trying to

LEFT: Mt. Whitney is the highest point in California at 14,494 feet. A shaft of sunshine broke through the dense overcast this morning providing dramatic light for this mountain icon.

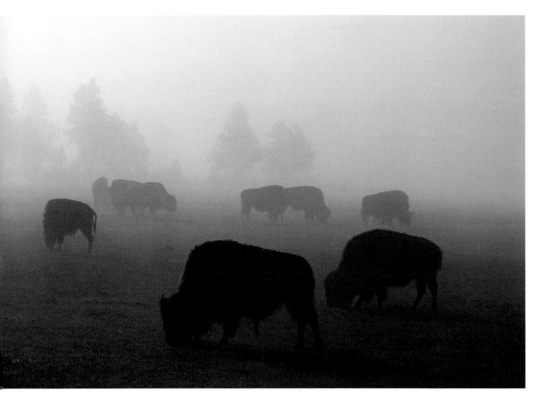

The soft light and fog impart a strong sense of depth as the far bison disappear into the damp mist.

figure out what shooting mode to use or metering pattern, or slow in getting your gear out of the camera bag, many wonderful images that are blessed with fabulous light will only be a memory in your head. Most photographers understand the need to be speedy when photographing wildlife action, but even landscapes may require speed to capture the light. At times, it does seem like you are chasing the light, trying to catch it at just the right moment before it disappears beneath the horizon or behind the clouds.

Some excellent light conditions are easy to predict, but all too temporary. I photograph in some of the best game parks of Kenya which include Samburu, Lake Nakuru, and Masai Mara every year. The opportunities for photographing wildlife are superb every day. I especially like the red light at dawn or dusk for wildlife photography because the warm light brings out the colors in the animals fur and the low angle of the sun softens the shadows. Unfortunately, the equatorial sun rises rapidly in the sky so by 2 hours after sunrise, the golden color in the light is gone.

Let's look at one example where fleeting light really makes the image. I have been fortunate to conduct fall color photography workshops in Michigan's beautiful Upper Peninsula for the past 25 years. The fall colors are superb every year, but the peak does vary from 1 year to the next. Early October tends to be an unsettled period as summer loses out to "Old Man Winter". The weather changes rapidly from hour to hour as storm clouds gallop across the moody skies on a northwest wind.

On calm mornings during the peak of fall color, I lead my students to small lakes where the opposite side is a riot of reds, oranges, and yellows from the maple and birch trees. All of these colors are reflected in the lake's still water offering stunning photo opportunities. The red light of early morning sun really brings out the colors in the fall foliage and the reflections. This is terrific light, but if luck prevails, it can get even better. Occasionally, we'll have a calm, but mostly cloudy morning, but we may gather at a secluded lake anyway hoping for a break in the clouds. Should the early morning sun worm it's way through a hole in the clouds as they drift by, the entire lake lights up and the storm clouds in the western sky turn black. The contrast between the colorful fall foliage and the black storm clouds is so dramatic and photogenic that it can overload your visual senses. It is a rare opportunity to

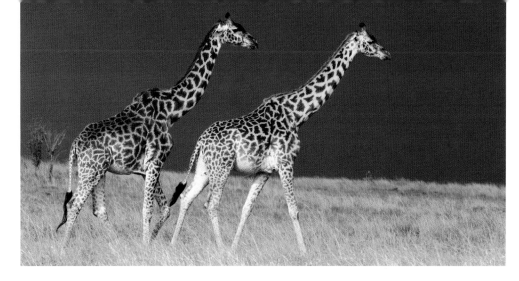

These Masai giraffes are bathed with golden sunshine at sunset. The black storm clouds behind them make this scene especially stunning.

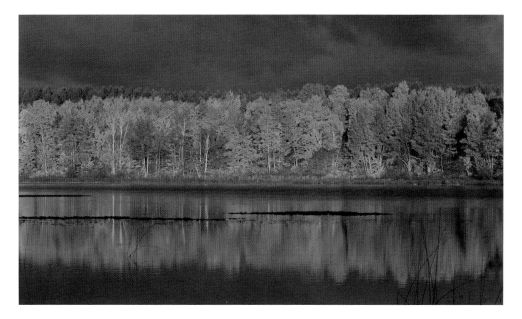

Thornton Lake in Northern Michigan is always stunning at peak autumn color, but especially so at dawn when black storm clouds fill the western sky.

make images with incredible light, but it may not last long. Often, in only a matter of minutes, another cloud slides in from the north and chases away the spellbinding light.

THE QUALITIES OF LIGHT

Light possesses four qualities that determine how photogenic it is. You must have enough light so it can be accurately recorded by the cameras sensor. Numerous factors influence a second important quality which is color. A third factor is the direction the light is coming from. Finally, harsh light such as bright sun tends to create brilliant highlights with dark shadows which is known as high contrast light. The light on a cloudy day tends to minimize deep shadows so the light is low in contrast. It's imperative that you understand how these four factors: amount, color, direction, and contrast work together to offer you fantastic light or work against you.

AMOUNT OF LIGHT

You need a certain amount of light to photograph. If it is totally dark, you won't be taking many traditional images. Often you won't have enough shutter speed to shoot sharp images with sufficient depth of field if the light is too dim.

Assume you are focused on a deer in dim predawn light. With a 500 mm f/4 lens, your camera suggests proper exposure is 1/30 second at f/8 with the cameras ISO set at ISO 100. You know from experience (and reading this book) that shooting

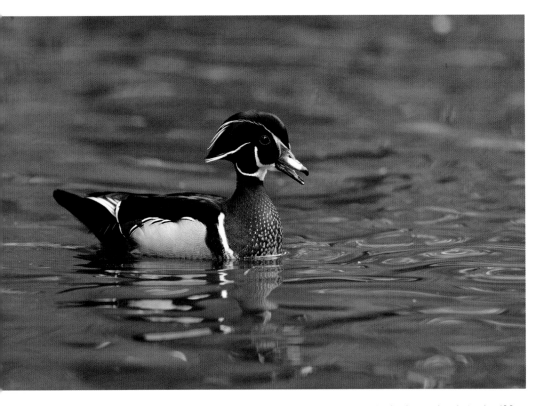

About 100 wood ducks frequent this wooded pond. The light was so dim on this cloudy morning that using ISO 500 was necessary to get enough shutter speed to shoot sharp images.

f/8 to f/4. This also permits using 1/125 second at f/4 giving you enough shutter speed, but reducing your depth of field.

Another way to work in dim light is to use a tilt/shift lens to tilt the lens a bit so you still get plenty of depth of field without stopping down the lens much. You wouldn't use the tilt/shift lens on a deer, but it works fine on a patch of wildflowers. Finally, if all else fails, it is possible to bring extra light with you and fire a flash.

Dim light is effective for certain subjects because the contrast is low, but forces you to learn and use the best techniques. Using a tripod is mandatory and be sure to use a cable release or self timer to fire the camera for critical sharpness. The tripod enables you to use slow shutter speeds in most situations and still get perfectly sharp images.

TOO MUCH LIGHT?

You might be surprised to find there can be too much ambient light at times. Anyone who likes to turn a waterfall or wave crashing on the rocks into a silky mass of motion knows what I mean. During the middle of a cloudy day which provides wonderful light for a waterfall in the forest, the exposure might be 1/8 second at f/22 with the camera set on ISO 400. To show the motion of the water cascading over the rocky falls, a longer shutter speed in the 1 or 2-second range is needed. There are several ways to effectively reduce the amount of ambient light hitting the sensor. The obvious way is to set the ISO to the lowest possible setting,

a crisp image at 1/30-second shutter speed with a 500 mm lens is slim to none-even on a tripod. What are your options? Perhaps it might be possible to wait a bit for the sun to rise above the horizon increasing the amount of light. Most animals tend to move on so it's not a good option here, but could work if you were photographing a wildflower that isn't going to wander away.

An effective way to "increase" the amount of light is to increase the sensitivity of the sensor by changing the ISO from ISO 100 to ISO 400, a gain of 2 stops of light. Now you could successfully photograph the deer by using an exposure combination of 1/125 second at f/8. Another way to "increase" the ambient light without changing the ISO speed is to open up the lens 2 stops, from

typically ISO 100, but it could be ISO 50 on some cameras and ISO 200 on others. In this example, moving the ISO from ISO 400 to ISO 100 eliminates 2 stops of light so proper exposure is now ½ second at f/22. To make the shutter speed even longer, put a polarizing filter on the lens. Depending on how it is rotated, it subtracts about 1 to 2 stops of light and removes quite a bit of glare too, revealing the color and detail hidden behind the glare. Let's say the polarizer subtracts 2 stops of light. Now proper exposure is 2 seconds at f/22 which easily blurs the flowing water.

USE THE TIME OF DAY TO ADVANTAGE

I am a waterfalls addict so I seek them out to photograph frequently. An excellent strategy for photographing them so all the slow shutter speed options are available to you is to visit the waterfalls late in the day. As the sun gradually sets, the ambient light drops until it reaches a level where it is easy to use the shutter speed you want. If you are looking for the silky water effect of an 8-second exposure, waiting till sunset will certainly give you the chance to shoot it. Just be sure to have a flashlight or headlamp (my choice) with you to make your return trip easier.

The shutter was open for a few seconds allowing these recently fallen autumn leaves to trace their path as they swirl about in the whirlpool at the base of Rock River Falls. This is an unusual image depicting motion that can be captured with a camera, but you can't see when viewing the scene.

NEUTRAL DENSITY FILTERS

Digital photographers don't need to use many filters because it is so easy to adjust color later on, but some filters are exceedingly useful to digital photographers. A special filter that allows you to use a long exposure to let a flock of geese blur as they explode from the marsh, wildflowers to become swaths of color as they sway in the breeze, or showcase the movement of water is called the neutral density (ND). It does not (or shouldn't) affect the color of the light that passes through it because it is a neutral gray. These filters come in different strengths which block a specific amount of light. The one I favor is a 0.9ND filter. ND filters are made by most companies that make filters. They come in various sizes to fit the filter threads of your lenses and in different densities. Each 0.1 value is equivalent to 1/3 stop of light. Therefore, a 0.6ND filter blocks 2 stops of light while the 0.9ND filter I use blocks 3 stops of light from passing to the sensor. If the exposure is ½ second at f/22 without the filter, adding a 0.9ND filter blocks 3 stops of light, making a 4-second exposure possible. The drawback to using strong ND filters is they make the viewfinder darker and may make the autofocus mechanism become inaccurate or not work at all. The 0.9ND filter I use darkens the viewfinder by 3 stops so it is harder to compose the image and focus critically, especially if the light is already dim. A stronger ND filter makes the viewfinder so dark that it might be impossible to focus accurately in dim light so don't overdo it.

COLOR OF LIGHT

The color of light is determined by its wavelength. In college physics, I met Roy G. Biv who isn't a person, but rather a way to memorize the sequence of visible colors in the light. If you take the first letter of each color in the series of colors: red, orange, yellow, green, blue, indigo, and violet, you generate the mnemonic device Roy G. Biv. Red light has the longest wavelength of the colors listed here and the wavelengths get progressively shorter as you proceed to violet. Short wavelengths have high energy, but they don't penetrate obstacles very well. Red wavelengths are less energized, but penetrate better because they are longer.

Enough of this physics! How does all this help us understand the colors of the natural things we want to photograph. A sunrise is red because all the light has to penetrate a great deal of our earth's atmosphere when the sun is low on the horizon as opposed to being directly overhead. The shorter wavelengths on the blue end tend to be absorbed or scattered by dust and water molecules leaving only the longer red wavelengths to penetrate. That's why sunlight at the beginning or end of the day has such a pronounced red cast. Since only a small portion of the other colors are able to penetrate the atmosphere, the red and orange wavelengths predominate. The red light early and late in the day is extremely photogenic light for many subjects. Mammals, birds, and landscapes photograph beautifully in red light. However, red light isn't always desirable. Red hurts the color of blue wildflowers, imparting an unwanted magenta cast to them.

As the sun climbs higher in the sky, the light from the sun travels through less atmosphere so the other colors penetrate better which increases their amount in the light, reducing the red effect. Eventually, the light may approach a middle of the day bright sun temperature of 5500 K which is often called white light. A lower Kelvin temperature such as 3000 K is very red while a higher value such as 9000 K is blue light indeed. As the sun descends in the western sky, the Kelvin temperature falls again and becomes red just as it sinks below the horizon.

During the middle portions of a sunny day, the color temperature of the light can change dramatically. While the color temperature might be close to 5500 K, if you photograph a wildflower that is growing in the shade of a large oak tree, the color is quite different. Since the sun cannot strike the wildflower directly because the tree is blocking the light, the wildflower is illuminated by the blue sky. The sky is blue because molecules in the upper atmosphere tend to scatter the shorter wavelengths on the blue end of the visible light spectrum. Eventually, this scattered blue light is reflected down to the earth and illuminates the shady areas. This means a lot to photographers. Photographing a yellow wildflower in the shade will produce an image that is unnaturally blue in color, something to be avoided. On the other hand, the natural blue cast in the shade can be used to enhance the color of a

blue wildflower so it can be beneficial too, depending on the subject. Normally it is wise to avoid photographing warm-colored subjects in blue light.

Film photographers use warming filters or a touch of fill-flash to reduce the effect of the blue light. Digital photographers have it much easier which I will explain shortly.

Another light condition that you frequently encounter is cloudy weather. Clouds tend to scatter blue light too so light has a blue cast on cloudy days. However, the blue in the light on a cloudy day isn't as great as the blue in the shade of a sunny day. It is important to understand that open shade tends to have more blue in the light than on a cloudy day. You will soon be introduced to the concept of white balance so understanding how and why the color of light changes during the day helps you master white balance.

Your surroundings influence the color of the light on the subject. A terrible situation is a white mushroom growing in a forest. Whether it is cloudy or sunny, if the mushroom isn't in the sun, the light has a blue cast to it. You could use a warming filter or touch of fill-flash to take out the blue, but another color is present too. Green leaves reflect primarily green light. So in addition to the blue light, there is a strong green color cast to deal with too. Warming filters won't remove the green

The light on a cloudy day has a blue cast in it. Extra blue in the light is unfavorable for photographing warm-colored subjects, but can be helpful when blue is a key component of these larkspur wildflowers.

light so you might have to resort to a magenta filter which does absorb green. This witch's stew of blue–green light was tough for film to handle, but it is easy to solve with digital by using the white balance controls.

White Balance

The color of natural light depends on the time of the day, cloud cover, and colored objects reflecting light on the subject. Our brain tends to filter out color casts. We can look at a white flower on an overcast day without seeing the blue color cast in the light. But, digital sensors record the light as they "see" it. A white flower photographed in blue light has a blueish cast unless we take corrective action first. Fortunately, digital cameras offer a white balance control so you can closely (but not always perfectly) adjust the prevailing color cast in the light to make the image appear as if it was taken in white light without a color cast.

Digital cameras offer several white balance settings which may include auto, daylight, shade, cloudy, tungsten, white fluorescent light, flash, custom, and color temperature. Custom, color temperature, and auto are settings that can be adjusted. Daylight, shade, cloudy, tungsten, white fluorescent light, and flash are fixed corrections that are often referred to as presets. You must learn to decide which setting is best for the shooting situation.

Auto white balance

The auto setting let's the camera examine the light so it can adjust the white balance to match the light. This might sound like the best way to go and it often works well, but sometimes the camera just doesn't know what you want. For instance, using auto white balance to photograph a gorgeous red sunset drains the color from the sky-not exactly your intention. For outdoor images, the auto setting normally works fine and gets you close to the best white balance.

Daylight, shade, and cloudy

Daylight, shade, and cloudy presets are easy enough. If the subject is illuminated by the sun, use the daylight preset to avoid color casts. As you will remember from our previous discussion, the light is somewhat blue on a cloudy day so selecting the cloudy preset removes the unwanted blue cast. The light in the shade is even more blue so the shade preset works well anytime the subject is in the shade. However, it isn't always desirable to remove a color cast. When photographing blue flowers in the shade, it might be best to put the white balance on daylight to keep the blue cast so the blue flowers do come out blue in the image.

Tungsten and fluorescent light

You'll encounter tungsten and white fluorescent light indoors. While you won't be making many (if any) nature images using this light source, you will certainly want to use one of these presets to match the light source when photographing your friends, family, and pets indoors. These light sources vary a lot in terms of color, so

using custom white balance may be more accurate.

Flash

Digital cameras offer a flash preset because the color temperature of most flashes is slightly higher in degrees Kelvin (around 6000 K) than standard white daylight. Unless the flash has a built-in filter that is pale yellow, the color of the light emitted by the flash is slightly blue. Using the flash preset takes care of the blue color cast by producing a slightly warm (yellow) balance when it is chosen.

Custom white balance

This setting sounds complicated and difficult to use, but it is easy once you get used to it and incredibly useful in difficult light situations. If I shot JPEGs most of the time, I would use custom white balance most of the time too. The exact method of using custom white balance varies from camera to camera, but here is a summary of how it works. Go to a well-stocked camera store and buy an 18% gray card for a few bucks. (Some manuals tell you to use a white sheet of paper, but the gray card may be more accurate.) Set the camera on any white balance setting and photograph the gray card in the exact same light as the subject you intend to photograph. Set the camera on custom white balance. Now bring the image of the gray card up on the LCD monitor. Select the image of the gray card to import the white balance data. With the camera set on custom white balance, go ahead and photograph the subject

The light illuminating this mushroom has a decided blue color cast on this cloudy day and a green cast too from light reflecting off the green leaves in the forest. The best way to deal with this blue-green light is to use custom white balance if you shoot JPEGs. If you shoot RAW images, then the blue–yellow and green–magenta colors are easily adjusted in the RAW conversion.

to get excellent color. Using custom white balance is a way to teach the camera how to render white as white, no matter what color casts are present in the light. Not only does white come out as white, but also all of the other colors are accurate too.

The advantage custom white balance has over picking a cloudy setting is the cloudy setting merely takes out some of the blue and thereby makes the image more yellow. But, a green or magenta color cast would not be corrected by the cloudy setting. Custom white balance corrects for both blue/yellow and green/magenta color casts at the same time. Remember the white mushroom in the green forest on a cloudy day? The light has a blue and green color cast that is nicely neutralized with the custom white balance setting. Just be sure to photograph that gray card using the same light that is illuminating the mushroom.

Color temperature

Finally, the color temperature choice permits you to set the color temperature in degrees Kelvin. The Canon 20D for example can be set anywhere between 2800 K and 10,000 K in 100 K increments. This setting is useful if you have a color temperature meter that measures the color casts in the light so you can determine how much filtration is necessary to neutralize the light. Since color temperature meters are expensive and not necessary anymore to get great color, you probably won't be using this setting much. Nevertheless, you can use color temperature effectively without a color temperature meter. If you like

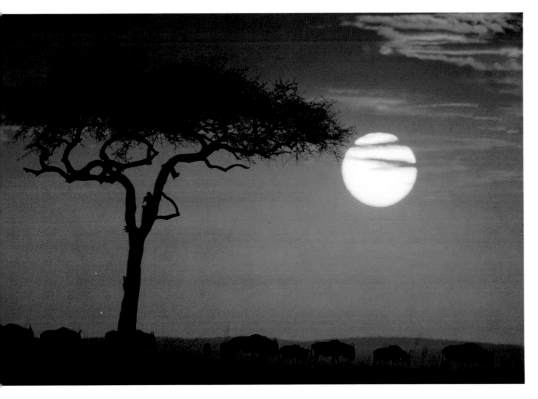

Setting the color temperature white balance control at 10,000 K will add lots of magenta to your sunrise or sunset. These are migrating wildebeest as they pass underneath an acacia tree at dawn.

JPEG AND RAW WHITE BALANCE CONSIDERATIONS

One of the drawbacks to shooting JPEGs is you don't have as much color adjustment capability as you do with RAW. You do have some, but it is not desirable to make a lot of color corrections to a JPEG image because the file is already compressed so some data is lost. It is important to get the white balance as close to what you want as possible when you shoot the image. Either use the presets to match the light or use the custom white balance setting for best results.

If you prefer to shoot RAW files, the white balance can easily be adjusted after the image is made without any loss of quality. You might decide to use the auto setting all of the time since you plan to manually adjust the blue/yellow and green/magenta color sliders anyway with your RAW converter program. That means you don't need to worry about actually matching the light while shooting in the field. It is one less thing to worry about. This is an effective way to operate, but many still prefer to match the color of the light so take your choice.

Here is what we do. We shoot RAW images only and process them later with PhotoShop CS3. Even though we only shoot RAW, we can still view the image on the LCD monitor of our cameras. How is this possible? A part of the RAW image is a tiny JPEG file that brings up the image on the monitor. We find it easier to do our initial edit of RAW images if this JPEG is as attractive as possible. Since we like warm-colored images, we tend to leave the white

magenta sunrises or sunsets, try setting the color temperature to 10,000 K. Your image will have a strong magenta color cast which might be just what you want!

Are you surprised that setting the color temperature to 10,000 K produces a magenta image? Isn't the color of 10,000 K light extremely blue? It sure is! Magenta light on the Kelvin scale is around 2000 K, not 10,000 K. This can be confusing at first

because digital cameras and image editing software such as PhotoShop work the same way. By setting the color temperature to 10,000 K, you are telling (lying if you will) the camera or software program that you are shooting in very blue light so the camera and software add a lot of red to counteract the blue light. Since the light really wasn't blue, you get a magenta image which might be just what you want.

balance setting on cloudy most of the time even if it is sunny. This produces a little warmer (yellow) JPEG image which helps us make our initial selection before converting the RAW images.

CHOOSING THE COLOR SPACE

You must select the appropriate color space which ultimately determines the range of colors you'll see in your image and get on the print. The two common color spaces found on digital cameras are sRGB and Adobe RGB 1998. The color space sRGB is often the default setting. This color space is best for photographers who shoot JPEG images and plan to make prints from the images by sending the image file directly to the printer without working on the file with software. This color space was originally developed to work with the limitations of computer monitors for displaying a wide range (gamut) of colors. Now computer monitors are much better at displaying colors so the more narrow range of color offered by sRGB is a limiting factor.

Adobe RGB 1998 offers a wider range of colors and is the preferred color space for professional nature photographers. This color space was made for commercial printing to extract the maximum color detail out of a digital file. Since skilled nature photographers want the best color possible in their prints, it is the color space most frequently used. Stock agencies also prefer digital images that are sent to them to be shot in this color space. If you hope to sell images, make your own prints, and

plan to work on your images with software such as PhotoShop, be sure to set the camera to Adobe RGB 1998. This is the color space I always use. However, some applications such as digital projection and posting web images at the present time require sRGB color space for the best results. This is not a problem since images shot with Adobe RGB 1998 can easily be converted to the sRGB color space when it is needed.

DIRECTION OF LIGHT
Front-Lighting

From the very beginning, most photographers are advised to photograph their subject with the light coming from behind them. This direction of light is called front-lighting and it does reveal the shape and colors of the subject nicely. Front-lighting is low in contrast because the frontal direction of the light on the subject causes shadows to fall behind the subject so they aren't "seen" by the sensor. Front-lighting works very nicely for many subjects so it is wise to use it much of the time. However, front-lighting is used so much that it tends to make images appear commonplace and even boring. Whenever possible, I suggest trying another light direction to see if it works better than front-light.

This baby gray treefrog (adults are gray) is quietly waiting for a snack to walk by. Due to the blue and green light that is present, this frog photographs best by using custom white balance and soft front-lighting to reveal the detail in the skin.

Sidelighting

This light strikes the subject from the side. This is a gorgeous light direction to use when it works, but you do need the right kind of subject. Sidelighting has more inherent contrast than front-lighting because it causes shadows to fall to the side of the subject opposite the light source which is recorded by the camera's sensor. This increase in contrast is frequently effective because it reveals texture in the subject. Sidelighting is particularly good on sand dunes, snow scenes, and even wildlife if the light isn't too harsh. Sidelight is perfect for revealing the patterns in a sand dune such as those in Death Valley National Park. The shadows created by sidelight impart a feeling of depth in a two-dimensional image. While sidelight isn't right for every subject, when it does work, it produces memorable images.

Anytime you have a subject that has plenty of texture such as these sand dunes in Death Valley, always consider sidelighting.

BackLight

Backlight is the most dramatic light direction of all. This light comes from behind the subject to the camera. It works exceeding well on all translucent subjects such as leaves, dewy spider webs, water drops, frost patterns on windows, and the delicate petals of wildflowers. This light direction is probably the least used by beginners, but successful photographers soon learn to exploit this wonderful light direction to make many outstanding images. By it's very nature, backlight tends to be higher in contrast than all other light directions because shadows face the camera so the sensor must record plenty of contrast.

Backlight doesn't work for everything, but when it does work, the results are beautiful. The best way to learn to use backlighting well is to spend some time shooting nothing but backlit images. Certain subjects tend to be better for backlighting than others. Backlight always works well for translucent subjects because the light passing through the subjects reveals intricate details most effectively. The translucent leaves of ferns, shrubs, and trees are amazing when photographed with backlight. During autumn, it's effective to collect colorful leaves and lay them on a light table. By filling the frame with the pattern in the leaf, the light table is excluded from the image and the details in the leaf that are revealed by the backlight make the image pop. For those who never shot slides, light tables were used to edit and sort slides. While you won't need a light table for that purpose anymore, you might consider keeping the

Backlight works fine for translucent or fuzzy subjects. The hairs on this spotted hyena are nicely rimmed with Backlight.

one you have to use for backlit close-up images of nature. Backlight also works well on nearly all hairy or fuzzy subjects. Rabbits, milkweed seeds, hairy wildflowers such as prairie smoke, and the spines on cacti all photograph superbly with backlight.

Photographing toward the sunrise or sunset is another example of using backlighting since you are shooting toward the light. The first rays of sunlight at dawn or the last rays near dusk are both red in color and fairly low in contrast so your digital sensor can handle the contrast in the light. Mammals and birds photographed in this type of backlight make outstanding images. This is a time to make silhouettes as well. Placing a nicely shaped tree, cacti, wildflower, sleeping butterfly, bird, or mammals against the red sky so the subject is entirely in silhouette is most effective and a sign that you have joined the ranks of advanced photographers. Beginners tend to use front-lighting most of the time, while seasoned photographers employ the creative uses of side and back-lighting whenever possible.

Sometimes you have light coming from all directions at once. A good example is a cloudy day where the clouds act as a giant diffuser, scattering light everywhere so shadows are weak or nonexistent. Due to the lack of harsh shadows, this is wonderful light for making portraits of wildflowers or photographing a large clump of them. It is superb for making enchanting close-up images of mushrooms, lichens, berries, frogs, amphibians, and similar subjects. Normally on cloudy days, it is best to avoid including the white sky in the photo so concentrate on subjects that lie entirely below the horizon. Leaving out the white sky is not a rule though since there can be successful exceptions. In fact, I tend to avoid rules anyway, preferring to call dropping out the white sky a guideline. I only have one guideline that is almost a rule and that is if the subject is translucent, shoot it backlit!

It doesn't have to be a cloudy day to have soft light from all directions. The light is very soft and diffuse before sunrise and after sunset. Light is soft in the shade cast by a nearby mountain or forest too. Many canyons in the Western US reflect beautiful red light into the bottom of the canyon that can be used most effectively to make stunning images.

CONTRAST

Contrast can be good or evil! It's the difference between the darkest part of the image and the lightest. A bird photographed on a cloudy day is low in contrast while that same bird photographed backlit in bright sun has high contrast. Film and digital sensors do not see the light like our eyes do. We are able to see details in a wider range of contrast that either film or digital plus our eyes quickly adjust to allow us to see detail in the darkest shadows and the brightest highlights. Cameras cannot do this since at the moment of exposure, only one f/stop is being used while our eyes instantly open up and close down as needed.

Too much contrast is often harmful to making a beautiful image because the highlights might be overexposed so they are lacking in detail. The shadows could be blocked up or totally black with no detail too. In the worst case, both the shadows and the highlights have no detail. Having critiqued many thousands of images made by my students over three decades, a common problem is excessive contrast because too many images are shot in the middle of a sunny day without any regard for selecting the angle of the light carefully. Perhaps this is such a common problem because we are taught to shoot on bright sunny days early on. Skillful photographers learn to scout for subjects when the light is harsh, but don't use that

Black and white subjects are inherently high in contrast. The front-lighting on this Grevy's Zebra with the Red-billed Oxpecker works best for this situation. Side-or back lighting tend to compound the excessive contrast problem.

light very often to photograph unless they can modify it. Excessive contrast is one of the top four problems I find when critiquing images. The others are unsharp images, poor subject selection, and distracting backgrounds.

Excessive contrast doesn't only happen during the middle of a sunny day. It is quite possible to have soft light on a cloudy day and still have too much contrast. Photographing a white flower where the background is a shaded forest that is almost black could easily be too much contrast for the sensor. Unless you like black backgrounds, the contrast inherent in this situation could result in a harsh image. Perhaps it is possible to select another blossom or change the shooting angle to include a more natural green background behind the white flower.

Skunks, bufflehead ducks, black-billed magpies, and zebras have high subject contrast. All of these are mostly black and white to begin with so your digital sensor may have trouble recording detail in both the light and dark portions of the subject. These subjects were a huge problem for slide film due to the narrow latitude of contrast that the film could record. Fortunately, digital can work effectively with a bit more contrast, especially if you shoot RAW images because RAW converter software offers some tools to expand the dynamic range effectively. Of course, always shoot the exposure so the histogram begins close to the right side without clipping. Since backlight and sidelight tend to increase the contrast of a subject, it is a good guideline (not a rule) to photograph high contrast

subjects like skunks in soft, low contrast light that is typical on a cloudy day.

While too much contrast is often a problem, sometimes it is exactly what is needed to make the image exciting. The shadows cast by the early morning sun on sand dunes is the perfect example. The shadows delineate the shape of the dunes, imparting a sense of depth. It creates an image that appears you can walk into. The same image of the sand dunes shot on an overcast day with no shadows lacks depth and is uninteresting. This is an important use of contrast. A digital image is a two-dimensional object. It has width and height, but no depth. Shadows used well imply depth in the image.

Shadows can make a subject look round. Photographing giant saguaros (a tall cacti found in Southwestern Arizona) using backlight not only make the spines glow, but also the highlights along the edge of the cactus that gradually becomes shadows on the side facing you give the cactus shape. The interplay of highlights and shadows on the cactus makes it appear round in the image, a most pleasing effect.

How to Control Contrast

Although contrast can be useful, more often it is detrimental to your photos because it hides detail in deep shadows or overexposed highlights. Fortunately, there are many tactics that can be successfully

employed to manage contrast. The most obvious way to avoid excessive contrast in your images is to shoot in low contrast light. Soft early or late sunlight or the revealing light on cloudy days are perfect examples. By avoiding harsh bright sun during the middle of the day, your problems with excessive contrast are reduced enormously.

Diffusion cloths, disks, or panels are perfect for turning harsh bright sunlight into bright diffused light that is low in contrast. These useful devices which are made by PhotoFlex and other companies are frequently used by nature photographers to improve the light on small subjects such as wildflower blossoms, mushrooms, lichens, frogs, and even lizards. The cloth, panel, or disk is made with a white material that nicely diffuses sunlight to eliminate harsh shadows. The diffusion disk is exactly that, a piece of white material that is enclosed in a flexible wire frame that snaps open. It is easily used by holding the disk so bright sun passes through the material on the way to the subject. The material diffuses the light quite nicely, but it is important to get a diffuser big enough so the sun on the subject and the background are both diffused. If you diffuse only the light on the subject, the background which is still lite by sun is too harsh and will likely be overexposed in the final image. A diffusion cloth is a large piece of white material that you hold up to diffuse bright sun. It is hard to do this yourself, but easy to do if you have a helper. Diffusion disks are made in several popular sizes. The 32-inch diameter one works well for most nature photographers. Diffusion cloths can be purchased at any fabric store in various sizes. Old parachutes that can be purchased quite inexpensively at army surplus stores work too.

REFLECTORS

These light modifying devices come in a variety of sizes and colors and work fine for lowering the contrast in your subject. The reflecting surface might be silver, gold, or a combination of silver and gold called soft gold or perhaps some other color such as white. The reflector doesn't usually need to be as large as a diffuser because you are bouncing light into the shadows of the subject and not trying to influence the background which is more distant (usually). Reflectors are quite effective for photographing wildflowers or insects in soft early morning sun when backlighted. Since the camera is pointed toward the light source, hold the reflector so the light coming to the camera bounces off the reflector and lights up the shaded side of the subject.

LOWER CONTRAST WITH ELECTRONIC FLASH

Modern electronic flash equipment can easily lower contrast too. By using fill-flash, the objectionable shadows in the subject can be reduced. Modern flash that is dedicated to your system is easy to use. These flashes automatically measure the fill-flash exposure, turning the flash off when you get the amount of fill light you asked for. A good place to start is to set the flash for −1.5 stops. Normally this control is on the flash and the camera body as well. Meter the subject to determine the best natural light exposure. When the flash fires, the camera measures the light from the flash, turning it off when the flash exposure is still 1.5 stops too dark. If you had shadows in the subject that were 3 stops underexposed, the flash opens up the shadows by 1.5 stops, reducing the contrast. We'll cover flash is much more detail later.

SPLIT-ND FILTERS

These are made so one side of the filter blocks more light than the other side. These filters come in various strengths and may have a hard edge where the clear glass becomes tinted or a soft edge where the transition is more gradual. Common graduated ND filters include the 2 stop and 3 stop versions with soft and hard breaks. These filters were enormously useful for shooting film and popularized by the late Galen Rowell, one of the great photographers of our time. They are still useful in digital photography too, but their value is declining due to the power computer software programs offer in processing your digital images. High-quality split-ND filters are expensive so you may want to put off buying them until you find that you truly need them.

COMPUTER SOFTWARE ADJUSTMENTS

Contrast can be reduced or increased easily with many computer software programs such as PhotoShop or PhotoShop Elements. While the exact details are

beyond the scope of this book, a number of tools are available to tame or at least control contrast. One popular tool is the shadow-highlight control in PhotoShop CS3. By moving a slider, it is easy to bring up the exposure in the shadows and/or to lower the exposure in the highlights to effectively reduce the contrast in the scene.

Levels and curves are other controls that offer more precision for adjusting the contrast in your images. These tools can reduce contrast with amazing results, especially if you shoot RAW images. There are times to increase contrast too. While photographing bison in a heavy snowstorm, I used a slow shutter speed to permit the snow to streak against the dark fur of the bison. There was so much streaking snow though that the bison no longer had black fur. Using a levels slider to make the darkest pixels in the scene even darker, the streaking snow showed up much better against the dark fur of the bison.

It is possible to shoot two images of the same scene while changing only the exposure. A scene with too much contrast can be tamed by shooting one shot with the highlights properly exposed. Then shoot a second image to properly expose the shadows. Using software, the two images can be combined so detail in both the shadows and highlights are preserved. This is a wonderful way to expand the dynamic range of your image!

FILTERS

The need for filters has entirely changed for me since switching from slide film to digital. When I shot film, I used numerous filters that include the 81 warming series, 85C, polarizing, warm-toned polarizing, magenta, neutral density, and split-neutral density. All of these filters were needed in various sizes which cost plenty of money and added considerable weight to the camera bag. In addition, it takes time putting filters on the lens and taking them off and they have to be cleaned frequently too. Since it is so easy to adjust the colors of a digital image with software, no longer are 81 warming series, 85C, magenta, and warm-toned polarizing filters needed.

Polarizing Filters are Critical

The most useful filter for digital photography is the polarizing filter. Some are called linear while others are circular. Both do the same thing by removing polarized light, but the linear polarizer may not work well with certain metering systems. Circular polarizing filters work with all metering systems so it is wise to get this type.

Polarizing filters are made with two pieces of glass that are mounted in a ring so one piece of glass can be rotated separately to achieve the desired effect. This makes the filter thicker than most which becomes an even bigger problem if the polarizing filter is mounted on still another filter such as a UV protection filter. A common problem that happens is the thick polarizing filter causes vignetting (dark image corners) when used on short focal length lenses. What happens is the wide angle of view permits the lens to "see" the edge of the filter causing black corners.

Solving the Vignetting Problem

Vignetting caused by thick polarizing filters can be solved in a number of ways. First, avoid using them on short focal length lenses (just kidding). If your camera has a digital crop factor, it is less likely to have a vignetting problem because the image is recorded only with the center of the lens. The edges where the vignetting may occur are already cropped off. Second, you might consider buying a large polarizing filter for your short focal lengths lenses. If the filter size is 72 mm on the wide-angle lens, buy a 77 mm polarizing filter and an adapter ring that has 72 mm threads on one side and 77 mm on the other. Since the edge of the polarizing filter is further away from the edge of the lens, the angle of view of the lens is less likely to see the filter ring eliminating vignetting problems. Third, some polarizing filters are made extra thin to solve vignetting problems. These cost a bit more and are somewhat fragile, but they can eliminate the problem with wide-angle lenses. Fourth, some software programs such as Adobe's PhotoShop CS3 have advanced features that include vignetting correction. Fifth, you could always crop any digital image where vignetting is a problem.

Polarizing Filter Strategies

These filters are marvelous for removing or reducing glare on wet objects, revealing the colors and detail underneath. Polarizing filters are highly recommended for anything wet such as autumn foliage or wildflowers after a gentle rain. By removing glare, the subjects colors are visible and become

more saturated. Anytime you photograph lakes, streams, or waterfalls, consider using the polarizer. At times it can be difficult to see the effect of the polarizer. The best way to see it is to concentrate on water. As you turn the polarizer, the water on a stream for example darkens a bit when the glare is removed. This is the polarizer position you normally what to use. A word of warning, always turn the polarizer in the direction you normally turn it to screw the filter on the lens. If you turn the polarizer the other way, you might accidently unscrew the filter from the lens and drop it, destroying an expensive filter.

The polarizing filter darkens blue sky by removing polarized light. This effect is most noticeable when shooting at right angles to the sun because more polarized light (which is eliminated by the filter) is present in the sky at that angle. To find the area of the sky where the polarizer has the most impact, point your right hand at the sun. With you left hand, draw an arc keeping the angle at 90 degrees to the sun. The polarizer has the greatest effect anywhere along the arc you drew. Just after sunrise and before sunset, the polarizer will darken the sky in the north, south, and directly above you most. If the sun is high overhead, then the greatest impact will be anywhere near the horizon. However, it isn't necessary to always turn the polarizer to get the maximum darkening effect because it can be too much. Images with a nearly black sky because too much polarized light was eliminated can appear quite unnatural so be careful with it.

Many photographers are not aware that if you change the composition from vertical to horizontal or vice-versa, the polarizing filter must also be adjusted to be effective. Always check to be certain you are using the polarizer to best advantage. Everyone needs to use a polarizing filter most of the time and do it correctly to get the maximum content in their images.

Finally, the useful polarizing filter can be used as a variable neutral density filter. Depending on how you adjust the filter, it absorbs 1 to 2 stops of light. If you need to use a longer shutter time such as 4 seconds instead of 1 second, mounting the polarizing filter on the lens and setting it for maximum effect will enable you to blur flowing water or perhaps make an impressionistic image of wildflowers waving in the breeze.

Composing Strong Images

8

WHAT IS COMPOSITION?

Composition is the creative side of photography, so it is a bit harder to frame within a set of rules that always lead to excellent results. Creating interesting compositions is easier for some than others, but everyone can learn to compose effectively by thinking about what the image is saying. As you gain experience photographing nature, composition becomes easier and more intuitive. Composition depends a lot on personal preference so follow your feelings too.

Good composition is recording the subject in the most effective way. That seems obvious, but doesn't offer any ideas on how to achieve that goal. Composition is the thoughtful choice, placement, and arrangement of primary and perhaps secondary subjects, lines, shadows, shapes, and colors within the image. Composition involves a lot more too. It includes using lenses well to affect the size of the foreground and background elements with respect to each other, to use effective zones of depth of field, eliminating distractions from the image, and even choosing shooting angles to use the light to best advantage or to control the background. All of these creative controls available to photographers are part of composition.

I don't believe in photographic compositional rules because there are valid exceptions to all of the "rules". Instead, it is better to offer guidelines that normally work well. These guidelines offer a good place to start so learn what they mean and use them in the beginning.

Here are some guidelines that have worked well for me over my 30-year career. Try following these guidelines to help get started, but don't be afraid to reject or modify them for your own use. Eventually, as you develop your shooting eye, you'll acquire a compositional style that is natural to you and it will continue to evolve throughout your photographic career.

LEFT: This bull elk is driving another bull away from "his" cows in mid-September. The implied action in the position of his head, space in front of the elk for room to move, and the non-distracting background all work together to make this a pleasing composition.

119

This ruffed grouse was feeding next to our home. By carefully selecting the best angle, we could keep the house out of the background. We like wildlife looking into the frame. While the breast is close to the left side, having the head looking back over it's shoulder leads the flow back into the image.

COMPOSITIONAL GUIDELINES
Compose Hand-Held

This single tip will help you more to produce well-composed images than any other. While using a tripod is often critical for shooting sharp images, tripods are detrimental to making strong initial compositions. Tripods actually hinder selecting stunning images from the chaos of nature. Suppose you find a colorful clump of wildflowers growing only a few inches above the ground. The best angle could be photographing straight down from above. Perhaps a 45-degree angle to the ground is better or even a ground level shot may offer the best viewpoint. Perhaps the whole clump of wildflowers makes a great photograph or maybe three blossoms on the left side of the flower patch work best. Maybe a single blossom is the strongest image. If you are composing on a tripod to view each possibility through the camera, it takes too much time to keep repositioning the tripod. It is far more efficient to hand-hold the camera and look at each potential image by viewing it through the viewfinder.

Once you see an excellent image in the viewfinder, then get the tripod and move it into position. Remember where you were holding the camera so you know where the tripod has to hold the camera to make the shot. Composing landscapes hand-held is especially valuable because there are so many ways to compose them. Hand-holding makes it convenient to rapidly change the composition from horizontal to vertical too. Walking closer to a foreground to emphasize it in the landscape image is often effective and easy to do when you aren't laboring with a tripod.

Recently, we photographed the sand dunes in Death Valley National Park and the famous rocks of the Alabama Hills. These landscapes were huge so we mainly used lenses from 12 to 300mm. In each case, we hand-held the camera first as we explored the area, framing potential images in the camera's viewfinder before mounting it on the tripod. We fine-tuned the composition on the tripod, determined the best exposure, and focused carefully to make the final image.

There are many possible images at the edge of a lake with autumn reflections. The quickest way to spot some fine images is to walk along the shoreline slowly looking through the camera. When you spot an image you must have, then attach the camera to the tripod. We call this composing hand-held.

When to Compose on a Tripod

There are times to compose on a tripod though. Heavy lenses such as a 300 mm f/2.8 or a 500 mm are too heavy to hand-hold while trying to compose images. In this instance, mount the big lens on the tripod and find your subject such as a squirrel. Approach the subject slowly until you think it is large enough in the viewfinder and take a look. If the subject is still too small, slowly approach a bit closer and try again. Once the subject is the size you want, fine-tune the composition and shoot the image.

Keep the Horizon Level

Be careful to keep the horizon level. Lakes that flow downhill to one side of the frame or a mountain range that is obviously tilted to one side are common errors that should be avoided. Some cameras offer optional grid screens that can be inserted into the camera. The grid lines make it easy to line up the far horizon so it is level in the image. Just line up the horizon with a horizontal line on the grid screen to keep the image level. However, the far horizon must be directly opposite to you. If you line up a level horizon with a horizontal grid line and shoot at an angle that isn't 90 degrees to the shoreline of a lake for example, the shoreline will not be level. In this case, let the horizon line flow downhill somewhat and use the vertical trees along with the vertical lines on the grid screen to keep the vertical lines straight up and down. You could also attach a level to the hot shoe of the camera to help you level the horizon. Digital software can level the horizon after the image has been taken too. This is enormously helpful, but no substitute for sloppy technique. Try to keep the horizon level to begin with.

Viewpoint Choices

You have a choice of photographing a subject at eye level, from above, or from below. It is often effective to get above the subject and shoot down on it. This angle works well for many patterns in nature such as frosted leaves, large groups of mushrooms, or a field of flowers. Many stunning landscape images are made by shooting down on them from an elevated position. The fabulous view from Yellowstone's Artist Point of the gorgeous canyon and Yellowstone river is an excellent place where shooting down into the canyon is a super viewpoint.

Shooting straight at the subject without shooting down or up does work well for many subjects, but it is the most used

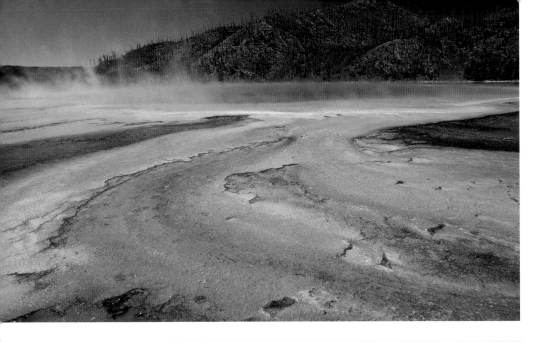

angle so it tends to lead to commonplace images. Still, go ahead and photograph the subject from eye level if it truly makes sense. But, always consider if shooting up or down at the subject works better.

The least used angle is shooting up at the subject and this is unfortunate. This angle is seldom used among beginning photographers because it is an unusual angle. We are not accustomed to viewing most subjects this way and it may be difficult to get the camera into position to use this angle. However, this worm's eye view is ideal for photographing many subjects. It makes animals seem larger and perhaps more threatening as in the case of an elephant or bison. This low angle shows the stalk and gills of a mushroom clearly. When photographing wildlife, shooting from eye level or slightly lower produces exciting and unusual images. When photographing small animals such as rabbits or shorebirds, I prefer to lay flat on the ground to get the lowest possible angle rather than mount my camera on a tripod with its legs

TOP: Grand Prismatic spring is gorgeous from the boardwalk during the summer, especially if there is a slight North breeze so the steam blows away from you revealing the foreground. Use a wide-angle lens here.

BOTTOM: This is an entirely different view of Grand Prismatic spring from a hill on the opposite (south) side where a long telephoto lens nicely extracts a section of the colorful bacteria mats. In both cases, use a polarizing filter to get the most color saturation.

extended and shoot down on the subject. Photographing an animal at eye level or slightly below is a successful guideline to follow and borders on a rule! Be careful though. Shooting up at the subject could produce distracting backgrounds that include white parts of the sky or branches.

TELEPHOTO LENS STRATEGIES

It isn't always possible to select the exact viewing angle you want. A robin perched in a tree 10 feet up is 10-feet high. Unless a small hill is nearby, you won't be photographing it from eye level. You'll be lower than you want to. Conversely, you might someday photograph the polar bears near Churchill, Manitoba from a Tundra Buggy where you must shoot down at the bears. This isn't a wonderful angle for bear photography, but necessary for your safety. One way to reduce the angle in both situations is to use a long telephoto lens to photograph the subject. By photographing animals further away with long lenses, the robin appears to be lower in the tree and the polar bear appears to be higher. Shorter focal length lenses do the reverse and make the shooting angle more extreme because you have to be closer to the subject.

WIDE-ANGLE LENS VIEWPOINTS

Wide-angle lenses that include focal lengths in the 17–28 mm range are terrific for creating a viewpoint that emphasizes the foreground. To emphasize the wildflowers in a mountain meadow with a snow-covered peak in the background, use a very short focal length lens close to the flowers to make them fill the foreground. A 20 mm lens placed a foot away from a clump of Red Indian paintbrush emphasizes the wildflowers while reducing the size of the mountain behind them. Such images tend to command attention because it is an unusual viewpoint and perspective.

It's also effective to use wide-angle lenses from a higher shooting position above the ground to fill the frame with a large foreground such as a field of golden poppies or beautiful rock formations. Using a wide-angle lens 4 to 5 feet above the ground to shoot down on the ground offers an aerial perspective. This is a technique that works effectively to photograph gorgeous color patterns in thermal areas such as Grand Prismatic Spring in Yellowstone National Park.

TELEPHOTO LENSES

Telephoto zoom lenses are terrific for isolating intimate landscapes when it is possible to shoot down on the subject from a hill. Many possibilities exist for shooting down on gorgeous landscapes in mountainous regions or even from tall buildings.

When photographing a subject such as a wildflower from eye level, it is often

Too many photographers shoot down on animals. We find images are more intimate if the shooting angle is at the same level as the head or slightly below. The low viewpoint was used to capture this Bighorn sheep portrait.

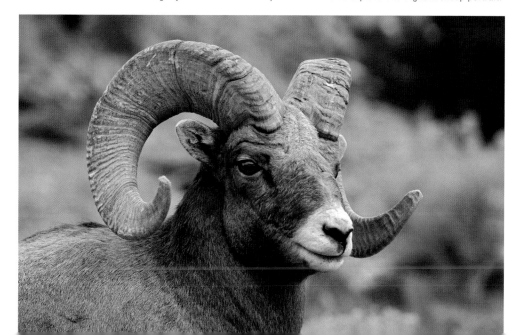

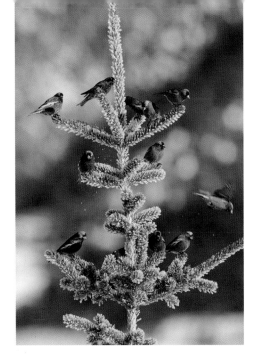

Birds tend to perch higher than you are. Use a long telephoto lens such as a 500 mm to shoot from further away. This reduces the shooting angle so these gray-crowned rosy-finches don't look so high in the treetops.

Although this rosy-finch was perched 8 feet high, the 500 mm lens gently brought it down to eye level.

possible to select the angle carefully to include out-of-focus flowers in the foreground, background, or both. By using a shallow depth of field around f/5.6 and focusing on a single blossom, it is simple to make many poetic images of wildflowers that are surrounded by swirls of soft colors from the out-of-focus blossoms. Since telephoto lenses compress the foreground and background blossoms together and depth of field is reduced when magnification increases, it is quite easy and effective to make wonderful selective focus images.

DON'T CENTER EVERY SUBJECT

It is a worthwhile guideline to avoid placing the main subject in the middle of the frame. A series of bird, mammal, or wildflower images where the main subject is centered or bulls-eyed in the center of the frame becomes boring and static. Most subjects suggest a flow where off center placement works best. A duck looking to the right could better be placed on the left side of the image to give it room to look to the right. A tall wildflower that is hanging down to the left might best be placed so the stem occupies the right side of the

frame and the blossom is hanging down from the upper left corner.

Since digital images are so easy to crop with software, it is not quite as necessary to avoid the dreaded dead center subject. I use the center focusing point in my digital camera anytime I photograph difficult-to-track subjects. The center focusing point is the cameras most accurate focusing point and there is less chance of accidently cutting off a wing tip, hoof, or tail of the subject if it is centered in the image. The image can easily be cropped later to make a stronger composition. Of course, cropping the image eliminates pixels which may be needed to make a large print.

THE RULE OF THIRDS

There is a well-known compositional idea called the "Rule of Thirds" that is helpful to reduce the tendency to put so many subjects in the middle of the image. The "Rule of Thirds" is useful to know, but like any rule, there are exceptions so we'll refer to it as the "Guideline of Thirds" from here on. The guideline of thirds reminds you to divide the digital sensor into thirds both horizontally and vertically. Wherever these lines intersect at four different points, these points are called power points. They tend to be a good spot to place the main subject. All four power points don't work all of the time though. It is still necessary to identify the flow in the image. A gray squirrel perched on a limb that is bent down from the upper right and a squirrel that is looking to the left composes well if the squirrel is placed at the upper right power point. Here's another way to use

the power point idea. Since the image is divided into thirds, it makes sense to put the sky in a landscape image at the upper one-third position if the foreground is more interesting. If the sky is more exciting, try placing the sky at the bottom one-third position so the gorgeous sky fills two-thirds of the image.

Don't take this thirds idea too far. It is effective to change the ratio. If a landscape foreground is especially stunning, including only one-quarter sky might be the best way to go.

IMAGE EDGES

Check the edges of the image for distractions that should be avoided. A patch of white sky in an autumn color image, a stick or any hotspot along the edge shouldn't appear in the image. Unfortunately, most consumer grade cameras don't show everything in the viewfinder that ends up being recorded. Many cameras only show around 92%. Your choices are few here. You can either buy an expensive high-end camera body that reveals 100% in the viewfinder or learn to live with the shortcomings of most cameras. If your camera's viewfinder only shows 92% of what actually will be recorded, try moving the camera a bit in all directions to see if any distractions are present along the margin of the image as seen in the viewfinder. If you see a distraction,

The main body of this strutting peacock fills the lower left power point. The tail feathers nicely flow to the upper left and right power points too.

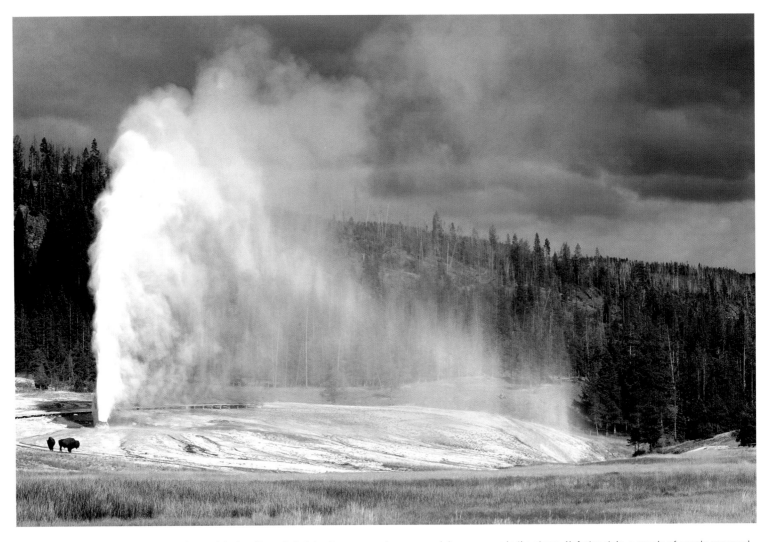

Beehive geyser is unpredictable, but truly special when it erupts in late afternoon sun because a rainbow appears in the steam. Unfortunately, a couple of people managed to get into the scene, but they were covered up with steam using PhotoShop.

adjust the composition slightly to avoid it. Of course, cropping the digital image later with software is an effective strategy too.

It is easy to remove distractions with software along the edge of the image and in the middle too. Barbara once got the special opportunity to photograph beehive geyser in Yellowstone National Park. Beehive geyser is not predictable and doesn't erupt very often. It was a stunning late afternoon image with a gorgeous rainbow in the spray. Two bison were standing near the geyser too, providing a sense of scale.

While many distractions can be removed or covered in the digital darkroom, it is wise to shoot the finest image you can before editing it later with the computer. By making the finest possible digital image in the field, you spend less time working on it with software and you'll become a better photographer too.

KEEP THE IMAGE SIMPLE

Avoid including too many unrelated elements in the image. The key to making strong images with impact is to isolate photogenic subjects and eliminate clutter. Making the subject large in the viewfinder often eliminates distractions. Rather than photograph a large mass of wildflowers, some of which are wilted and in poor shape, move in closer and carefully select a group of three outstanding blossoms in mint condition for your image.

This American copper butterfly perched on a flower is a clean and simple image with no distractions in the background.

NUMBERS OF SUBJECTS

You may hear that including odd numbers of objects in the image such as one, three, or five makes a better composition than even numbers like two, four, or six. The theory is that even numbers of objects such as two frogs or four flowers are easy to divide once again. Odd numbers are unbalanced so it is more difficult to divide the subjects. It is true that a fine group of five wildflower blossoms does look nice, but so does a group of six, even if they are easy to divide into two groups of three. After all, you could always divide a group of five blossoms into a group of three and a group of two. Still, there is visual appeal to groups with odd numbers so take advantage of them. But, if you find a group of photogenic subjects with even numbers, go ahead and photograph them anyway because you will love them too.

USE LEADING LINES

Lines are a key element of composition. Learning to use them effectively comes by learning to "see" lines and placing them where they will do the most good or the least harm.

Horizontal Lines

Let's look at simple horizontal lines first. These lines do not have to be perfectly straight, but may curve a bit. The horizontal lines of overlapping sand dunes or mountains are perfect examples of horizontal lines. These lines tend to impart a feeling of restfulness or peace in the image. A series of overlapping horizontal lines that begin at the bottom of the image and rise to the top make wonderful patterns so be sure to use them whenever possible. Even a single horizontal line such as the far shoreline of a lake can be useful.

It is best to avoid putting a strong horizontal line dead center in the middle of the frame. A strong line bisecting the frame tends to divide the image into two smaller images. Try putting a single strong horizontal line either lower in the frame if the area above the line is the most interesting part or above the middle of the frame if the foreground is more exciting. However, this is only a guideline. Images that have strong reflections often work well when the dominant horizontal line bisects the image separating the subject and it's reflection. However, most subjects and their refection

These three lions are amusing because they all have the same pose. This is a good example showing where odd numbers of subjects tend to be quite pleasing.

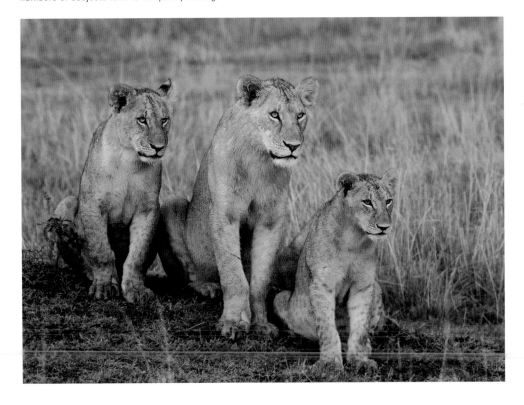

still work best if the line is not centered in the middle of the image.

Vertical Lines

These are active lines that convey the feeling of motion and height. The vertical trunks of trees or the stems of tall flowers are common examples. Fine images can be made with a single strong vertical line on one side of the image or a series of strong vertical lines across the image which makes a wonderful pattern. Keep a single vertical line out of the middle of the image so it doesn't divide the image into two equal parts.

Unfortunately, because vertical subjects are frequently tall such as a tree or giant saguaro cactus, most photographers tend to point the camera up to include the top. As soon as you do this, the vertical lines tend to converge or lean in toward the top because the base of the object is closer to the camera than the top. Leaning vertical lines are unnatural and distracting, so it is normally best to avoid them when possible. Vertical lines can be prevented from leaning by not pointing the camera up. Unfortunately, this often means the top of the subject is cut off. The leaning vertical line problem can be solved by finding a higher position to shoot from, so the camera doesn't have to be pointed up. If this isn't possible, try moving back a bit and use a shorter focal length lens. Keep the optical axis of the lens parallel to the ground. While the subject's image is smaller than you wanted, cropping the digital image later will restore its size, but you lose pixels. An excellent (expensive) solution to this problem is to buy an 85 mm Nikon perspective lens or any of the three Canon T/S lenses which come in 24 mm, 45 mm, and 90 mm focal lengths. The shift capability of these lenses makes it easy to keep vertical lines vertical. Fortunately, leaning vertical lines can be fixed with some software programs such as PhotoShop CS3.

Leaning vertical lines aren't always detrimental. Sometimes it is desirable to make vertical lines lean in. An effective way to do this is to use the widest lens you have such as a 24 or 17 mm. Try lying on your back in the forest when the trees are adorned with autumn color or frosted during the winter and shoot straight up. If you are surrounded by trees, all of them lean in creating a circle which is a unique viewpoint that is quite pleasing.

Diagonal Lines

These lines are common in nature and very active. They work well to suggest depth in the image because the lines recede into the background and become closer together. Since most people read the page in a book from left to right, beginning the diagonal lines in the lower left portion of image and letting them flow to the upper right corner makes a very strong composition, especially if a dominate subject occupies the upper right corner. The diagonal lines lead the viewer to the main subject. A series of horizontal lines can be turned into diagonal lines by choosing a shooting position at an angle to the horizontal lines. The closer you are to the horizontal lines and the shorter the lens, the easier it is to turn them into diagonal lines.

Curved Lines

These lines are extremely photogenic whenever they are found. The gentle curves of a winding river are common examples of the famous "S curve". While using the S curve is a bit of a cliché, it still works very well photographically. Gentle curves are common in nature so use them in your composition whenever possible.

FORMAT
Square Format

There are three formats that you can use to compose your image in. The shapes of these formats include square, rectangular, and panoramic. While the vast majority of sensors in digital cameras are rectangular in shape, it doesn't mean you are limited to that shape. Using software, it is simple to crop a rectangular image into a square. Some images such as flower patterns or tight portraits of animals work well as a square. When making a print from a square image, it may be desirable to make the borders so they are even on all sides to preserve the square format. At times, it is desirable to print a square image with one side of the border wider than the other to avoid centering the square image in the frame. Since lenses throw a circle of light that is cropped by the typical rectangular digital sensor, I suspect more cameras of the future will use a bigger square sensor to avoid wasting the cropped portion of the circular image focused by the lens. This would be an excellent way to increase the size of the digital sensor, so more pixels could be added.

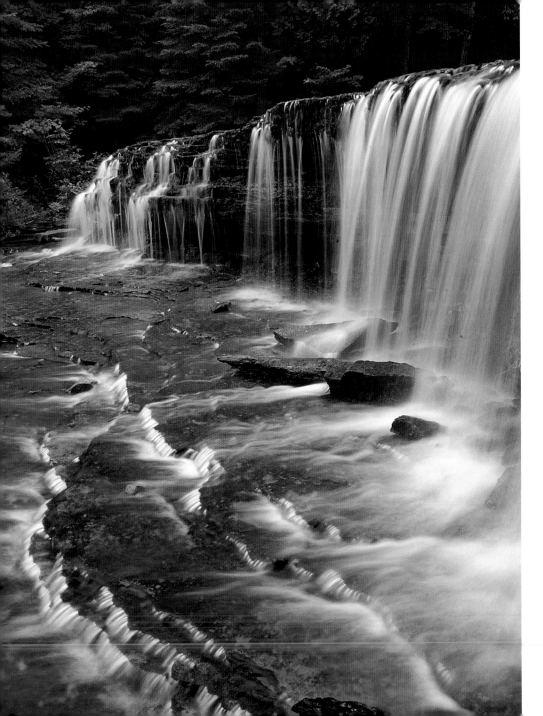

Rectangular Format

Your camera probably uses a rectangular sensor to record the image. Since one side is longer than the other, it makes sense to use the long side to shoot vertical or horizontal images which covers the flow of the image best. Subjects that are taller than they are wide such as giraffes, trees, flowers that bloom along the side of a tall stem, and skinny waterfalls suggest vertical compositions. A wide subject like a sideways view of an elephant, a mountain range, or autumn color reflections in a lake usually makes excellent horizontal images. But, there are no rules here. A tall giraffe that is balanced with a lot of acacia thorn bushes could be a horizontal image while many autumn color reflections in lakes work well as vertical images. Usually a vertical or horizontal composition suggests itself right away. If you are in doubt, compose the subject both ways and decide later when you edit them. Perhaps both vertical and horizontal compositions work!

Panoramic Format

The panoramic format is an exaggerated rectangle where one side is at least twice as long as the other side. Everyone shooting digital cameras can easily shoot panoramics with their cameras. This format is tremendous when you have a subject

The diagonal lines in the rock and the falling water start you in the lower right corner and lead to the upper left. While AuTrain falls is small, the shallow river permits walking in the water so you can photograph it from unexpected angles.

where it works well. It is an unusual format that has only recently become widely used to make nature images, so it is sure to draw attention. Long panoramic images make gorgeous prints on the wall and generate a lot of interest in viewers because they are stunning to see.

FANTASTIC PANORAMICS

Since digital images are easy to align precisely with software, it is simple to shoot fabulous panoramic images once a few field techniques are learned. Using software, it is easy to assemble multiple images into eye-popping panoramics.

Choosing Great Panoramic Subjects

You must develop your eye for seeing panoramic possibilities. Not every scene works well as a panoramic. Since the successful panoramic image must fit in a narrow rectangular box, look for photogenic subjects that are long. Usually these are horizontal images, but vertical subjects could work as a panoramic too.

The scene should be quite interesting throughout the length of the panoramic. If the subject has some especially strong points on the left or right side of the image or both sides, so much the better because these points serve to anchor the panoramic. The autumn color of a beech-maple climax forest reflecting in the quiet waters of a small Northern Michigan lake is a beautiful candidate for the panoramic treatment. Even a strong pattern such as the sand dunes in Death Valley National Park make a super panoramic. Although

learning to see and shoot panoramics is new for all of us, the act of shooting panoramic images is straightforward and easy to master.

Panoramic images work best if the subject is not especially close to you, so a 50 mm or longer focal length lens is needed. Shorter focal lengths tend to bend the horizon and cover so much sky that you may get huge differences in the brightness of the sky which can be disturbing in a print.

LEVEL THE TRIPOD

Level the tripod first. It helps if your tripod has a bubble level built-in such as my Gitzo 1325. While it is easy to level the tripod on a solid wood floor, it is not nearly as easy to level the tripod in snow, mud, water, brush, or on a hillside. These situations are the normal places where nature photographers make their images. If you take your time, it is possible to level the tripod in the most difficult of circumstances. Unfortunately, on unstable ground such as mud, the tripod easily becomes tilted with the slightest pressure from the photographer.

I once used to struggle with leveling the tripod precisely until one of my students came to the workshop with the perfect answer. Gitzo makes a video adapter that was designed for video applications, but it works perfectly to level any tripod head. Gitzo calls it a G1321 leveling base. It is easy to use. Remove the flat base that comes with the Gitzo 1325 tripod and insert the leveling base. Level the tripod as best you can. It doesn't have to be perfect. Now twist the column underneath the leveling base and the whole thing comes

loose. Hold on to the column and move it until the leveling base is perfectly level as indicated by the bubble level in the leveling base. Twist the column again to lock everything up nice and snug. With practice, it only takes a few seconds to perfectly level the base that the tripod head rests on. The leveling base only works on certain Gitzo tripods so make certain the G1321 leveling base is compatible with your tripod. Hopefully, manufacturers of other tripods will address this new need to make it simple to level the tripod.

LEVEL THE CAMERA

Even though the tripod might be perfectly level, it doesn't mean the camera is level on the tripod. Most tripod heads can be tilted in all directions too. The camera must be level with the horizon or your series of horizontal images that make up the panoramic image will slope to one side or the other. Fortunately, it is easy to level the camera. Insert a double bubble level in the hot shoe of the camera. Tilt the camera until the bubble is perfectly centered in the circle of both bubble indicators. Now the camera is level side to side and front to back with the world and the horizon should be level across the images that make up the panoramic.

USE A SPECIFIC WHITE BALANCE

Do not use auto white balance because the camera might change the white balance as the images that make up the panoramic shift from mostly shade to full sun for example. It is best to set a specific white

Panoramic images are appealing so learn to shoot and print them. This frozen scene of the trees on Two Top Mountain near our home was made with five separate images

This beautiful Michigan lake was captured with three separate images. Be sure the tripod and camera is perfectly level so the images stitch together easily.

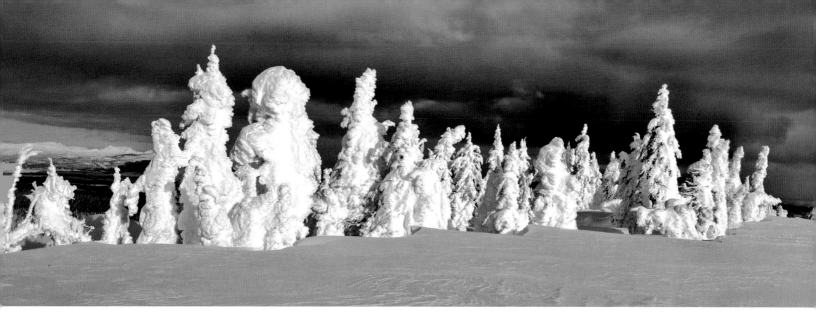

and stitched together manually.

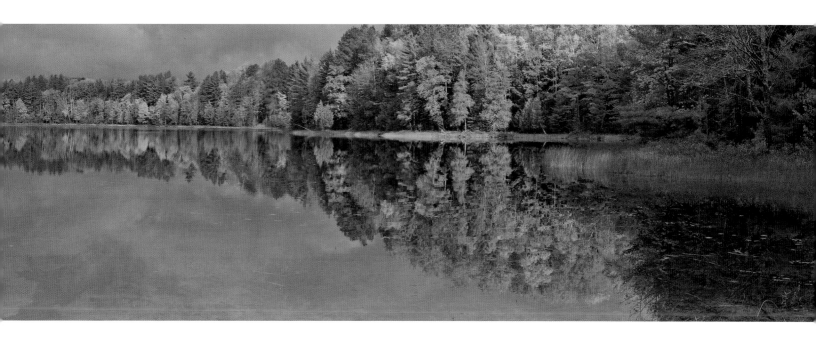

balance such as sun, shade, or cloudy so the same white balance is used for the entire series of images that make up the panoramic.

USE MANUAL EXPOSURE

Set the exposure manually. As the series of images change during the sequence, autoexposure cameras change the exposure from one image to the next when the meter detects differences in light or reflectance values. You want the same exposure throughout the series of images so they match up better when you put them together. Since you don't want to blow out the highlights, manually meter the brightest part of the scene and set the best exposure for that. Use this exposure for the entire set of images, even if one end of the scene is darker than the brightest part. If you begin with the darkest part of the scene, you run the risk of overexposing the brightest areas.

FOCUS CAREFULLY

Most people focus manually on the scene to make it easier to line up the images later. I have found that slight changes in focusing distance don't seem to be a problem and give me a higher degree of sharpness. Normally in a horizontal pan, the entire subject is fairly close to the same distance anyway. Therefore, I typically fine-tune the focus from shot to shot by using the back-focus button control on the camera.

MARK THE PANORAMIC SEQUENCE

Once you have the camera and tripod level, the scene metered and carefully focused, begin the panoramic on either the left or right side of the scene. The first image to take is your hand. Stick your hand in front of the lens and shoot an out-of-focus image of it. This shot marks the beginning of the panoramic series. Photograph your hand again at the end of the series. If you don't do this, you are apt to delete the first frame or two before you realize the images make up a panoramic scene because individual images often don't seem well composed. The images of your hand marking the beginning and ending of the panoramic series saves you time.

BEGIN SHOOTING THE PANORAMIC

Now shoot the first image. Then pan the camera over enough so the second frame overlaps the first frame by at least 25% and continue to repeat this process until you reach the end of the scene. Don't be afraid to shoot more than you think you might use. If you don't want the entire scene later, it is easy enough to delete. But, if you fail to include everything you might use in the panoramic, there is no way to get it back later.

While it seems counterintuitive, it is best to shoot a horizontal scene as a series of vertical images. This puts more pixels on the subject and give you more wiggle room. When you line up the images to assemble the final panoramic image, it is necessary to crop part of the top or bottom of the image to make it a perfect rectangle again. Starting out with extra space above and below the main subject simplifies this process.

PANORAMIC SOFTWARE

There are numerous software programs that automatically stitch your images together to make the final panoramic image. It seems that new programs are being introduced to the market on a monthly basis and established programs are constantly updated. Virtually any image processing software program has a way to make panoramic images. Since I use PhotoShop CS3, the Photomerge feature works fine. Barbara is excellent at making panoramics and she lines up each image manually, but you do need to understand PhotoShop well to do it.

A Google search will find many popular panoramic programs that automate the process and produce technically fine images. Some of these programs include PhotoVista Panorama 3.0, PanaVue Image Assembler, ArcSoft Panoramic Maker, and Realviz Stitcher EZ. Canon includes PhotoStitch software with many of it's cameras too.

RIGHT: Northern Cardinals are easily attracted to backyard feeders. A tray full of sunflower seeds was put near a convenient bush so it could be photographed without the feeder appearing in the image.

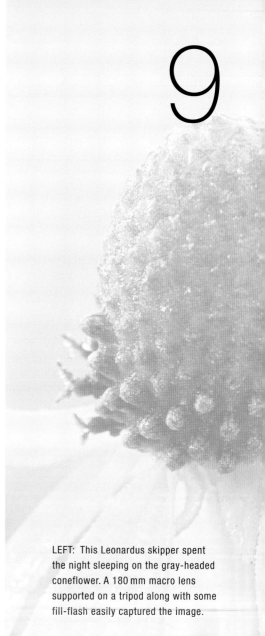

The Exciting World of Closeups and Macro

Closeup nature photography is available to everyone. You are limited only by equipment and your own imagination. Closeup opportunities abound in your backyard, especially if you maintain a flower garden that attracts insects. Nearby woods and fields offer numerous closeup opportunities too. Even if you live in a densely populated city, urban parks and local nature centers offer many closeup subjects. Even during winter, it is easy to grow your own flowers or buy flowers at the local greenhouse so you can photograph gorgeous blossoms indoors, perhaps by window light with a reflector or fill flash to reduce contrast. Shooting indoors eliminates the problem of trembling flowers due to the breeze enabling the use of long exposures for maximum depth of field.

Just what is a closeup? Making a tight shot of a maple tree that fills the frame with autumn foliage and branches is a closeup of the tree. But, generally the closeup range is considered to begin with a much smaller subject such as a tulip or rose blossom. While there is no definite place where everyone agrees the closeup range begins, let's pick a subject that is 5 inches in diameter or smaller. This covers thousands of potential subjects so you won't run out of possibilities.

MAGNIFICATION

Magnification describes the relationship between the actual size of the subject and the size of its image on the sensor. Photographing a 4-inch butterfly so its image size is 1 inch long on the sensor means the magnification is 1/4 (1:4) life-size. Dividing the size of the subject's image on the sensor by the actual size of the subject determines the magnification. In other words, at 1:4 magnification, the image of the subject on the sensor is 1/4 of its actual

LEFT: This Leonardus skipper spent the night sleeping on the gray-headed coneflower. A 180 mm macro lens supported on a tripod along with some fill-flash easily captured the image.

size in real life. At 1:2 life-size, the size of the subject on the sensor is half as big as it is in real life.

The closeup range ends once you reach life-size magnification which is usually written as 1:1 magnification. Here the size of the subject and its image on the digital sensor are exactly the same size. When this magnification is reached, shooting at life-size and higher magnification is called macro photography. The subject must be tiny to effectively use such high magnifications. However, nature abounds with wonderful macro subjects such as a tiny spider, flower bud, dew drop on a flower or blade of grass, a single snowflake, the face of a cute grasshopper, or the delicate pattern in a butterfly wing.

Anyone can be an excellent closeup and macro photographer for two reasons. First, the information available on closeup photography in the form of books, magazine articles, and web content makes the techniques you must know available to everyone. Second, the equipment to make closeup and macro images is much better than it was years ago. There are plenty of ways to get close which include macro lenses, quality closeup lenses on zoom lenses, and extension tubes that preserve automatic features between the camera and the lens. Tripods that work easily near the ground, through-the-lens metering for both natural light and flash, simple

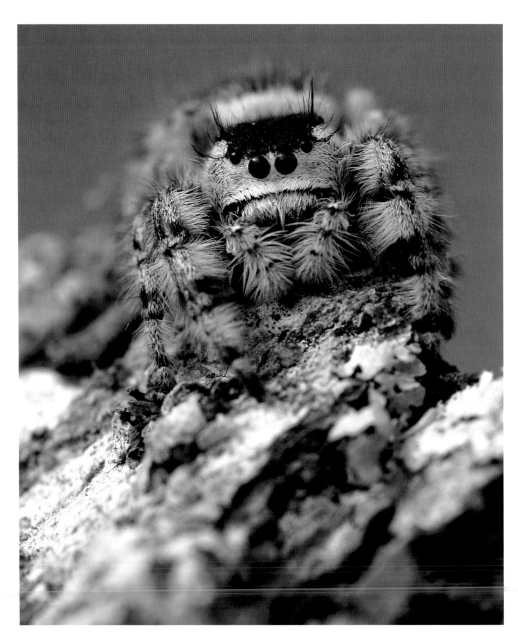

A 100 mm macro lens with a 25 mm extension tube was used to capture this adorable jumping spider at greater than life-size magnification.

fill-flash techniques with modern equipment, reflectors and diffusers to improve the light, and even plamps to stabilize the subject all simplify closeup photography.

Digital cameras make it easier and cheaper for everyone to shoot closeups and enter the macro range of life-size (1:1) or higher. Since the digital sensor on most cameras is smaller than a 35 mm slide that was 36 mm × 24 mm in size, the crop factor of the digital camera makes it easier to fill the frame with a tiny subject. For example, the 100 mm macro lens that is made by most camera systems probably obtains life-size or 1:1 magnification just by focusing the lens to the closest focusing distance. If your digital camera has a 1.6x crop factor (due to the smaller sensor size), the 100 mm macro now acts like a 160 mm lens and your subject is larger in the viewfinder without using other macro accessories. Finally, since it is so easy to crop the digital image with software, it is practical to make the subject even larger by cropping out part of the image. The image file size is reduced by cropping the image which may limit the size of the print that can be made from the smaller number of pixels being used. However, if you don't crop too much, increasing subject size in this way is useful at times.

It's fun to make big images of tiny subjects. These images have appeal to other viewers because they reveal the intricate parts of a flower or insect that most people never notice. However, you must develop excellent shooting habits to consistently produce sharp images. In addition, the working distance which is the distance

A highly magnified macro shot of this little sunflower reveals color and texture that most people never get close enough to see.

between the subject and the lens gets much smaller as magnification increases, so this causes problems. Also, depth of field, which is the zone of sharp focus is very tiny at macro magnifications. These limitations make macro photography challenging, but the problems they create can be minimized.

There are many ways to make excellent closeup images that cover a wide range of budgets from inexpensive to expensive. No one way is the right way for everyone. We all have our preferences.

TRUE MACRO LENSES

A variety of macro lenses are made by most camera systems that focus much closer than regular lenses. Most true macro lenses can focus close enough to reach life-size magnification at the closest

focusing distance. These lenses are optimized to produce incredibly sharp images in the closeup range. Macro lenses are convenient because you can switch from photographing a maple tree to a single leaf under the tree just by focusing the lens closer.

Macro lenses are more expensive, larger, and heavier than other closeup accessories such as extension tubes or closeup filters so they do have some drawbacks. Nevertheless, macro lenses are extremely efficient for creating high-quality closeup images.

LONG MACRO LENS PROS AND CONS

Macro lenses are widely available in three common focal lengths. You may find macro lenses for your system in the 50 mm, 100 mm, and 200 mm range. The exact focal length may not precisely match these numbers, but they should be close. For instance, the Nikon intermediate macro is a 105 mm lens while the long Canon macro is 180 mm in focal length. Longer macros are more expensive and weigh more than shorter focal length macros so these factors need to be considered.

However, if money isn't a deterrent and you don't mind carrying a bit more weight, do consider a long macro in the 180 mm to 200 mm focal length. These macros have three enormous advantages over macros in the 50 mm and 100 mm range. I feel the most important advantage

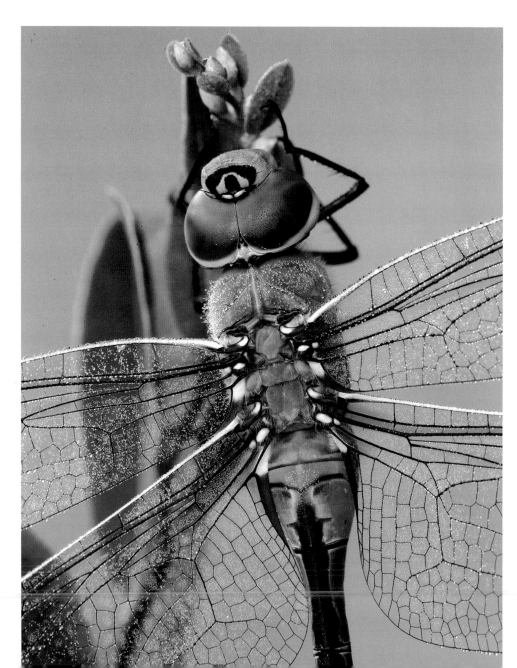

Using a 180 mm or 200 mm macro lens to capture this green darner dragonfly portrait easily throws the distant background completely out-of-focus.

is the lens angle of view. The longer the focal length, the smaller the angle of view that the lens "sees." This means it is much easier to select or control the background. Distracting backgrounds frequently ruin closeup images which are easily avoided by using a longer focal length macro and selecting the shooting angle carefully to eliminate or minimize distractions.

Increased working distance is the second reason for going with the 200mm macro. Since most macro shots require the use of a tripod, having extra working distance is always beneficial. Photographing a dew-laden spider web or grasshopper is easier if you can set up the tripod further away from the subject. If you have to put the tripod only inches from the subject which would be necessary with a 50mm macro, most likely the grass that is attached to the spider web or supporting the grasshopper would be bumped causing the dew drops to fall or grasshopper to jump away. Having the working distance of the 200mm macro greatly simplifies placing the tripod. By moving slowly, it is often possible to carefully move the tripod and 200mm macro into position for wary subjects like butterflies or frogs without scaring them away. Many tiny animals like this have a small fear circle that you must respect to get the image. We have a fear circle too! Wonderful closeup subjects that make great images, but you don't want to hug include rattlesnakes, spiders, scorpions, cactus' spines, and poison ivy berries.

Staying further away from the subject helps in other ways too. If it is easier to use a reflector or diffuser to improve the light then you have more room to work with. When using flash, having more working distance tends to reduce the problem of the lens or lens hood blocking the light from the flash.

All long macro lenses in the 180mm to 200mm range come with a tripod collar built-in to the lens. This makes the lens easier to use on a tripod. The large macro lens is attached to the tripod head instead of the camera body. This balances the weight of the lens and camera better than if the camera body was attached directly to the tripod head. Since the lens easily rotates in the collar, it is easy to switch the composition from horizontal to vertical. This permits working on top of the tripod instead of flopping the camera off to the side which let's gravity pull the lens down making the image hard to compose. However, this problem can be solved by using an L-bracket on the camera body with 50 and 100mm macro lenses.

Long macro lenses have tripod collars that make vertical compositions in closeup photography easier to do. The Canon 180mm macro lens used to capture this dew-laden damselfly offered plenty of working distance and simplified the background too.

This dewy spider web image is nearly impossible to capture with a 50mm macro because the distance from the dew drops to the front of the lens is much too short. The working distance of a 200mm macro solves the problem.

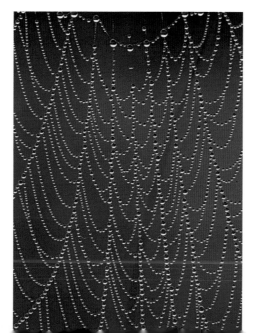

100 MM MACRO CONSIDERATIONS

We are strong advocates of using 180 mm and 200 mm macros for closeup images and always recommend them first. But, a new 200 mm macro might cost $1400 or more while the 100 mm macro is several hundred dollars cheaper in the $450 range. Is it really necessary to spend $1000 more for the 200 mm macro? The answer depends on your circumstances. If you have the money to spend and don't mind carrying the extra weight of the 200 mm macro, then that is the best answer. If weight or money is a factor, do consider the 100 mm macro. If you control the background by carefully selecting the shooting angle and picking a moderate aperture for less depth of field such as f/11 over f/22, busy or distracting backgrounds can be avoided.

The digital crop factor that most digital cameras have is another reason the 100 mm macro is a viable option. If the digital camera you own has a 1.6x crop factor, it makes the 100 mm macro appear to be a 160 mm lens that has the working distance of a 160 mm lens, a smaller angle of view, and increases magnification. To be accurate, the crop factor is often called the magnification factor, even though nothing is being magnified. The focal length of the 100 mm macro lens doesn't actually change either. While the 100 mm macro lens used on a digital camera that has a crop factor seems to have more magnification, it really doesn't, but appears to when the image is cropped in the camera due to the smaller sensor.

PROBLEMS WITH 50 MM MACROS

I would not recommend using a 50 mm macro for most closeup nature photography in the field. The lack of working distance and wide angle of view of the 50 mm lens is certain to be a serious problem. The only way you might try one is if it is dirt cheap or you get it free. A 50 mm macro on a digital camera with a 1.6 crop factor acts like an (50 mm × 1.6) 80 mm macro lens which is workable, but far from ideal.

CLOSE-UP AND ZOOM LENSES

Another excellent way to create closeup images is to put a high-quality close-up lens on the front of a good zoom. If you already own a lens that zooms out to a minimum of 300 mm at the longest focal length, then you have an excellent alternative to using more expensive macro lenses. Common zoom lenses that work well include the 75–300 mm, 100–300 mm, 100–400 mm, and 80–400 mm. Zoom lenses that reach at least 300 mm work better than short zoom lenses such as the 28–105 mm because they offer smaller angles of view, more working distance, and greater magnification. Many long zoom lenses also have built-in tripod collars too.

The close-up lens which is sometimes called a closeup filter, supplementary lens, or diopter is a piece of glass that looks like a filter and screws on the front of the zoom lens. The close-up lens enables the lens to focus very close which greatly increases magnification. Many different

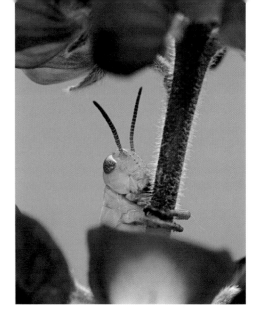

If you already own a zoom lens that reaches 300 mm, attaching a quality close-up lens to the front of it permits you to photograph this tiny grasshopper hiding in a flower.

close-up lenses are made. Some are quite inexpensive, but the quality is lacking. Cheap ones often suffer from a lack of sharpness and lower the contrast in the image. High-quality close-up lenses cost more, but more than make up for the added cost by producing much higher-quality images with vastly improved sharpness.

NIKON AND CANON CHOICES

Both Canon and Nikon make high-quality close-up lenses in the $60 to $150 range, depending on brand and size. The Nikon close-up lenses are made in the following sizes and powers.

Size

- 52 mm
- 3T (1.5 power)
- 5T (2.9 power)

- 62 mm
- 4T (1.5 power)
- 6T (2.9 power)

Canons' high-quality 500D close-up lenses are all the same power, but come in four different sizes to fit a variety of zoom lenses. These are made in 77 mm, 72 mm, 62 mm, and 58 mm sizes. Canon also offers the 250D series, but these are designed for use on lenses with focal lengths of 135 mm or less, so don't consider buying these.

It is important to use high-quality close-up lenses to obtain excellent images. Unfortunately, most camera stores only stock inexpensive close-up lenses that you should avoid. If the salesman wants you to buy a set of three close-up lenses that include a +1, +2, and +4 power, don't buy them. These are most likely single element close-up lenses that won't produce sharp images. Most likely you will have to special order good close-up lenses or buy them from a large mail order camera store.

As long as the close-up lens screws on the front of the lens, they should work on any zoom lens. If you intend to use a close-up lens on a variety of lenses that take different filter sizes, it is wise to buy one to fit on the lens with the largest filter size. For example, suppose you plan to use the close-up lens on a 100–400 mm zoom that has a filter size of 77 mm, a 75–300 mm zoom with a filter size of 58 mm, and a 180 mm macro with a filter size of 72 mm. Buy a Canon 77 mm 500D close-up lens which works perfectly on the 100–400 mm zoom. Then buy two adapter rings, each with 77 mm threads on one side so the 500D lens can be attached to it. On the other side of one adapter ring, get 72 mm threads. On the second adapter ring, get 58 mm threads. Now you can use the same close-up lens on all three lenses.

Advantages

Using close-up lenses is much cheaper (even the good ones) than macro lenses and are easy to carry since they are light and small. These filters don't cost you any light, unlike extension tubes and macros, so the viewfinder stays bright and exposure times don't get too long.

A huge advantage close-up lenses have is once you have sharply focused the subject, zooming out to increase magnification or zooming in to a shorter focal length to reduce magnification has little effect on focusing distance. This means it is easy to keep the subject in focus without having to move the tripod. Once you zoom a bit, it is only necessary to fine-tune the focus once again in the normal manner. With both macro lenses and extension tubes, changing the magnification usually means the camera distance needs to change too, forcing you to move the tripod. This sounds like a small thing, but the ease of using close-up lenses on zoom lenses is a powerful reason for using them. Although we prefer long macros, many other professional nature photographers use quality close-up lenses on good zoom lenses only and their results are superb!

Disadvantages

If you put a close-up lens on the front of any lens, you won't be able to focus on far away objects without removing it. This isn't much of a problem though since you are shooting closeup images anyway. To take a landscape image, just remove the close-up lens. With a macro lens, you can focus on infinity or on something very close by changing the focusing distance, so macro lenses are more convenient.

Close-up lenses work by shortening the focal length of the lens they are put on and thereby increase the angle of view. A reduction in working distance and an increase in the angle of view is not helpful. That's why using close-up lenses on zoom lenses that reach 300 mm works so well. With a closeup lens on the front of it, the real focal length might be 220 mm which is still quite good. If you used a close-up lens on the front of an 80–200 mm zoom, the lens might only be a 130 mm lens with all the problems of a shorter focal length.

No matter how high quality the close-up lens is, putting any additional glass in the optical path will cost you a slight loss of sharpness, which you probably wouldn't notice without running special tests to check sharpness. Macro lenses tend to be somewhat sharper because they are optically made for closeup images and no extra glass is put in the optical path unless a filter such as a polarizing filter is used.

EXTENSION TUBES

Extension tubes are metal spacers that fit between the camera body and the lens. They permit any lens to focus closer and come in different sizes. It is often best to buy extension tubes made by your camera's manufacturer. If available, it is important to buy dedicated extension tubes that preserve autofocusing, autoexposure, and auto aperture operation. Nikon makes extension tubes in different sizes while Canon makes a 12 mm and 25 mm tube. Tubes in the 25 mm to 50 mm range are the most useful. The bigger the extension tube, the more magnification you get with any lens.

Without getting too mathematical, extension tubes yield more magnification with shorter focal lengths. For example, a 25 mm tube yields life-size magnification with a 25 mm lens. This same tube only yields about 1:2 life-size on a 50 mm lens and 1:4 on a 100 mm lens. Of course, these lenses focus closer than the infinity setting, so you get additional magnification.

Extension tubes work really well on the common 300 mm f/4 lens. By putting a total of 50 mm of extension tubes between the 300 mm lens and the camera body, the 300 mm lens is now able to focus so close that you can think of it as a 300 mm macro lens. If your digital camera has a 1.6x crop factor, you can fill the viewfinder with even smaller subjects while enjoying the benefits of having more working distance and a smaller angle of view. Moreover, nearly all 300 mm telephoto lenses have tripod collars too. It is quite likely that

your camera system doesn't make a 50 mm extension tube. With my Canon system, I stack two 25 mm extension tubes together to make 50 mm of extension. While Nikon offers many extension tubes, they don't preserve autofocus and may not work with your digital SLR. Instead, consider buying a set of Kenko extension tubes that work with your system. The Kenko set I use for the Canon EOS system comes in a set of three which includes 12 mm, 20 mm, and 36 mm tubes. These can be used individually or in any combination. Autofocusing and autoexposure is preserved!

The advantages of extension tubes are that they are inexpensive and effective. Being light and compact, they are easy to carry in the field. Since extension tubes don't have any glass, they don't hurt the optical quality of the lens. Extension tubes work tremendously well behind any fixed focal length lens.

There are some disadvantages in using extension tubes, but they are easy to deal with. Putting an extension tube between the lens and the camera body makes it impossible to focus on infinity unless you remove the tube. Extension tubes sometimes don't work well on zoom lenses and may not even couple to them. Since you have to put the extension tube on and take it off when not needed, they are slower to use than a macro lens. Extension tubes do cost you light (unlike close-up lenses), so

Extension tubes are used for more than macro images. Most big telephoto lenses don't focus very close. Using a 25 mm extension tube increases close focusing capability so small birds such as this Cassin's finch appear larger in the image.

you may lose some of your automatic capabilities such as autofocusing and/or autometering. When buying extension tubes for your system, always check with the dealer to make sure they are compatible with your system. It is wise to buy extension tubes that preserve AF if they are available from the camera manufacturer or an aftermarket brand such as Kenko or Sigma.

TECHNIQUES FOR SHARP IMAGES

Closeup images require adopting techniques and strategies that consistently produce sharp results. Light is lost when using extension tubes or macro lenses to magnify the image. As magnification increases, depth of field decreases rapidly so apertures such as f/16 are necessary to make the most important parts of the subject sharp. Due to loss of light and depth of field considerations, typical shutter speeds for closeups are frequently in the 4–1/8 second range. Magnifying the image also magnifies any movement of the camera or subject, so it becomes far more challenging to make super sharp images. Using a tripod is absolutely mandatory for making stunning images with natural light. Be sure to use a tripod that is designed so the legs can be spread wide making it easy to work near the ground where so many closeup subjects are found.

Depth of field which is the zone of acceptably sharp focus becomes very shallow at high magnifications from 1/4 life-size and greater. For instance, at three times life-size, the depth of field at f/16 is only a couple of millimeters. It is critical to focus carefully in all nature photography, but especially macro since the limited depth of field available isn't sufficient to mask minor focusing errors. It is best to manually focus the lens on the most important part of the subject such as the eye of a robber fly or wing of a butterfly. Perhaps a specific part of a wildflower is most important such as the stamens so focus on those.

Since depth of field is so limited in closeup photography, align the focusing plane with the most important plane in the subject. Consider a dewy spider web or the wings of a sleeping butterfly. To make the dew on the web or the wings of the butterfly as sharp as possible, the focusing plane and the plane of the dew drops caught in the web or the wings of the butterfly must be parallel, so the limited depth of field covers the subject as completely as possible. Shooting the dew-laden web or butterfly wing at an angle will certainly throw part of the subject out-of-focus. The greater the angle to the plane of the wing, the more out-of-focus part of the subject will be. It is better to choose an angle where the dominant subject plane and sensor plane are parallel.

A tripod is absolutely mandatory for making natural light images in low light. These dewy blueberries might be a fine breakfast snack, but never eat the good compositions until you are done. Neither one of us noticed the jumping spider until we viewed the image on the computer.

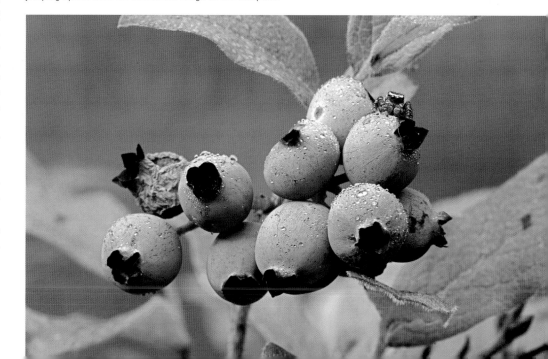

USE OPTIMAL APERTURES FOR SHARPNESS

The apertures on most lenses begin at f/2.8 or f/4 and end with f/22 or perhaps f/32. Depth of field is shallow at f/2.8 and greatest at f/32. Since depth of field decreases as magnification increases, surely f/22 or f/32 is the best aperture to use to get the most depth of field. While f/22 offers far more depth of field than f/11, it does not produce sharper images. The aperture value refers to the physical size of the aperture in the lens. As the aperture size decreases, a higher percentage of light rays passing through the aperture strike the edge which causes those rays to bend. This bending of light is called diffraction and reduces sharpness. It is possible to get more depth of field at f/32 for example, but sharpness declines due to diffraction. Lenses are most sharp about 2 to 3 stops down from the largest aperture (smallest f-number) on the lens. If your macro lens covers the range of f/4 to f/32, the sharpest apertures hover around f/8 to f/11. The f/4 and f/5.6 apertures are quite good though so don't be afraid to use them if you wish. At f/16, sharpness begins to decline slightly due to diffraction and becomes much worse at f/22, but it still may be acceptable. The smallest aperture is f/32, but diffraction renders this aperture useless unless sharpness is not that critical.

LEFT: Depth of field is limited in closeup photography. Focus on the most important part of the subject such as the eyes of this robber fly. This image shows the depth of field at f/3.5. RIGHT: Here is the same image using f/19 for more depth of field.

SOLVING WIND PROBLEMS

Wind makes shooting sharp closeup images almost impossible with natural light. Fortunately, there are many strategies that can be employed to minimize wind problems. One effective technique is to trip the camera with a cable or remote release. By waiting for a lull in the breeze, fire the camera immediately when the subject finally stops moving by pressing the cable release which is connected to the camera. Some cameras have remote releases which are not connected directly to the camera, but still permit you to fire the camera at the optimal moment. It is effective to peer through the viewfinder of the camera without touching the camera or the tripod. By watching the subject sway back and forth in the viewfinder, it is easy to see when the subject is perfectly still relative to any of the lines etched on the viewing screen. When you see the subject is motionless against a line on the viewing screen, trip the shutter immediately. Unfortunately, this technique requires patience or it may make you a patient. Too many photographers become impatient and trip the camera when the subject is almost holding still, not when it is motionless. When using shutter speeds of 1/8 second and longer, the subject must be motionless or it will not be sharp.

This green gentian wiggles if the air is moving at all. Use a plamp to stabilize the plant and a cable or remote release to trip the shutter as soon as it is completely still.

SELF-TIMER CONSIDERATIONS

Many photographers use the self-timer instead of a remote release to trip the shutter. The self-timer works fine most of the time. By setting the camera on self-timer, you can compose the shot on the tripod, press the shutter button gently and the camera fires the shot two to perhaps 10 seconds later. This lets any vibration created in the camera by pressing the shutter button to dissipate. The amount of delay depends on your camera model which can be varied in many models. Two seconds is plenty of time to allow vibration created by pressing the shutter button to disappear. While this technique works very well when wind is not a factor, it is ineffective if you are waiting for your flower to stop wiggling in a slight breeze because you don't know if the subject will be holding still when the self-timer runs out and trips the shutter. In this case, the remote or cable release is clearly the best way to fire the camera since you can shoot as soon as the subject holds still, not two, four, or perhaps 10 seconds later.

Avoiding wind is an effective strategy. Since the best light tends to occur early or late in the day when the atmosphere is often calm, closeup nature photographers tend to shoot most of their images during these two periods of time. On calm mornings, dew and frost might be present to add their own special closeup opportunities. Some of my best closeup meadows are surrounded by tall trees which block the prevailing wind from blowing the subjects too much. Hanging a cloth on the upwind side of a wildflower can help block the breeze making sharp images possible.

PLAMPS TO THE RESCUE

The plamp (plant-clamp) is a device made by Wimberley that works enormously well for holding subjects still. By carefully attaching the plamp to a wildflower to avoid hurting the stem, the flower can be forced to hold still permitting sharp images. Using the plamp is easy. Attach the plamp to a light stand or cheap tripod and place it near the flower. Now attach the other side of the plamp to the flower so the plamp doesn't appear in the image. This holds the flower still most of the time. By bending the plamp carefully to change the angle of the subject, it is easy to adjust the shooting angle of the flower to utilize a different background such as a green meadow or blue sky.

MIRROR-LOCKUP

There are times when there is no breeze at all, so using the camera's self-timer is quite effective. Hopefully, your camera offers a choice of timer delays. Ten seconds is useful if you plan to run around the camera and get in the photo too, but it is a long time to wait if you don't need the time. Many cameras offer a 2-second delay which is the best choice for closeup photos. Be sure to check the cameras instruction manual carefully to see if the self-timer delay is adjustable. Many cameras do have adjustable delays, but this fact is often hidden in the manual. For example, the popular Canon 20D uses a 10-second delay when the camera is set on self-timer. If the mirror-lockup option is set and the self-timer drive mode is selected, the self-timer defaults to a useful 2-second delay.

The motion of the mirror may cause the camera to vibrate on the tripod a bit causing a slight loss of sharpness, especially with shutter speeds in the 1/8 to 1/30 second range. If you do not need to peer through the viewfinder to see if the subject is swaying a bit, it is a good habit to use the mirror-lockup control if your camera offers it. If your camera does not provide for mirror-lockup prior to the exposure, avoid the shutter speed range just mentioned.

TERRIFIC LIGHT FOR CLOSEUPS

Unlike landscape photography, closeup subjects are small making it easy to modify the light to improve the image. Wildflowers, mushrooms, frogs, and nearly all other closeup subjects photograph well under overcast conditions because the light has low contrast which reduces the problem of overexposed highlights or shadows with no detail.

Unfortunately, most of us find wonderful subjects when the light is not ideal for them. A super flower blossom in bright sun might be way too high in contrast, especially if the background is shaded.

Diffusion Disks

Too much contrast is easily solved by using a white diffuser. When the diffuser is placed between the subject and the sun, the light instantly becomes low in contrast, being similar to the light on a cloudy day. Be sure to use a diffuser that is large enough to diffuse the light on the flower and the background. If you diffuse the light only on the flower and leave the background in bright sun, the background will be too bright. Most of the time, I use

32-inch diameter diffusion disks made by PhotoFlex. These disks have a metal frame, so the diffusion cloth is stretched to maintain its shape. The disk is easily held above the subject by a helpful friend or you. Since the camera is mounted on the tripod, one hand trips the shutter while the other holds the diffuser. The diffusion disk is the best way to work for any subject such as cactus flowers, poison ivy, or dewy butterflies where you absolutely don't want the diffuser to touch the subject.

Diffusion Cloths

Diffusers that work fine include white nylon parachutes from military surplus stores and white nylon material purchased from fabric stores. These must be supported, but they do work well when they can be hung between two trees with snap clothes pins or held by a friend. Make sure the diffusion cloth is thick enough to diffuse the light to eliminate hard shadows, but not so thick that it reduces the exposure too much. A 2 to 3 stop reduction in light is just about right. Using a large parachute is effective when the subject requires you to photograph it by shooting toward the ground.

Here is how to use the parachute successfully to reduce contrast. Find a wonderful subject such as a mushroom family or wildflower. Push a stick in the ground on the other side of the subject to hold the parachute up so it doesn't droop between the lens and the subject. Throw the parachute over you and the subject and work underneath it. Bright sun instantly becomes bright overcast with the parachute. If you carefully pull the edge of the parachute all around you and the subject, it blocks gentle breezes too making sharp images easier to obtain.

Never throw a diffusion cloth over cactuses because the spines of the plant tear holes in the fabric or break off, becoming embedded in the cloth where they may end up in you when you fold the cloth up.

All diffusers work best if the shooting angle is toward the ground because the device can easily diffuse the light falling on the subject and the background. If the shooting angle is parallel to the ground, the diffuser may not work because it won't diffuse the light on the background. In this situation, it may be better to modify bright light by using reflectors or fill-flash.

REFLECTORS

These light-modifying devices come in a wide variety of shapes and colors. You can make them at home by attaching aluminum foil to a piece of cardboard. The reflector you put in the front window of your car to keep it cooler could double as a photographic reflector too. We have used the 22-inch multidisk made by PhotoFlex for years with wonderful success. The disk comes with four reflector colors and a diffuser all in one. The four reflector colors are gold, gold and silver combined, silver, and white. The gold or gold/silver combination is terrific for orange, red, and yellow subjects because it enhances the

On a sunny day, using a diffuser to soften the light on this aster and the background lowers contrast and saturates the color.

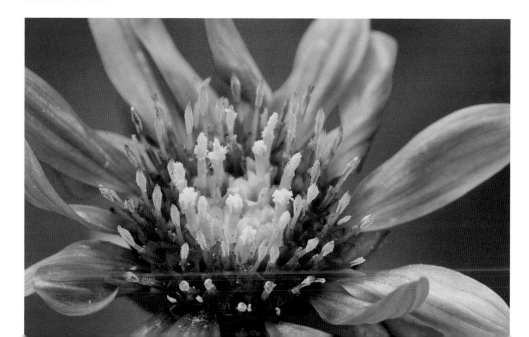

colors. Use the silver or white side for blue, white, or violet colors to avoid adding unnatural warm color casts.

Using Reflectors

Reflectors are easy to use since you can see their effect as you move the reflector from side to side. The reflector is used to bounce light into the shadows of the subject. Moving the reflector closer to the subject increases the amount of light striking the subject which reduces the contrast. Moving the reflector further away reduces its ability to soften shadows.

When light is very soft and low in contrast such as might be the case on an overcast day, it is possible to use the reflector very close to the subject to actually increase the contrast a bit. Reflectors can add enough light to the subject without adding anything to a background that is several feet away so the background darkens relative to the subject. Changing the light ratios helps to separate the subject from the background.

Cross-Lighting with Reflectors

Nature photographers often use front-lighting which works fine much of the time. However, if you always use front-light, your images tend to have a look of sameness after awhile. Here's a wonderful way to use your reflector. During dawn when the light has a reddish color cast, assume you find a gorgeous wildflower blossom or butterfly laden with dew. Instead of photographing the subject front-lighted by shooting toward the West, instead put the camera on the shadowed side so the lens is pointed toward the East. Now the subject is backlighted. If it is not translucent, major portions of the subject will be severely underexposed if you expose for the highlights. This light is very high in contrast which creates deep shadows and perhaps overexposed highlights too. However, backlight does nicely rim-light the subject. To lower the contrast, place a reflector near the camera to bounce the golden sunlight back toward the shaded side of the subject. When held at the proper distance (a couple feet away), the light bouncing off the reflector nicely opens up the shadowed side of the subject eliminating dark shadows. Since contrast is greatly reduced, it is easy to obtain detail in both the dark and light portions of the subject. Using the reflector in this way is known as cross-lighting because the dawn sunlight comes from the East and the reflector bounces it back toward the East so the light crosses itself. When done properly, you still get wonderful rim-lighting on the subject and plenty of detail in the shaded side too! It is a hugely successful technique so be sure to add it to your bag of tricks.

CLOSEUP FLASH TECHNIQUES

Advances in camera and flash technology have made using flash for closeups no more difficult that using natural light.

Modern flash units are called dedicated flashes when they are made for a particular camera system. The camera measures the light emitted by a flash and turns it off when the desired exposure is achieved. This is called through-the-lens flash metering. It is a wonderful system because using any photographic equipment that cost you light such as an extension tube, macro lens, or filter is automatically compensated for by the flash meter in the camera. The camera turns the flash off when the sensor records enough light.

Selecting the flash unit to purchase is easy. If you are using a Nikon camera body, choose from any of the fine Nikon flash units that are dedicated to the camera body you have. If you shoot Canon, Pentax, or Olympus, choose a dedicated flash for your camera. Sometimes a system may make more than one dedicated flash. The features will vary a bit, but the biggest variable will most likely be the power of the flash unit. Bigger and more expensive flashes emit more light which is important if you hope to light a subject that is some distance away. Macro subjects are close to the camera so power is not that important. A small dedicated flash works fine for closeup photography, as long as it can be used off-camera and placed near the front of the lens.

Flash is especially useful for nocturnal subjects like night-blooming cacti, singing frogs, and moths. Very tiny subjects such as horse flies, spiders, beetles, and some wildflowers also need flash to put enough light on the subject to make a sharp image. In these examples, flash is used as the sole light source. Since the flash duration with a dedicated flash unit is 1/1000 second or shorter, making sharp images when using flash as the sole light source is easy if the lens is properly focused, even if shooting hand-held!

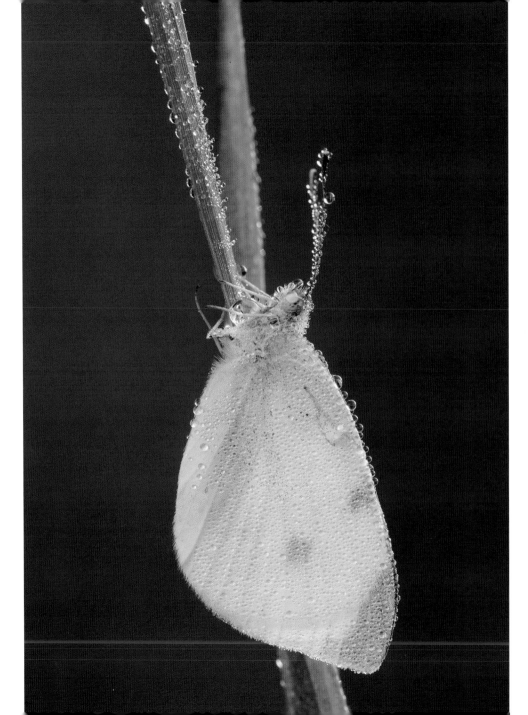

Another important reason to use electronic flash for closeups is to fill in shadows. Using the flash as a fill light to open up shadows in the closeup subject that are caused by natural light is a skill that all closeup photographers must master. Effective fill-flash is an enormously successful technique that helps you become an exceptional photographer.

Placing the Flash

Before using an electronic flash as the sole light source or as a fill light, the flash must be put in the best location. Most cameras come with a hot shoe on the top of the camera. Unfortunately, this position creates lousy light when flash is used as the only source of light. On camera flash is too frontal, eliminating all shadows which makes the photo look flat since there are few shadows so little depth is suggested. This position often causes the red-eye effect in animals where the eyes become bright red. Moving the flash off to the side somewhat both eliminates the red-eye effect and introduces some shadows. Another serious problem with the flash mounted on top of the camera body for closeup photography is subject distance. Often the subject is so close to the front of the lens (especially at the higher magnifications) that the flash cannot be tilted down enough to light the subject. Instead, the light from the flash passes above the subject without illuminating it. Even if the flash can be angled correctly, in many cases the lens hood blocks

Like most macro subjects, fill-flash or reflectors help add sparkle to this dewy cabbage white butterfly.

the light. This often happens at magnifications from 1:2 (one-half life-size) and above because the working distance is so small.

In closeup photography, the flash works best if it is placed near the front of the lens. This can easily be accomplished by hand-holding the flash. A simple way to reposition the flash is to use a flash bracket that attaches to the bottom of the camera body or perhaps to the tripod collar of the lens (if your lens has a collar). A variety of brackets for supporting the flash are available. Three good sources for them include Wimberley, Kirk Enterprises, and Really Right Stuff. It can be confusing to buy the perfect bracket for your system because a variety of brackets are made to work on all the different systems. The best way to get precisely what you need is to call any of these companies and tell them exactly what you have so they can select the best equipment for you.

Once the flash bracket is attached to your equipment, attach the flash to the other end of the bracket. A good flash bracket lets you adjust the angle of the flash relative to the subject. With the flash now mounted near the front of the lens shade, it is a simple matter to rotate the flash a bit, so it is pointed at the subject. A good place to start is about 30 degrees above the line connecting the subject and the lens. This will create a shadow underneath the subject. Try moving the flash a little left or right of the lens too. Now you have a small shadow under the subject and to the opposite side as well. These angles eliminate the red-eye problem and the presence of shadows suggest depth in the image.

Using Your Hand to Hold the Flash

Flash brackets aren't always needed. If the camera is supported by the tripod, it is easy to trip the camera with one hand while holding the flash near the front of the lens. This is the technique I use most of the time. For example, I like using flash as a fill light when making closeup images of wildflowers, mushrooms, lichens, and insects. Once the subject is properly focused with the camera mounted on a tripod, it is effective to place the flash near the front of the lens, point the flash at the subject, and fire three shots, each time moving the flash to a different position. Since it doesn't cost anything to shoot extra digital images, try holding the flash near the left side of the lens and slightly above it, directly above the lens, and to the right side of the lens. The flash illuminates the subject differently in each of the three images. One image may clearly be better than the others.

Firing the Remote Flash

Since the flash isn't mounted on the camera's hot shoe, how is the flash triggered? Three commonly used methods to trigger the flash include the dedicated flash cord, remote controller, and using the built-in flash to activate the remote flash. All methods work well, but each has advantages and disadvantages.

Dedicated Flash Cords

Camera manufacturers make these flash cords that connect the flash to the camera. Dedicated cords permit the camera to control the flash, preserving through-the-lens flash metering which is crucial in closeup photography. The cord should be long enough (at least 2 feet) so you can hold the flash anywhere you want it near the front of the lens. This system does work quite nicely.

The most serious drawback is the cord may get in the way at times and may even bump the subject if you try to use if for sidelighting or backlighting. If you are careful though, all of these problems are easy to avoid. The most serious problem is the length of the cord restricts where you can place the flash. If the cord is 2 feet long and you need to put the flash 3 feet away, you are out of luck.

The Flash Remote Controller

A far more convenient way to fire the flash, but more expensive, is to use a remote controller. Canons' unit is called the speed light transmitter (ST-E2). Nikon is called the wireless flash controller. These flash controllers slide into the hot shoe on the camera and maintain through-the-lens flash metering.

I always use the wireless flash controller when using flash. It is incredibly convenient to hold the flash where it needs to be (even behind the subject for rim-lighting) without fussing with a cord that connects the flash to the camera. I demonstrate the use of wireless flash controllers in my field workshops almost reluctantly, because I know it will cost many of my students some money. While my students may have heard of the controller, few ever realized the advantages of it until I show them. Once they see how it simplifies using flash, especially for fill

applications, they order one right away. As I write this, the Nikon flash controller is about $80 (street price) and the Canon ST-E2 runs about $215.

Use the Built-in Flash to Trigger the Main Flash

A third option that is terrific is some systems are designed so the pop-up flash on the camera can trigger a remote flash. This system does work nicely and eliminates the need to buy dedicated cords or remote flash controllers. Unfortunately, most cameras and flashes aren't set up to do this. As technology evolves, I am certain this capability will become more prevalent.

Fill-Flash Techniques

While it is very effective to use flash for the main or only light source in some situations, I feel flash is far more useful as a supplementary light. Using flash as a fill light is necessary for making the best closeup images. Fill-flash solves a host of problems. Most closeup subjects have deep shadows. Even on a dark overcast day when the light is extremely low in contrast, a mushroom has dark shadows underneath the cap which acts like a hat. Fill-flash easily adds light to the darkest areas, lowering the contrast, and revealing the detail in the stalk and perhaps gills of the mushroom.

The color of light is a huge problem for film and somewhat of a problem for digital, although the colors produced by a digital camera are easy to adjust, especially if you shoot RAW images. Pink Calypso orchids grow near decaying logs in dark coniferous forests around my home. The orchids are always in the shade so the light is extremely blue. A warming filter would reduce the excess blue or the shade white balance setting could be set to solve this problem. But, neither method eliminates all the extra green light that is reflected from the foliage to the orchid. The color temperature of the light emitted from the flash is neutral in color since it is balanced for daylight around 5500 to 6000 K. Even if the flash exposure is 1.5 stops under the natural light exposure, the light from the flash greatly minimizes the color cast in the natural light.

Using Fill-Flash

Due to through-the-lens metering, effectively using flash as a fill light is quite simple to do today. Most D-SLRs have two exposure compensation controls, one for flash and one for natural light. Make sure you know where they are, which is which, and how to adjust them.

Fill-Flash Example

Lewis's monkeyflower is a common wildflower along wet streams in the mountain drainages of the Northern Rockies. After finding an excellent blossom, mount the camera on the tripod and carefully focus and compose the image. Without using any flash at all, take a natural light exposure and check the histogram. Make sure the histogram is close to the right side without clipping any highlights. Once the best natural light exposure is set, bring in the flash and set it for a compensation of −1.5 or −1.7 stops, depending if the flash is set for 1/3 or ½ stop intervals. Using one of the three methods described earlier to trigger the flash, hold the flash close to the lens on the left side and fire a shot. Check the histogram again to make sure nothing is clipped and no pixels are flashing. There shouldn't be anything since the flash is adding very little light to the highlights where clipping would occur first. Try another shot with the flash held close to the front of the lens hood and right above it. Now take a third shot with the flash held on the right side of the lens hood. By bracketing the flash angle slightly, one image may be better than another. Since there is no cost to shooting digital images, it is effective to bracket the strength of the fill-flash by trying another set of three images with the flash set at −1 stop and perhaps a third set with the flash set to −2 stops.

Since the camera can measure the flash and natural light exposure separately, this permits using the flash and natural light compensation button at the same time. Most modern flash units permit exposure compensation with a control on the flash and the camera. However, adjusting the flash compensation on the camera might cause a problem because it forces you to touch the camera which could change the focus slightly. It's best to adjust the exposure compensation on the flash.

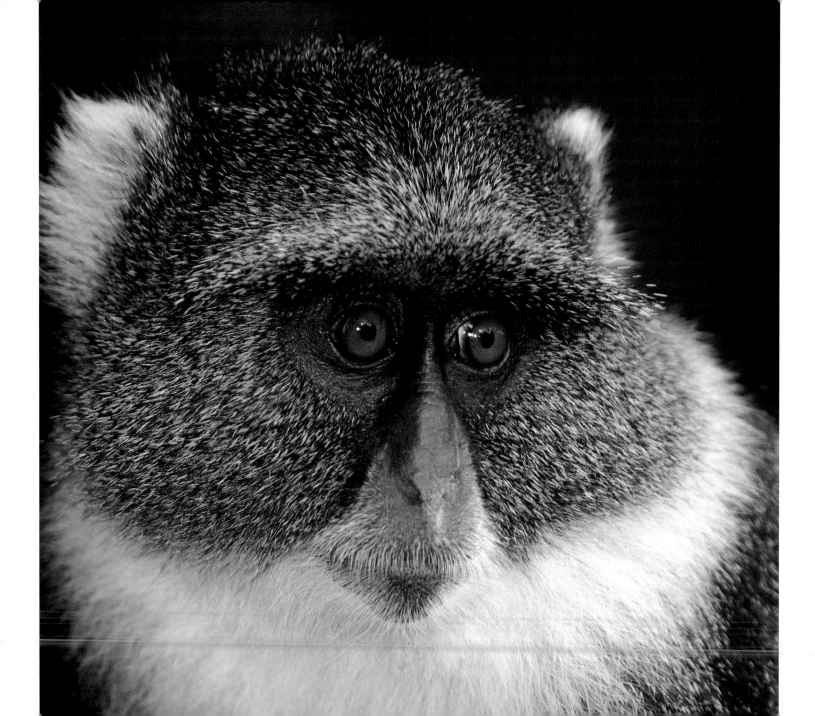

Using Flash Effectively

Using electronic flash to create wonderful images is a goal everyone can achieve. Unfortunately, many photographers are intimidated by these seemingly complicated devices. Digital photographers tend to quickly become comfortable with flash because they review the good (or poor) results of their efforts right away on the LCD monitor so they can make corrections until the images are pleasing.

PROBLEMS WITH ON-CAMERA FLASH

Flash is capable of achieving excellent lighting effects. Unfortunately, if your camera has a built-in flash, the light it produces creates terrible images most of the time. Any flash used on top of the camera produces nearly direct front-lighting so all shadows fall behind the subject. This creates images that appear to have little depth because shadows are critical for suggesting depth and revealing shape. Images shot with on-camera flash are often said to be flat. Your flash images will improve dramatically if you learn to use flash off the camera, combine flash with natural light, and use more than one flash at a time. None of this is difficult, but it does require some study and practice to become adept at it.

Advantages of Flash

Flash produces light whenever and wherever you need it. This makes it possible to take photos no matter how little natural light is present. Anyone who photographs nocturnal wildlife or subjects in dim light appreciates this advantage. Another important benefit of using electronic flash is it is balanced for daylight around 6000 K. Flash can remove an unwanted color cast in natural light. A white flower photographed in a green forest has an undesirable green color cast, but flash can minimize the green cast easily. Since it is easy to fire a flash that is not directly mounted on the camera with cords or wireless technology, it is simple to

LEFT: A single on-camera flash illuminated the face of this Sykes monkey at the Mountain Lodge near Mt. Kenya. The monkey was perched on a branch in deep shade so the much brighter background didn't go completely black.

angle the flash to achieve whatever lighting effect you want. Another powerful advantage is short flash durations (usually about 1/1000 second) freeze subject or camera movement yielding sharp images. This permits shooting hand-held high magnification images of insects that are perfectly sharp and still use f/16 depth of field.

Disadvantages

Modern flashes are expensive ($250–$400 for the best ones) and do require effort to learn how to use them well. Having a flash and accessories that go with it takes up precious room in the camera bag and adds weight. You need a power source to use flash. This is normally batteries which must be kept recharged. Some flashes are designed so they can be plugged into AC power, but extra cords are needed to do this.

A huge problem with flash is the terrible looking light it creates when used poorly. Flash is prone to produce images with too much contrast unless steps are taken to reduce the problem. Flash is inherently high in contrast for two reasons. Large light sources create more diffused light and lower the contrast in an image. Flash is a tiny light source used near the subject so it illuminates only the part of the subject that is facing the flash while the other side remains very dark or totally black creating dark shadows. That is why accomplished nature photographers often use diffusers on the flash like portrait photographers to reduce the contrast. The second reason why a single flash is so high in contrast is there is no fill light in many cases. We all know bright sun creates images that can be beautifully exposed on one side, but burdened by deep shadows (often times objectionable) on the other side. A single flash used off the camera as the main light can create worse images than bright sun due to even more contrast! While the shadows on a sunny day are problematic to photographers, at least the blue sky is acting as a fill light to open up the shadows. Since a single flash doesn't have a fill light to open up the shadows unless the photographer combines available light with flash, the shadows are black with little or no detail. The contrast range is much greater with flash than it would be if the light from the sun was used.

Flash does seem complicated. Anyone who studies the flash instruction book learns this quickly. Flashes are powerful tools with many different features so the manual seems difficult because so many different capabilities are covered. But, most of the features you want to use are straightforward and easy to learn if you take it one step at a time. Don't try to learn everything the flash does all at once. Break it down and learn a little at a time.

Finally, flash is intimidating because it is difficult to see how the light illuminates the subject since the flash duration (the

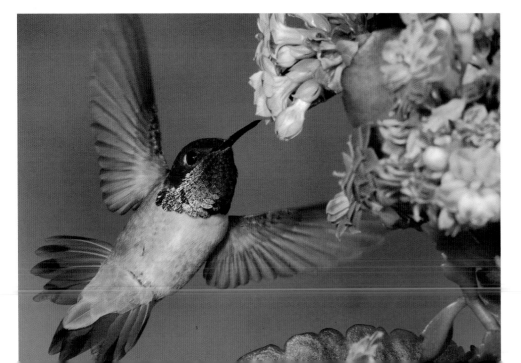

Firing five flashes at one time was necessary to capture the colors of this male rufous hummingbird and keep the background from going black. Three flashes illuminated the hummingbird while two flashes evenly lit the painted background. The instant feedback digital offers helps to learn simple and complicated flash techniques quickly.

Using a single flash as the only light source at the sync speed of the camera nearly always causes a black background. This background isn't desirable for the gray treefrog that was hunting insects during a calm morning.

Here is the same frog using natural light as the main light and a tiny pinch of fill-flash (−2-flash compensation) against a natural green background. Use flash carefully!

amount of time the flash is illuminating the subject) is so short. However, as you work with flash, you'll soon learn to judge the lighting effects you get just by where you place the flash.

THE INVERSE SQUARE LAW

This is an important law of light that describes what happens to the intensity of light over distance. The law states that the quantity of light is inversely proportional to the square of its distance. That should clear things up!

Perhaps an example of how the inverse square law works is easier to comprehend. The inverse square law describes what happens to light as it spreads out over distance. Let's say the proper aperture to use is f/16 when the flash is 4 feet away from the subject. If you cut the flash to subject distance in half to only 2 feet, you do not double the amount of light hitting the subject. Instead, you quadruple the amount of light or add 2 stops of light to the subject. Conversely, if you move the flash back to 8 feet from the subject (twice as far), the amount of light striking the subject is only 1/4 as much because the beam of light is spreading out rapidly so the intensity drops. If you move the flash to 16 feet from the subject, the amount of light drops another 2 stops for a total of 4 stops. As you can see, the light output of the flash rapidly drops as the distance to the subject increases which affects how you use flash tremendously.

The typical electronic flash won't do you much good if the subject is 50 feet away since very little of the flash actually reaches the subject. That's why flash photos often end up with a black background.

If you flash a wildflower and don't allow natural light to help light the scene, a background that is 20 feet away appears completely black because the light from the flash spread out so much that little was left to light the background. Most skilled nature photographers avoid black backgrounds, especially for daytime subjects, but they are suitable for nocturnal subjects.

It is possible and productive at times to use fill-flash with telephoto lenses to reduce shadows in birds and mammals. This means the flash must be fired from quite a distance away from the subject. The typical flash by itself isn't able to throw much light on the animal due to the Inverse Square Law. However, flash extenders can be purchased at reasonable prices that mount on the flash head of most flashes. A flash extender is made with a special material that concentrates the light from the flash and keeps it from spreading out rapidly, greatly increasing its effective fill-flash range. This is a very useful device that is widely used in wildlife photography. It works well when it is needed, but don't feel like you need to use it all the time. When you have gorgeous light illuminating the subject, often it is best to use natural light and forget about adding fill-flash. The last thing you want to do is destroy the mood of early morning red sunlight.

SELECTING YOUR FLASH SYSTEM

Consider the flash system made for your camera first. All the major digital camera companies make flashes specifically for their cameras. Since these flashes are made to work closely with the camera, these flashes are often called dedicated flashes, offering advanced through-the-lens (TTL) metering capabilities which makes them easy to use. For general flash photography with a single flash or multiple flash, it is impossible to beat the system made for your camera. A dedicated flash properly exposes the subject most of the time. In situations that are light or dark, perfect flash exposures are easily made by properly using the flash compensation control. Since dedicated flash has TTL metering, using fill-flash successfully is easily accomplished.

You need at least two and sometimes more identical flashes to do multiple flash photography. Two is needed frequently so one flash can act as the key light while the other is used to fill in the shadows created by the key flash. Dedicated flashes are easy to use and can be adjusted to provide a variety of lighting ratios. Barbara uses a Nikon SB-800 for fill-flash with her Nikon system. We own five Nikon SB-800 flashes to complete a multiple flash setup to photograph hummingbirds. These flashes used in combination are wonderful to work with and greatly simplify flash photography. Using dedicated flashes for your camera is the best way to go.

Determining Flash Exposure

The easiest, quickest, and most accurate way to determine flash exposure is to rely on dedicated flashes to automatically determine proper exposure for you. Modern systems that use TTL metering are amazingly accurate. Since the camera and flash work together to fire the flash and measure the light as it passes TTL, the camera turns the flash off when proper exposure is achieved. If you don't have dedicated flashes, then another good way to determine the best exposure is to use a flash meter. Unfortunately, these are expensive. Since your digital camera has a histogram, it is quite feasible to set up multiple flashes and guess at the best exposure. By using the histogram to guide you, it is easy to zero in on the best exposure. This works well and is exactly what I do anytime I can't use TTL flash metering rather than using my flash meter or sloshing through the quagmire of guide numbers.

When TTL Flash Fails

There are times when TTL flash metering fails due to subject reflectance. Like natural light exposure meters in cameras, the built-in flash meter in the camera is programmed to make everything middle tone or 18% reflectance. If the subject is a very dark red, blue, or green for example, the camera keeps the flash on until it becomes middle tone in reflectance which overexposes the subject. Conversely, a TTL flash metering system darkens white, pink, or light yellow flowers to make them middle tone. Since nature photographers often photograph very light or dark subjects, they frequently run into exposure problems due to subject or environmental reflectance values. You know that subjects with a reflectance that is not close to 18% require exposure compensation. But, it is quite feasible to find a middle tone brown insect crawling on light tan sand. While the reflectance of the brown insect doesn't throw the flash exposure off, all the light tan sand surrounding it which is the environment does so exposure compensation toward the plus side is necessary.

Flash Compensation Guidelines

Like natural light exposures, the subject or environmental reflectance values that vary considerably from 18% do cause poor exposures. To solve this problem, a flash exposure compensation control is found on the camera, flash unit, or both. Do not confuse the exposure compensation control for natural light with the one for flash. These two controls are different so be sure you know where they are, which is which, and how to use them. It is absolutely critical to know how to compensate flash exposure. Here are some useful guidelines. Any light-colored subject such as a yellow butterfly, pink wildflower, or light tan grasshopper needs about 1 stop more light so set the compensation dial to +1 stop. Any subject that is pure white or close to it needs about 2 more stops of light. Dark subjects such as a maroon flower might need less light, perhaps −1 stop. Black subjects need about 2 stops less light.

The beauty of shooting digital cameras is you have both the highlight alert feature and the histogram to check your exposure after taking the image. Get in the habit of checking these tools with each subject you photograph, especially if you use exposure compensation. If you use flash to expose a light yellow flower and set the compensation control to a +1 compensation, take the shot and check the histogram. Be certain the histogram is not clipped on the right side of the graph, but it should end close to the right side. If the histogram is clipped a bit, too much compensation was given so reduce it to only +0.5 stop compensation and try again. Once you get the histogram data

close to the right side of the chart without clipping, you have an excellent exposure.

DO YOU NEED A FLASH METER?

If you don't have TTL flash metering, it is possible to use a special meter that measures flash. However, these meters are expensive ($300–$500 range), but they do work well for single and multiple flash setups. I own and used to frequently use a Minolta Flash meter. However, now that I have a histogram to go by, anytime flash is necessary with units that don't offer TTL metering, I set up the flashes where I think they need to be and then take a shot. By checking the histogram, it is quickly apparent if the image is properly exposed. If the exposure is too dark, moving the flashes closer, increasing the ISO setting on the camera, or using a larger aperture puts more light on the subject. If the exposure was too light, doing the reverse subtracts light. Once the histogram ends close to the right side of the histogram graph, proper exposure is assured.

Flash Sync Speed

Digital single-lens reflex (D-SLR) cameras have a flash sync speed which refers to the fastest shutter speed that can be used with electronic flash successfully. Depending on the model, the sync speed is typically in the shutter speed range of 1/125–1/250 second. Please consult your camera manual to determine the exact sync speed for your camera.

The reason the camera must have a flash sync speed is due to how focal plane shutters work. The shutter prevents light from striking the sensor until it opens and then sends the sensor into darkness once again when it closes. The shutter is made with two blades that are often called curtains. When the shutter opens, a light-tight curtain moves out of the way so light reaches the sensor. At the end of the exposure, a second curtain moves to block the light once again. Let's say the flash sync speed for the camera you have is 1/250 second. When shooting at that shutter speed, the first curtain opens, the flash fires illuminating the subject which reflects back TTL and is recorded by the sensor, and the second curtain begins its movement to block the light. The same pattern holds for all slower shutter speeds. However, if you try to use 1/500 second, the first curtain begins to open, but to achieve the high shutter speed of 1/500 second, the second curtain chases after the first curtain before it gets to the other side. Essentially, you have a rapidly moving slit for an opening. Since flash has such a short duration of perhaps 1/1000 second, the sensor must be fully exposed when the flash fires so every part of it can be exposed. This is impossible with a moving slit where the entire sensor isn't uncovered at any single moment in time. If you have flash photos where one side is black, you probably fell victim to this problem when you set the shutter speed higher than the sync speed. Camera's with dedicated flash communicate with each other so usually the camera won't let you set too high of a shutter speed. This problem is much more likely to happen with any non-dedicated flash or manual flash photography.

Slow-speed sync

In normal flash photography, you must use a shutter speed that matches the sync speed which is listed in your cameras manual *or any slower shutter speed*. Be aware the flash works at any shutter speed slower than sync speed too. Using slower shutter speeds permits mixing flash with ambient light easily to solve many lighting problems. The technique of using flash to light the foreground while using long shutter speeds to allow bright natural light to properly expose the background is commonly employed by skilled nature photographers today.

However, be careful when using shutter speeds slower than sync speed. If the ambient light on the foreground is bright and you use flash as the main light for the subject, it is possible to get ghosting. This happens when the flash records a sharp image of the subject while the bright ambient light creates a second blurry image if the subject or camera moves during the exposure. If the foreground is several stops darker than the background, this ghost effect is unlikely to occur because little ambient light from the subject strikes the sensor.

High-speed sync

If you could make the flash emit light longer, it would be possible to use faster shutter speeds with flash and still properly expose the entire sensor. Many cameras with their dedicated flashes can do this. Canon and Nikon refer to this as focal plane high-speed sync so the flash can be used at all shutter speeds. When you set high-speed sync to use fill flash on a bird in flight, you can shoot at 1/500 second or faster and still get proper exposure. The camera does

this by firing a series of very quick flashes over a longer period so the rapidly moving slit in the shutter is able to expose the entire sensor. High speed sync is useful anytime you need to use flash with fast shutter speeds that are faster than sync speed. Using fill-flash for portraits of animals in bright sun where high shutter speeds are needed is a good use for this technique. If many cameras can shoot successfully with flash at all shutter speeds when set to high-speed sync, why bother having a sync speed at all? The drawback to firing a series of rapid flashes so the flash appears to be a continuous light source is the effective range drops by 2 stops or more so you must be much closer to the subject.

USES FOR FLASH
Flash as the Only Light Source

There are times when so little available light is present that flash is the only way to take an image. Caves are a good example. Even if the cave you are visiting is lit with artificial light, it may be too dim and poorly angled to light the scene well so flash needs to be used. Many forms of nocturnal wildlife such as owls, singing frogs, salamanders, and raccoons require flash to make images of these nighttime animals. In these cases, flash is the only light source being recorded by the sensor.

Using a single flash off-camera to photograph anything tends to create images with too much contrast and black backgrounds. Usually it isn't desirable to have black backgrounds and so much contrast that detail is lost. Direct frontal flash produces a strange look too since the subject lacks shadows so little depth is apparent. There

are better ways to use flash so let's explore those.

Reduce Contrast with Fill-Flash

Fill-flash is used most frequently to lower contrast by opening up shadows when the light is bright. Sun and even bright overcast may create harsh shadows in the image. By using a touch of fill-flash, additional light is added to the shadows reducing contrast. Fill-flash with dedicated flash systems is both easy and quite beneficial for making beautiful images.

Anyone can effectively and easily use fill-flash with a D-SLR that has a dedicated flash. For example, let's learn how to use fill-flash on a sleepy dragonfly that is laden with dew. Set the camera on aperture priority and matrix or evaluative metering. Compose the dragonfly and set the aperture to f/16 for depth of field. Since the subject isn't going to move and you are using a tripod (hopefully) to support the camera to ensure a sharp image, use ISO 100 for the finest quality (less noise). Take a shot and look at the histogram. Make sure the histogram data is close to the right side without clipping any highlights which would be the dew drops. The highlight alert (blinkies) shows you if there is any overexposure. If the histogram isn't where you want it, adjust the exposure compensation control until it is. Be sure to use the natural light compensation control, not the one for flash.

Now that the histogram is where you want it for the natural light exposure, set the flash exposure compensation to a minus value. This control is on the flash, the camera, or both. The flash exposure compensation control is normally labeled with a plus

 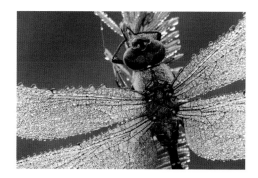 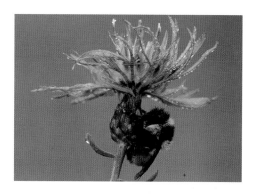

LEFT: This dewy dragonfly is photographed backlit in the soft dawn light. The backlight makes the translucent dew drops sparkle more than front-light. Since light can't penetrate through the center of the dragonfly, its back is dark. CENTER: Adding a tiny dose of fill-flash (−1 2/3 compensation) adds light to the back reducing contrast and revealing detail with little effect on the already light wings. RIGHT: The spotted knapweed acts like a hat that shades this sleeping red-tailed bumble bee. Using fill-flash (−1 1/3 compensation) nicely opens up the shadows while still keeping the soft natural light mood.

and minus on it along with a zigzag arrow indicating flash. Depending on the camera, the increments for flash compensation are normally 1/3 or ½ stop. Deciding how much fill you want is a matter of personal taste. The goal is to open up the shadows to reveal detail, but not to use such a strong fill-flash that it overpowers the natural light appearance. Shadows provide a feeling of depth to the subject and reveal texture so don't eliminate them entirely. The amount of fill-flash to use depends on the situation and personal taste. Start with a fill-flash of −1.5 and bracket around that by also using −2 and −1 fill-flash. When first learning to use fill-flash, it doesn't hurt to bracket even wider to see what happens. While it does cost you a little time in editing, bracketing helps you enormously in learning to use fill-flash.

Flash as the Main Light Source

Mixing light from the flash with natural light is an outstanding way to use electronic

flash and fairly easy to do with modern equipment. While fill-flash is well known and widely used, it is possible to do the reverse and use natural light as the fill-light. Set the flash on automatic and use the more advanced metering modes. Canon has an evaluative metering system that measures the flash illuminating the subject and turns the flash off when it determines the subject is properly exposed. The names and exact controls vary with the system so you need to study the manual to find out exactly how your system operates. But, the general ideas described here apply to any system.

Suppose you find a light-colored mushroom deep in the forest. You don't want to use a single flash as the only light source to avoid harsh shadows. It is better to mix flash and ambient light together. The light in the forest suffers from a greenish color cast due to all of the green leaves so you want to use natural light only as a fill. You want flash to be the main light source

because it is balanced for daylight so the color is better for recording the mushroom. However, you should use the available light as a fill light to avoid black shadows. You don't need to run a lot of calculations to figure out what must be done. Use the flash and natural light automatic metering systems along with the histogram exposure aid to figure out what to do.

First, determine proper exposure for the flash. Set the camera on aperture priority and matrix or evaluative metering. Since this mushroom is light, set the flash compensation to +1 and take a shot with the aperture set on f/16 for depth of field. Check the histogram to make sure the data on the histogram is snuggled up against the right side without clipping. If the histogram isn't where you want it, try another compensation amount. At this point, you are only concerned about the flash exposure and the highlights in the image. Don't worry if parts of the image are black with no detail.

Now determine the natural light exposure. Keeping the aperture at f/16 (that's why you should use aperture priority), let the camera select the shutter speed to properly exposed the mushroom with natural light. Perhaps the camera recommends f/16 at 1 second. Once again check the histogram to be sure it is close to the right side. Perhaps this requires setting the compensation for natural light to +1 stop. Since the flash is the main light and natural light acts as a fill to avoid black shadows, it is necessary to set the camera to underexpose the natural light a bit. Since we have already determined that setting the natural light compensation to +1 properly exposes the mushroom, set the compensation back to zero so the natural light exposure is 1 stop underexposed. By using a dedicated flash cord or remote flash controller to separate the flash from the camera, hold the flash a few inches to one side and slightly above the lens. When you shoot the image, the flash perfectly exposes the mushroom and the weaker natural light fills in the places that aren't illuminated by the flash. The shadows are somewhat underexposed, but still retain plenty of detail. Of course, it is absolutely mandatory to have the camera supported by a tripod to avoid ghosting. If you tried to hand-hold this shot, the flash produces a sharp image because the flash duration is short. But due to the slow shutter speed being used, the natural light portion of the exposure is soft due to camera movement.

Increase Contrast with Flash

Flash can be used successfully to increase contrast such as darkening a background. Suppose you are photographing the maroon red flower of a northern pitcher plant. The background is a solid mass of light green sedges and grasses. You know the light background is distracting so toning it down is helpful. While it is possible to shade the background, flash can be used to darken the background. Set the camera to matrix and aperture priority. Use an aperture of f/11 which gives some depth of field, but not so much that the background becomes sharp. You are doing a portrait of the flower and want a non-distracting out-of-focus background. Focus on the flower and shoot an image. Check the histogram to make sure the data is close to the right-hand side without clipping. If it isn't, use the natural light exposure compensation control to get it there. Since the flower is dark, it could be necessary to set the natural light exposure compensation to −.5 stop for the best exposure. Now set the exposure compensation to −1.5 stops. You are deliberately underexposing the natural light portion of the image by 1 stop. The flower and the background are now 1 stop darker. Attach the flash with a dedicated cord to the camera (or use a remote controller) and hold the flash above the lens and slightly to one side so it creates some shadows in the flower blossom. Set the flash to full power and take a shot. The flash should properly expose the flower blossom (check the histogram to be sure), but the background which is several feet away receives little light from the flash so it is 1 stop darker relative to the flower.

Use Flash to Improve Color

Fill-flash is enormously useful for improving the color temperature of available light. Shooting images in a green forest

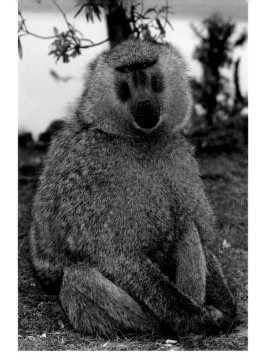

This olive baboon quietly rested under some green trees at Lake Nakuru. Fill-flash opened up unwanted shadows and removed most of the excess blue and green in the natural light.

was a huge problem for film since the green color cast made everything look awful. Since flash is balanced for daylight around 6000 K, using flash as a main light or a strong fill light overpowers the green cast in natural light, producing the colors we expect the subject to be.

Use Flash to Freeze Action

Electronic flash is a terrific way to freeze motion. Most electronic flashes at full power have flash durations close to 1/1000 second. Even though you must shoot at the flash sync speed of the camera which should be in the 1/125–1/250 second

range, flash still freezes the action if the ambient light is low because the light illuminating the subject is only on for 1/1000 second or less. If the natural light is within 5 stops of proper exposure though, you may get ghosting. This happens when the flash makes a sharp image, but the natural light is strong enough to also record on the sensor creating a double exposure where the natural light exposure shows blur due to camera or subject movement.

REAR-CURTAIN SYNC

It can be desirable to pan with a running animal or flying bird and photograph it with flash. When the ambient light is strong, you get a sharp image of the animal from the flash and a blurry one from the natural light which can be quite appealing because it shows motion. There is just one problem though. When you use flash and natural light together to reveal motion, the flash fires at the beginning of the exposure (as soon as the first shutter curtain opens all the way) and goes out. Meanwhile, the longer natural light exposure is still being captured by the sensor. The result is an image where the animal is sharp and the blur is ahead of the animal instead of behind it. Fortunately, this problem is easily solved with most cameras because they offer a special setting for this situation. Depending on the camera, it may be called rear-curtain or second-curtain sync. This setting makes the flash fire at the very end of the natural light exposure so the blur of the running animal is behind the sharp flash image of the subject instead of in front of it.

USING MULTIPLE FLASH

Using two or more flash units at one time solves numerous lighting problems while offering tremendous creative choices. Multiple flash once was difficult to use well because you needed to learn how to use guide numbers or buy an expensive flash meter. Once again, TTL flash metering with dedicated flashes has simplified this process enormously.

Selecting Your Multiple Flash Setup

Always consider flash made by your cameras manufacturer first. You want flashes that are dedicated to the camera so they can communicate with each other. Canons 580 EX flash units are ideal for multiple flash. A great choice for Nikon is the SB-800 flash units. Pentax offers the AF-540, Olympus has the FL-50, and Sigma builds the EF-500 DG ST which is available for Canon, Minolta, Nikon, Pentax, and Sigma cameras. All of these units provide TTL flash exposure control.

Firing Multiple Flash at the Same Time

The first question you might have is how do you fire two flashes simultaneously in a multiple flash setup? We commonly use five flashes at once (and sometimes seven) for advanced high-speed hummingbird photography. There are a few prevalent ways to do this and all work well. Multiple Canon flashes for example can be fired at the same time by putting the Speedlite Transmitter ST-E2 in the hot shoe of the camera. By setting all of the Canon 580 EX flash units

on slave, pressing the shutter causes the ST-E2 to send an infrared signal that fires all of the flashes instantly without using any wires. This wireless system is most effective as long as the flashes aren't too far apart and the signal from the transmitter isn't blocked. Another way to fire multiple Canon flashes is to mount one Canon 580 EX flash unit in the hot shoe and select the master setting on the flash. Set all the other flashes to slave. These flashes are now controlled by the 580 EX unit attached to the camera. Nikon has a somewhat similar system which they call the creative lighting system. It's important to make sure the camera and the flashes you intend to use communicate with each to provide TTL metering and offer the ability to fire all of the flashes at the same time. No matter what multiple flash setup you decide to purchase, check carefully with the dealer for options and make sure everything you plan to use is compatible with each other.

Setting Up the Multiple Flash System

Using multiple flash at one time is a wonderful way to light your subject exactly the way you want it. Since more than one flash is used, it is easy to put a key flash somewhat above and perhaps 30 degrees to the right side of the subject. This flash nicely illuminates the right side of the subject, but deep black shadows appear on the left side since the flash couldn't light it. Add a second flash (fill) to the setup by placing in on the left side of camera-subject axis, but keep it close to the axis to avoid creating crossing shadows on the subject. While it depends on the subject and personal preference

of the photographer, normally the fill-flash is placed so it is at least 1 to 2 stops weaker than the main flash. A third flash could be used above and slightly behind the subject to rim it with light. This light is called the hair light. If you don't want a black background, then you will benefit from placing a flash that is aimed at the background to light it up. Using three or more flashes at once might sound like a challenge to figure out, but it really is easy once you do it a few times.

SUPPORTING THE FLASH UNITS

Using more than one flash at a time means you must use flash supports to hold them in place. Many flash stands are made so what you need depends on your intended use and personal preferences. I use Manfrotto stacker stands (Model 3320) because they are quite stable, can hold the flash as high as I will ever need it, and they are designed to stack together

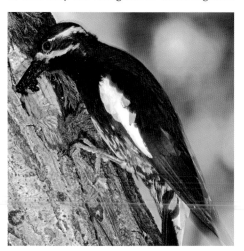

This male Williamson's sapsucker was feeding it's young. This pair excavated their nest cavity on a tree that was leaning over. To photograph this nest that was only 4 feet above the ground, a key and fill-flash was used to light the bird. A third flash lit the background.

so five stands are compact. These stands are made to accept a variety of connectors. I use the Manfrotto 3102 rapid adapter which is 3/8 inch in size. Now a Manfrotto #482 micro-ball head can be attached to the rapid adapter on top of the stand. By using the mini stand that came with my 550 EX flash, it is easy to slide the mounting foot into the mini stand and screw it on to the #482 micro-ball head on the flash stand. Since the flash is mounted on the small ball head, it is easy to point the flash in any direction.

Power for the Flashes

Rechargeable batteries and AC power are the two most frequent ways to power electronic flashes. When there is no AC power anywhere close, using rechargeable batteries is an effective way to go. Of course, if you are using four flashes at one time and each takes four batteries, you need 16 batteries to power the setup, plus you need a second set of 16 batteries if you don't want to run out of power at an inconvenient time. Using batteries is a serious problem with multiple flash, but it does work if you have a second set of charged batteries and two or three battery chargers. It is preferable to use AC power, but many modern flashes are not designed to utilize this power so batteries may be your only choice.

Adjusting Light Ratios for Two Flashes

Using multiple flashes is a terrific way to light your subject well. But you need to know how to place the flash units and vary the lighting ratios. Normally, you want to avoid flat light (total front-light) because few shadows are created so the subject lacks depth. On the other hand, you don't want shadows so dark that color and detail is hidden. From lots of experience, I find that using a lighting ratio of 4:1 between the key and fill-flash resembles natural light well. The difference between the key flash and the fill-flash is 2 stops. Setting this ratio is easy enough, assuming the two flashes are identical. Last year I photographed a red-naped sapsucker at it's nest cavity. Since the woodpecker would face to the left as it perched at the nest cavity, I put the key flash 4 feet from the nest cavity. The key flash was 20 degrees to the right and slightly above the height of the camera. To reduce the light output of the fill-flash by 2 stops, I put this flash twice as far away at 8 feet. The fill-flash must open up the shadows created by the key flash that appear on the tree to the left of the woodpecker. I put the fill-flash on the left side of the imaginary line that connects the camera to the subject. The fill-flash was placed at the same height as the camera and as close to the camera-subject line as possible so it doesn't create any shadows of its own. This flash arrangement effectively illuminates the woodpecker. I used the histogram to determine the best flash exposure and found I needed to use f/16. Before the woodpecker even appeared, I photographed

the tree to see where the exposure was as indicated by the histogram. In this case, my exposure was 1 stop darker than I wanted it so I changed the ISO from 100 to 200. I could have moved the flashes closer or changed the aperture from f/16 to f/11 to get 1 more stop of light too. When I took my first image of the sapsucker, I checked the histogram one more time to make sure light feathers were not being overexposed.

Making This a Three-Flash Setup

The two-flash setup described above would produce fine results if the background was only a couple feet behind the woodpecker. However, if the background were several feet away or further, due to the Inverse Square Law, the light falls off rapidly as it travels over distance so the background goes black. Woodpeckers are active during the day so a black background appears unnatural. An easy way to solve this problem would be to place a large piece of bark or even a painted background 10 feet behind the nest cavity. Now I could point a third flash at the background. To make the background properly exposed, I needed to put an identical flash 4 feet away from the background, the same distance the key flash is from the woodpecker.

In this case, I didn't do that. A natural background such as another tree was not in a good position. Since the nest was 6-feet high, it would be difficult (but not impossible) to move an artificial background into position. There is another way to get a light background without using flash. This strategy works anytime the natural light

on the subject is much less than the background. This red-naped sapsucker nesting in my back yard was in dense forest. In the afternoon, the nest cavity is totally shaded by trees, but the background is a distance mountain in bright sun so the background was at least 5 stops brighter than the woodpeckers nest cavity.

My two flashes were set up so f/16 properly exposed the woodpecker. This means I had to keep the aperture at f/16 to control the flash exposure. However, flash properly exposes the woodpecker at sync speed

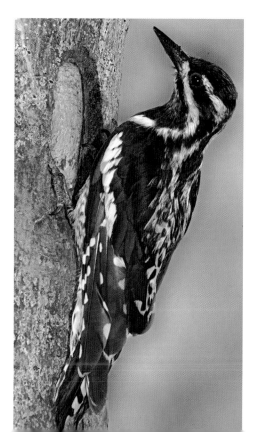

(1/250 second in my case) or any slower shutter speed. The mountain background was too dark if I shot at f/16 and 1/250 second. Leaving the aperture at f/16 while using manual exposure, I pointed the spot meter in my camera at the bright mountain and slowed the shutter down until the meter indicated a fine exposure for the mountain. This happened when the shutter speed was 1/30 second. By using an exposure combination of f/16 and 1/30 second shutter speed, I easily photographed the woodpecker, getting detail in the bird and the background. The aperture controls the flash exposure while the extra long shutter speed of 1/30 second allows the brighter natural light on the mountain to perfectly expose the background. Getting a ghost image from the woodpecker moving wasn't a problem because the natural light on the woodpecker was several stops less than the background. This method of using flash always works well anytime the subject has much less natural light on it than the background. It is a very effective technique that is well worth mastering.

Electronic flash has many uses in nature photography. It is nothing to be afraid of and quite easy to use once you get started. You'll make mistakes in the beginning, but mistakes are opportunities to learn. Enjoy your exploration of flash!

This red-naped sapsucker had dug it's nest in a live aspen in our yard. A key and fill-flash lit the woodpecker while a long shutter speed of 1/30 second allowed the bright mountain background to be exposed properly too. Learning to mix flash with natural light is crucial to successful flash photography. Manual exposure makes this technique easy to do.

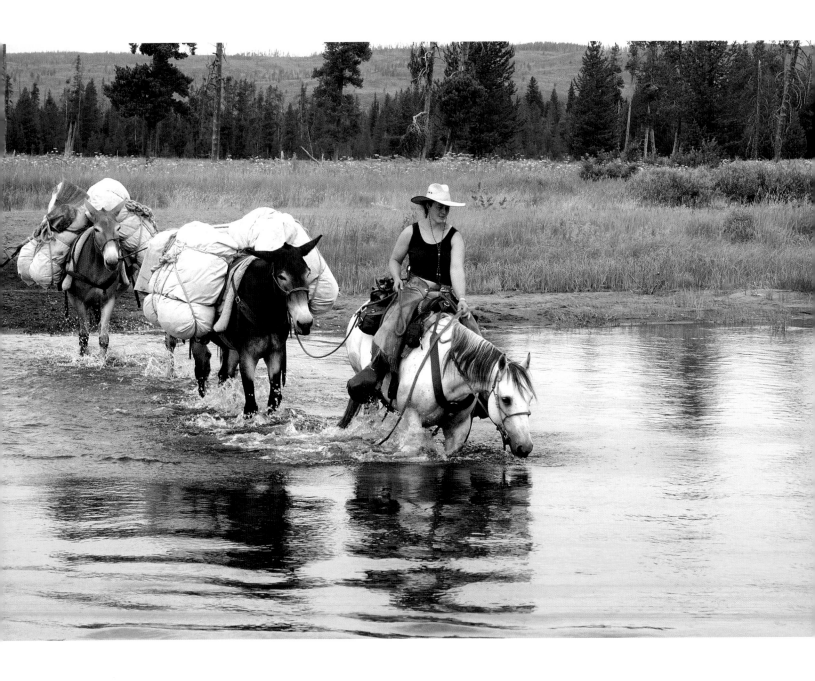

Carrying Your Photography Gear

While it is possible to make excellent nature photographs near the road where you can work out of your car, you will have to hike to the vast majority of exciting nature images. Even a relatively short hike of a few hundred meters means you must move your photographic gear to the site. There are numerous ways to move camera gear around so let's take a look at the options.

The easiest way to move camera gear is having someone carry it for you. Sometimes a non-photographer spouse or friend is happy to go along and carry some of the weight. While gorilla trekking in Rwanda, it is customary to hire a porter to carry your camera bag up and down the slippery mountain slopes for only a few bucks-a great bargain. But, most of the time you'll need to carry your own gear. Let's take a look at different ways to do that, but realize there is no one best way that is perfect for everyone.

THE CAMERA STRAP

Every new camera probably comes with a camera strap to help you carry it. It does work, but I have seen the strap fail when it wasn't properly fastened to the camera and let the camera crash to the ground. The strap is best for people who tend to drop things a lot. By using the strap, there is a better chance they have a grip on the strap when the camera is dropped. Camera straps have their downside too. When using tripods, the camera strap easily gets caught in the tripod leg or head locking mechanism. When shooting straight down during closeup photography, the dangling strap might strike the subject. Just because the camera comes with a camera strap does not mean you have to use it. Nearly every

LEFT: Michele Smith is our office manager who doubles as an expert mule packer and backcountry guide. We commonly use mules and horses to carry supplies and camera gear deep into the wilderness.

We never use camera straps. Dangling straps often get in the way and could strike these raindrops on an autumn maple leaf ruining the image.

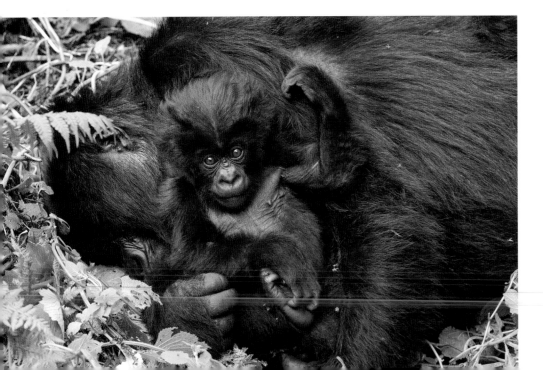

Most mountain gorilla visitors use porters to carry their camera equipment up the steep slippery slopes.

advanced nature photographer we know quit using camera straps years ago. Perhaps they aren't for you either! Some sort of camera bag or case is needed to carry all of your gear. Let's take a look at those.

HARD-SIDED CASES

Early in my career, I used a hard-sided aluminum case that was superb for protecting camera gear. The inside of the case was made with heavy foam that had to be cut out to fit my camera gear. This system worked well until I bought new equipment that wouldn't fit in the spaces I had cut out. The aluminum case was heavy too. Since it couldn't be made into a backpack, I carried it in one hand until that hand became tired, then switched to the other and so forth. I finally decided a hard-sided aluminum case wasn't the answer when I hiked 3 miles and climbed 2000 feet up a rugged snow-covered mountain in the Sierra Nevada Mountain range. I set the case in the snow and turned to set up the tripod. When I turned around to get the case, I discovered it slid down the mountain. I followed its trail for over a mile before finding it caught in the branches of a small conifer tree. The contents were fine so the case did its job perfectly of protecting the gear, but a camera case that can go on a joyride by itself leaves much to be desired. However, these cases do protect delicate gear well, so if you don't have to carry the

case far and want to protect fragile gear well such as flash equipment, these cases do work fine for this purpose.

SOFT-SIDED CASES
Shoulder Bags

These bags are offered in all different sizes. Usually, the bag has adjustable dividers inside so you can adjust the individual compartments to fit your equipment. These bags do work well if you don't have too much equipment which is quite possible with digital and you don't hike long distances. Shoulder bags are quick to use because a single strap fits over your shoulder as you walk along, so they are popular with street and travel photographers. It is easier to get to your equipment because you don't have all of the straps to undo like you would with backpack camera bags.

However, most nature photographers shy away from shoulder bags because they have lots of camera gear so all of this weight is on one side which gets tiring after awhile. The uneven weight makes you unbalanced, making it more difficult to hike and negotiate difficult terrain. Plus, you lose the use of one hand because it is holding the shoulder strap unless you slip it over your neck.

Backpack Camera Bags

Soft-sided camera backpacks are the most widely used type of camera bag used by nature photographers. Backpacks distribute the weight of the contents across your body. Since the bag is strapped to your back and fastened using quick release snaps around the waist and chest, both hands are free to carry a tripod, push away brush as you walk, slap mosquitoes, or any number of other uses.

Camera backpacks have been around a long time so they come in all sizes and shapes with many features. Visit the web sites of the leading manufacturers of soft camera backpacks to find out what is available. Lowepro, Tamrac, and Tenba offer many choices for the digital nature photographers. All of these companies and others make excellent bags. A good camera backpack bag is designed to fit your body snugly to make it easier to carry. Most have

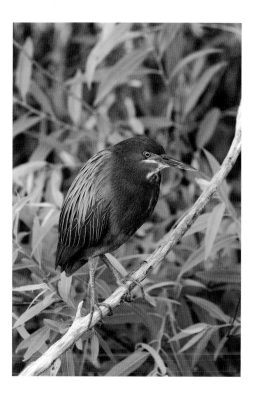

moveable internal dividers that can be adjusted to precisely fit your equipment. Since wet weather and nature photography go together, look for a bag that repels rain.

The bags we use are made by Lowepro. It is called the PhotoTrekker AW II and sells for about US $240. This bag easily holds two camera bodies, three or four small lenses, and a large 500 mm lens right in the middle of the bag, plus filters, CF cards, flash, and other small accessories. AW stands for all weather which means this type of bag has a special waterproof flap that can be pulled over the bag to keep moisture out. Except for the smallest commuter prop planes, this bag fits under most airline seats and in the overhead compartment, so it is airplane friendly.

Many backpacks are designed so the tripod can be attached to the bag. I tried this method, but found the large tripod I use bounces around too much. Instead, I carry my tripod by resting the padded legs on my right shoulder while holding it there with my right hand. This system works for me, but doesn't mean it is the best way for everyone.

Photographer's Vest

These are special vests that are filled with numerous pockets that use zippers, velcro,

Many of the best images are made by walking a long way from the car. Be sure to have a way to protect your gear from rain. We hiked more than a mile to find this Green-backed heron in the Florida Everglades, a place well known for sudden soaking storms.

and/or snaps to seal each pocket. Some photographers love them while others have no use for them at all. It all depends on personal preference and shooting style. Photojournalists are more likely to use a photographer's vest because they shoot hand-held a lot and need to move quickly. Nature photographers tend to stay in one place longer than photojournalists. A nature photographer hikes to a waterfall, puts their camera backpack down on the ground in a safe spot, and works out of the bag without moving it for the next 2 hours while they photograph the waterfall with an assortment of lenses. Since nature photographers tend to take their time, it isn't necessary to have instant access to all of their equipment.

I find expensive pieces of camera gear are prone to falling out of the vest at critical times and I constantly "lose" stuff in one of the many pockets so I don't use them very often. I wish to emphasize that is just me. However, if you don't have too much equipment, always remember where you put everything, and never have anything fall out, a photographer's vest could be perfect for you.

Long Lens Bags

Wildlife photographers frequently use super telephoto lenses to shoot the great images they get. It is important to protect long lenses, but still be able to get to them quickly. Using a long lens bag (sometimes called a case) is an excellent way to go. These are designed by the companies I mentioned earlier to fit big lenses. Be sure to ask for their literature, visit their web site, or look at the bags in a well-stocked camera store.

Speed is important in wildlife photography, so look for a long lens bag that is large enough to accommodate your lens with a camera already attached to it. To shoot the big lens, unfasten the top of the bag, take the lens cover off the lens, turn the lens hood around and attach to the lens, turn the camera on, and you are in business.

While photographing wildlife on a safari in Kenya, we teach our clients to snugly bungee cord the long lens bag to the back of their extra seat. The lens hood and camera body is already attached. Put this back into the long lens bag so the back of the camera body is facing up. Now place the lens cover over the camera body to keep it

We rarely use a photographer's vest. We hiked more than a mile up this shallow creek to find these autumn leaves swirling about in a miniature whirlpool. It is too easy for something to fall out of the vest when standing in water.

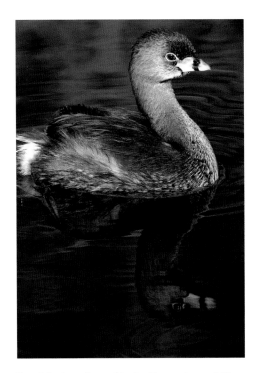

To get the lowest possible shooting angle, we laid on a boardwalk in the Everglades to catch this pied-billed grebe with it's reflection in a small pond. If we were wearing a vest full of camera gear, we would have to take it off to comfortably lay on the boardwalk.

Padded long lens bags are invaluable on a Kenya safari to protect the lens from bumps and dust. This tiny dik-dik at Samburu is always alert and wary because it has many predators. A long lens is usually needed to photograph it.

This mule deer doe calmly watched us along the road. Using a car as a blind to get close to wildlife and carry equipment is often effective.

clean. When it is time to use the lens, take the lens cover off, pull the equipment out of the bag, turn on the camera, and you are ready to capture some outstanding wildlife images. It only takes seconds to do this!

CAMERA BAG SETUP STRATEGIES

The contents of my camera bag vary with the season and what I plan to photograph. The biggest change from trip to trip is whether the 500 mm lens is in the bag or not. Here is how I load the camera bag for two entirely different shooting situations. I spend many days each winter photographing in Yellowstone National Park with the aid of snowmobiles. Yellowstone in winter offers numerous wildlife and landscape possibilities and some closeups on frosty mornings.

Here's a list of items I have in my camera bag to photograph Yellowstone in winter.

- 17–40 mm lens
- 24–70 mm lens
- 100–400 mm lens
- 500 mm lens
- 180 mm macro lens
- 1.4x teleconverter
- three 4GB Sandisk Extreme III Flash Cards
- a rubber blower to clean the sensor
- polarizing filters to fit all of the lenses except the 500 mm
- microfiber cloth for cleaning lenses
- one electronic cable release
- two digital cameras
- a few tools to tighten quick release plates and L-brackets
- extra batteries for everything that takes batteries

Now let's compare the camera bag contents for a totally different type of shooting experience. Northern Michigan is famous for summer wildflowers, small insects like dragonflies and damselflies, and spider webs. Since Michigan is surrounded by the Great Lakes and filled with small inland lakes, plenty of surface water is present. The abundance of lakes and ponds permits great quantities of water to evaporate into the air each summer day increasing the relative humidity. On cool, clear, and calm nights, the moisture in the air condenses on everything near the ground in the open meadows. All insects, wildflowers, blueberries, and spider webs are coated with a heavy layer of dew by dawn. These are wonderful subjects for the digital nature photographer.

Let's change the bag around to be more appropriate for the shooting conditions and potential subjects. It isn't likely the 500mm lens will be needed so that is left in the trunk of the car. This frees up a lot of room in the bag to accommodate more closeup photo equipment and accessories.

Bag Contents

- 17–40mm lens
- 24–70mm
- 70–200mm
- 180mm macro
- 65mm 1–5x Canon macro for the really small stuff
- 25mm extension tube
- Macro Twin Light flash system for lighting really tiny subjects
- Canon 580 EX flash for fill-flash
- Canon ST-E2 flash controller
- three 4GB Sandisk Extreme III Flash Cards
- blower brush to clean the sensor and lenses
- polarizing filters that fit all lenses
- microfiber cloth for cleaning lenses
- one electronic cable release
- two digital camera bodies
- a few tools
- extra batteries
- reflectors and diffusers for light control
- Wimberley plamps to hold flowers still

We leave most closeup gear out of the bag when we know we expect to photograph primarily birds and mammals like this gray catbird.

Making closeup images may require setting up the camera bag completely different than bird and mammal photography. We use two different bags to solve this problem.

Since the 500mm lens is waiting back in the car in its own long lens bag, the space that became available by its removal is now filled with extra closeup equipment (25mm extension tube and 65mm macro), plus light controls that include the reflector/diffuser combination, two kinds of flash, and a couple of plamps to help stabilize a closeup subject that might wiggle if the air is moving at all.

FLYING WITH CAMERA GEAR

An excellent way to carry some extra camera gear on an airplane is to use a photographer's vest which is the only reason I own one. It is easy to carry a couple small lenses and some other camera accessories on the plane in addition to my regulation size camera bag. Since I wear the vest, it isn't considered a second carry-on, so it is a good way to get a bit more on the plane. I never overdo stuffing the vest!

I fly from Michigan to Kenya and back at least once a year. I have never had any problems (lucky perhaps) flying Northwest and KLM. I avoid problems by following the rules as closely as possible and go out of my way to be extra friendly and helpful. I always travel as light as possible, taking only what I really need. A few changes of clothes is all that I need since I wash my clothes in the bush camp, but you could use a laundry service. I take two checked bags that aren't close to the weight limits. One bag is filled with clothes. Some of my less fragile gear is wrapped in the clothes. These items include a tripod, ball head, Wimberley Sidekick, extra rechargeable batteries, and cleaning materials. If this bag disappears, I can make due without it. The second checked bag is loaded with clothing that I wear once on safari and leave with the camp workers who are eager to have it.

My Lowepro carry-on camera bag is regulation size and accommodates a 500 mm, 100–400 mm, 24–70 mm, 1.4x teleconverter, and a few other small items. I wear a photo vest to carry a couple more small lenses such as a 100–300 mm and a 17–35 mm zoom plus a flash. I take two lenses that include the 100–400 mm and the 100–300 mm which cover similar focal lengths because that is an important range to cover on a Kenya safari and you never know when a lens will malfunction. Having two lenses that cover this important range of focal lengths is insurance. I do carry a computer with me too in its own bag. Generally, international flights permit one carry-on bag plus a computer bag too, but always check with your carrier before you show up at the gate.

It is wise to avoid using carry-on bags with wheels that are right at the size limit. The wheels make the bag look extra big and suggest that it is heavy too. There is usually a weight limit on carry-on baggage, so the last thing you want to do is draw attention to yourself with this setup and have them double check the size and weight of the bag. Being a friendly and courteous airline passenger who adheres to the regulations (as closely as possible) is clearly the best route to hassle free flying. Always try to board the plane earlier rather than later so some space remains for your carry-on baggage.

Carry as little as possible when you must fly. We always carry our most precious camera equipment on the plane. This bald eagle was easily photographed at Homer, Alaska which requires a lot of flying to get there.

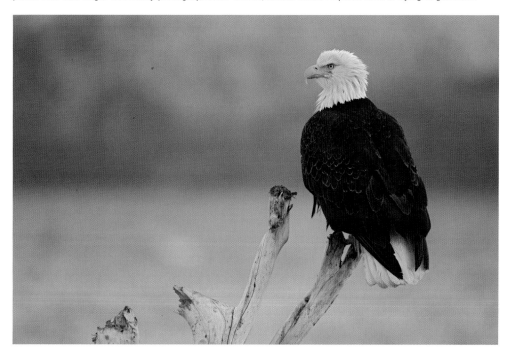

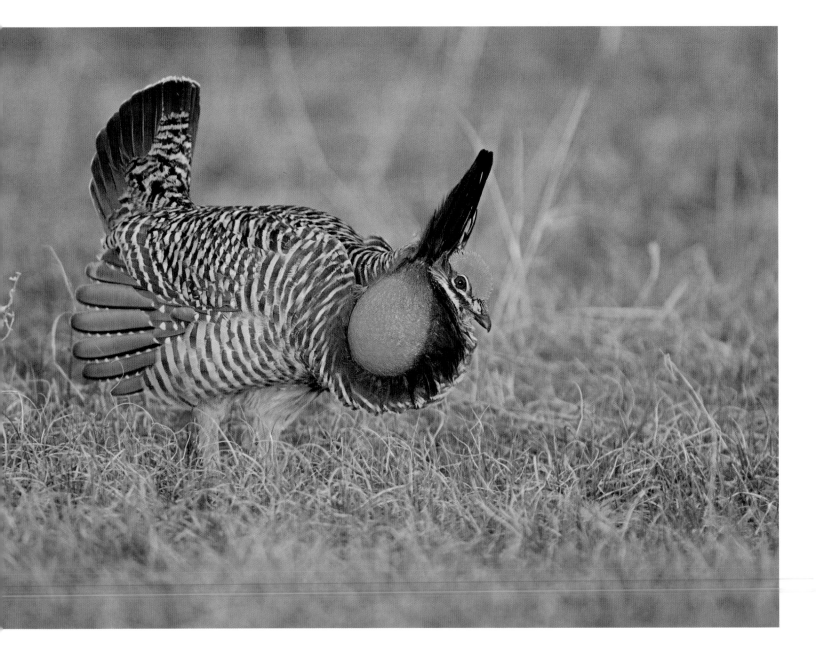

Final Thoughts

<div style="text-align: right">

12

</div>

Nature photographers' love being outside. Spending time finding a gorgeous wildflower or observing the mating dance of a prairie chicken is ample reward in itself. Many of us use nature photography as an escape from everyday life. Pursuing natural subjects to photograph gives us the incentive to get out of bed before dawn and drive to wild areas. We know many people who have become world travelers in their pursuit of photographing nature.

In addition to spending lots of time in wild places, many of us are attracted to the process of taking photographs. Most nature photographers love working their cameras and lenses to get the best images. Every newly introduced piece of photographic gear is carefully studied to see if it offers advantages over equipment that is already owned. The rapid advances in digital photography have kept scores of nature photographers happy and sometimes unhappy at the same time. We are excited to see the introduction of new equipment that makes shooting high-quality images easier. On the other hand, buying all this exciting new equipment is financially challenging for most of us.

Spending quality time in natural areas and perfecting the art and science of shooting nature images with fancy new equipment is rewarding in itself. But, the act of shooting images is not enough for many of us. Eventually, you may feel the urge to do something with your images. Everyone I know shares their images in some way. No particular way is right for everyone so let's look at some of the ways to share the images you have put so much time and money into producing.

LEFT: Nature photography is full of memorable moments. Thanks to Rick Rasmussen who guided us to this private prairie chicken dancing ground, we got to photograph these fabulous birds. Their calls made us wonder what the early pioneers thought when they heard these "boomers" for the first time.

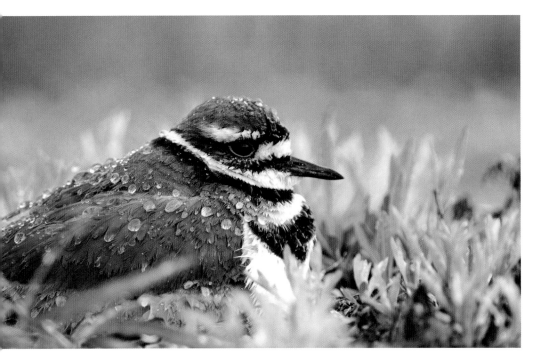

Like most photographers, we love seeing new equipment become available. Barbara used her new (at the time) Nikon 200–400 mm zoom lens to catch this killdeer brooding its eggs in the rain. These birds nest in the grass strip of our long dirt driveway every year.

DISPLAY PRINTS

Since the beginning of photography, prints have been the primary way images are shared with a mass audience. Photographers love having prints of their favorite images adorn their walls at home. Not only do prints that are tastefully matted and framed make beautiful wall decor, but this is a wonderful way to share them with visitors.

Prints make wonderful gifts too. Always consider giving prints of your best images to friends and family members at Christmas or on birthdays. Since a print is so personal, they are usually more cherished than anything you could buy at the store that is mass produced.

PROTECT SPECIAL PLACES

Perhaps a special place such as a pond near your home is threatened by development. Many photographers have used their images to protect these places so everyone can enjoy it now and in the future. A collection of prints depicting a special natural area might help sway the powers that be to protect it. Many wonderful places have been saved from being "improved" upon with the help of photographers. Indeed, Yellowstone National Park, the world's first, was protected in part with the help of early photographers. They photographed its incredible natural wonders and shared these images with important people who eventually saved Yellowstone for its scenic natural wonders.

EARN MONEY

It is possible to sell photographic prints at art shows and galleries. Quite a few professional nature photographers earn their living selling images in this way. While it is true that most nature photographers aren't getting rich, it still is an excellent way to earn a living.

GETTING PRINTS MADE

Making prints can be expensive or inexpensive, difficult or easy, depending on you. If you want only the finest quality prints that technology can produce, expect to pay a premium. If price is a consideration, then less expensive ways are available with little loss of quality. It is amazing how cheaply quality prints can be made by companies that specialize in digital print-making. Even Costco does a great job very inexpensively. Many excellent printmaking companies such as www.mpix.com will take care of your needs over the Internet.

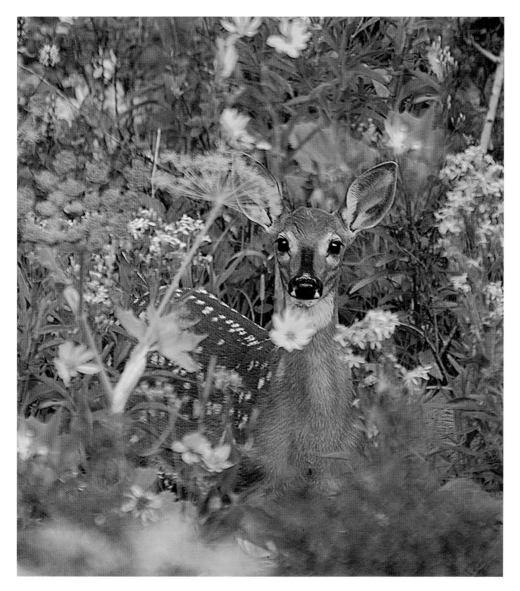

A digital slide show should have a theme, rather than random images. A theme could be baby animals like this whitetail fawn, Kenya wildlife, Antarctica, or wildflowers around your home.

If you prefer more control over your prints, then consider setting up a home digital darkroom. We use the latest version of PhotoShop to adjust our images and print them out in our office with Epson printers and ink. Doing it yourself does require a good deal of equipment and software, plus you must learn a lot about color management and imaging software. While it does take some effort and expense, making your own prints is fun and exciting!

PROJECTING DIGITAL IMAGES

The quality of digital projection is rapidly increasing while the cost of projectors is coming down. It is now possible to buy a good digital projector for $1000 or less. Using software such as ProShow Gold, it is easy to put together fine digital slide shows complete with wonderful dissolves and music too.

I know several incredibly good nature photographers who make digital nature photography programs using simple software to produce outstanding nature shows set to music. These shows are wonderful to behold. Digital shows should have a theme such as wildflowers, seasons, or wildlife. These programs are of great interest to nature centers, camera clubs, retirement homes, and public service groups. Presenting a well-done program is rewarding to the audience and to yourself. Digital shows is a wonderful way to share your images with a mass audience. Some presenters charge a small fee to cover their expenses. If you like creating programs and enjoy public speaking, presenting digital

programs is the perfect match for your talent and desires.

POST YOUR IMAGES ON THE WEB

Many people have their own web site or share their images by posting them on web sites that are designed for this purpose. Two web sites that permit you to post images include www.photo.net and www.nature-photographers.net. Perhaps your Internet service provider such as AOL offers a place to share images too.

GETTING PUBLISHED

One of the crowning achievements of any nature photographer is seeing their photos published in books, magazines, and calendars. Anyone would be thrilled to see one of their photos used on the front cover of a magazine, in the pages of a book, or showcased in a calendar. While you might think that getting published is difficult, I can tell you that it is not. Producers of these paper products need many thousands of images every year and you might very well have the images they want to buy.

Selling images successfully does require having super high-quality images of subjects that buyers want. Your images must be sharp, perfectly exposed, well lighted, and interesting to the client.

TEACH PHOTOGRAPHY

This is an excellent way to share your photographic knowledge and photos. While my favorite part of nature photography is spending time in wild places taking photographs, my second love is teaching others how to effectively photograph nature. I enjoy teaching photography more than seeing my photos published in books, magazines, and calendars. I love teaching photographic field workshops and leading exotic photo tours around the world. It is exciting to carefully guide a group of students to a special place when the weather conditions are perfect so they can make their own exquisite nature photographs. My success is realized through their success!

You could begin your photographic teaching career by offering a course on digital nature photography through a community enrichment program or perhaps at the local nature center. If you find you enjoy teaching, then you might begin teaching field programs further away from home. This is the exact route I took that evolved into a full-time career which has taken me everywhere from the Arctic Circle to Antarctica and more than 25 times to East Africa.

FINDING YOUR DIGITAL IMAGES

No matter how you want to share your images, you must find them first. Most photographers store images on the computer hard drive or preferably on a huge external storage device. You could use the software that comes with your camera to do this or buy an independent program.

We organize our digital images so we can find them easily, but not spend too much time at it. All of the images we shoot in the field are written to a SanDisk 4 GB CF card. We use a SanDisk card reader that is attached to our computer and use a software program called PhotoMechanic that handles RAW images quickly. Using the ingest control in PhotoMechanic, we download all images on the CF card to a folder called New Captures that is on our 120 GB external hard drive. We go through all of the images, deleting any that we don't want to keep. Each different subject is selected as a group and a title is applied to each digital file along with a unique number.

Recently, we have been photographing the red fox that lives nearby and has lost its fear of us. That means Foxy (Barbara named it) comes when called and eats out of our hand without biting the hand that feeds it. Out of 220 RAW images, we might keep only 40, the others being deleted because the fox moved, the image wasn't sharp, the fox blinked, or the pose was poor. The remaining 40 images are labeled, numbered, and moved from the New Captures folder to the red fox folder. Our folder organization is simple, but effective. We have a folder for all mammals in the US. Each species we have images of has its own sub-folder under the US Mammals

Teaching nature photography is a fun way to earn money for your hobby. Most teachers start locally, but it can lead to other things. Our early classes soon provided the opportunity to lead dozens of photo safaris to remote corners of the world including the best game parks in Kenya where these common zebras entertained us.

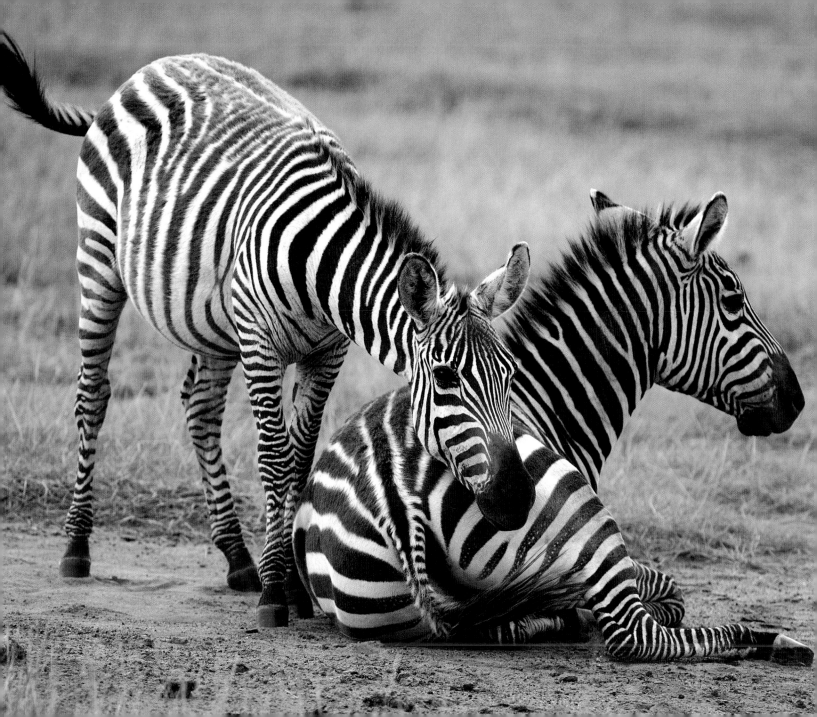

Everything on our tiny ranch is totally protected. Many wild animals learn you won't harm them making them easy to photograph. This red fox has shared our property for 3 years so far. She comes when we call her name.

Keep your image filing system tight and simple. Keep only the best images so edit ruthlessly. Keep the folders logical. To find this bald eagle image, all we have to do is go to the bird folder and look for the bald eagle folder. We could find this image in less than 1 minute.

folder. We have other main folders for wild-flowers, reptiles, amphibians, Yellowstone National Park, birds, Kenya, and many other subject groups. If we need a cheetah image, all that is required is to go to the Kenya folder, open up the mammal folder under Kenya, and select the cheetah folder. It takes about 5 seconds to get to all of the cheetah images.

There are plenty of software programs that can organize images far more precisely by using key words. But, all of these programs seem to be labor intensive to us so we resist using them. We would rather spend more time outdoors photographing than more time in the office imputing key words and other data that seems useless to us. Everyone will find their own answer to how they want to store and organize their growing collection of digital images. We find that simple and quick is the best way for us.

Enjoy nature photography and always keep it fun. A 15 mm lens a few inches from John's nose offers an unusual perspective and is a quick way to lose 100 pounds!